Freedom of Speech

Reflections in Art and Popular Culture

Patricia L. Dooley

Issues through Pop Culture

GREENWOOD™

An Imprint of ABC-CLIO, LLC
Santa Barbara, California • Denver, Colorado

Library of Congress Cataloging-in-Publication Data

Names: Dooley, Patricia L., author.
Title: Freedom of speech : reflections in art and popular culture / Patricia L. Dooley.
Description: Santa Barbara, California : Greenwood, An Imprint of ABC-CLIO, LLC, 2017. |
 Series: Issues through pop culture | Includes bibliographical references and index.
Identifiers: LCCN 2016052189 | ISBN 9781440843396 (hard copy) | ISBN 9781440843402 (ebook)
Subjects: LCSH: Freedom of speech—Social aspects. | Popular culture.
Classification: LCC JC591 .D66 2017 | DDC 704.9/49323443—dc23
LC record available at https://lccn.loc.gov/2016052189

ISBN: 978-1-4408-4339-6
EISBN: 978-1-4408-4340-2

21 20 19 18 17 1 2 3 4 5

This book is also available as an eBook.

Greenwood
An Imprint of ABC-CLIO, LLC

ABC-CLIO, LLC
130 Cremona Drive, P.O. Box 1911
Santa Barbara, California 93116-1911
www.abc-clio.com

This book is printed on acid-free paper ∞

Manufactured in the United States of America

Contents

Introduction

We live today in what is often called an age of popular culture, but that doesn't mean that everyone is happy about it. For as long as popular culture products have existed, many of their creators have been subjected to censorship. Thus, a crucial link has always existed between popular culture and freedom of expression, and it is this relationship that is explored here.

Through sets of historical and contemporary case studies, rich stories of the tensions and battles between the creators and critics of popular culture are retold. Disputes over popular culture products have driven government leaders to burn or otherwise ban them, punish their creators, and/or impose orders that they be changed in ways that will make them more "acceptable" to detractors. In response, the creators and distributors of pop culture products either agree to censor themselves, or choose to fight back through lawsuits or the use of other strategies. In the end, no one is better off when censorship leads to such resolutions.

Historically, popular culture has arisen out of folk culture traditions and is associated with the emergence and triumph of a mass-mediated society. This has brought challenges to the legitimacy of its forms, and most of these critiques have been couched in comparisons between high and low cultures. In 1974, for example, cultural critic and scholar Raymond Williams wrote,

> What is the relationship between high culture and popular culture? . . . It is said that high culture—"the best that has been thought and written in the world"—is in danger, or is indeed already "lost," because of widespread popular education, popular communications systems, and what is often called "mass society."

As seen in this book's nine sections, which range from theater to fashion, challenges to pop culture products have come from parents, teachers, religious figures,

government officials, and others who worry that they foment social and cultural pollution. On the other side are the creators of popular culture forms who unite with individuals, groups, and organizations who believe that censorship of popular culture products hurts the very fabric of society. Complicating the situation is the view that censorship of artistic works results in reduced opportunities for ordinary people to empower themselves and the groups they identity with. Without knowledge of these pivotal events, no one is truly educated.

ONE

Literature

INTRODUCTION

The literary arts include essays, novels, nonfiction, poetry, speeches, cartoons, comic strips, and dramatic scripts, among other things. Scrolls, manuscripts, books, magazines, newsletters, bulletins, leaflets, electronic and digital media, and more, are among the myriad formats that have been used to present such works. Historians have learned that Roman and Celtic writers were producing literature long before the advent of Christendom, and scholars divide the history of the field of literature into periods and movements. "Beowulf," an old English epic poem, is thought to be the oldest surviving literary work. Scholars have traced its origin to sometime between the 8th and 11th centuries.

Although history has not left us a complete record of the history of literary censorship, it is known that some early writers suffered the ultimate form of censorship—death—for refusing to bend to the will of authorities. In 399 BCE, in ancient Greece, philosopher and writer Socrates was forced to drink poison after refusing to recant controversial political and philosophical writings. Roughly a century later, the playwright Euripides defended the liberty of freeborn men and the right to speak and write freely, although he considered free speech a choice rather than a right.

The concept of free speech evolved over many centuries, and it became a foundational pillar of the United States, which codified it into the controversial First Amendment to its Constitution. Even today, though, Americans fail to agree on how much protection the First Amendment should give writers whose literary work challenges certain values and legal guidelines.

BOOK BURNING IN AMERICA

Throughout history, one of the most notorious methods for censoring ideas expressed on the written page has been book burning. Even before books existed,

leather scrolls, wax tablets, and other materials used as writing surfaces had been destroyed by fire-wielding critics. The earliest known incidents of the use of fire to destroy intellectual property took place in antiquity. In 612 BCE, the library of King Ashurbanipal, located in the Assyrian capital of Nineveh, was burned, and about 600 BCE, a scroll written by the Hebrew prophet Jeremiah went up in smoke in Babylon. In 213 BCE, the first emperor of a unified China, Qin Shi Huang, ordered the burning of all books except those in the imperial library and those that dealt with agriculture, medicine, and prognostication. Much more recently, well-known book-burning events were organized by the Nazis and other World War II fascists, and also took place during the Chinese Cultural Revolution of 1966–1976.

In a 2011 essay published in *Numéro Cinq*, Noah R. Gataveckas explores 10 motivations behind book burning, including killing what you love, primitivism, one's "God demand[ing] a sacrifice," for evil reasons, and others. In the United States, most book burners have been motivated to take such steps by strong disagreements with a book's contents. The perceived sinfulness of books has often served as a justification for the burning of books. Starting in 1873, for example, Anthony Comstock and the New York Society for the Suppression of Vice burned 15 tons of books deemed to be steeped in immoral content.

Various other forms of religious intolerance have also led to book burnings. The Amazing Grace Baptist Church, in Canton, North Carolina, organized a book burning to be held on Halloween 2009 to protest certain Bibles as well as the published works of various Christian writers and preachers. Although they were forced to cancel the actual burning of the books because local officials threatened to issue heavy fines if they did so, they tore them apart and threw them into trashcans. And from 2010–2011, Pastor Terry Jones of the Dove World Outreach Center, in Gainesville, Florida, burned copies of the Quran.

At times, certain authors' works have been singled out for destruction. In 1935, town officials in Warsaw, Indiana, and Fayette, Ohio, ordered the burning of all of their library's copies of books authored by Theodore Dreiser because of his characters' sexual promiscuity. And in 1954, following an investigation by the U.S. Food and Drug Administration, noted psychologist Wilhelm Reich was prosecuted for his use of orgone accumulators, a homeopathic medical device. After his conviction, federal agents burned his books, journals, and papers. More recently, churches in New Mexico and South Carolina have burned copies of J. K. Rowling's Harry Potter books, which they insist glamorize witchcraft.

Other reading materials regarded by conservative community leaders as threats to the well-being of children have been subjected to book burnings as well over the years. In 1948, for example, a group of priests, teachers, and parents publicly burned several hundred comic books in Spencer, West Virginia, and Binghamton, New York.

Disputes over political ideologies have also led to book burnings. During the 1950s Cold War era, a number of U.S. libraries burned books by authors considered dangerous by U.S. Senator Joseph McCarthy and his anti-Communist allies because of their purported pro-communist messages. Ironically, some book burnings have

been staged to send a message that has nothing to do with their contents. In 2007, the proprietors of Prospero's Books, a used book store in Kansas City, Missouri, burned some of their inventory to protest their perceived belief that people have become indifferent to the printed word.

AMERICA'S FIRST-KNOWN CASE OF BOOK BANNING (1650s)

William Pynchon's book *The Meritorious Price of Our Redemption* was published in London in 1650. When he brought it with him in his move to Massachusetts Bay Colony, Puritan authorities banned it for containing heretical contents. Pynchon's words were considered dangerous because they debated aspects of Puritan doctrine that conflicted with the accepted teachings of its ministers and leaders. In 1651, after Pynchon's books were burned, the Massachusetts Bay authorities put him on trial. After he issued a statement that seemed apologetic, a second trial was scheduled to commence in October. Before it opened, Pynchon returned to England, where he wrote and published even more scathing critiques of the way Massachusetts Puritans interpreted the religion's tenets.

THE HICKLIN TEST (1868)

In the late 19th and early 20th centuries, the history of U.S. literary and film censorship was influenced by an 1868 British legal decision that established a method for courts to use when forced to decide whether challenged literary material was obscene. Named after *Regina v. Hicklin*, the rule allowed for the banning and/or destruction of publications if any portion of it would have a "tendency . . . to deprave and corrupt those whose minds are open to such immoral influences, and into whose hands a publication of this sort may fall." The Hicklin test was an exceptionally strict test, as it meant that entire publications could be banned if even one word or image was offensive enough to be considered obscene.

The *Regina v. Hicklin* case concerned Henry Scott, who was caught selling copies of an anti-Catholic pamphlet entitled "The Confessional Unmasked." Prosecutors ordered the destruction of the pamphlets based on grounds that they were obscene. After Scott appealed the order, Benjamin Hicklin, the officer in charge of such orders, rescinded it because he did not think Scott's intentions were immoral. After the authorities appealed Hicklin's reversal of their order, the case was heard by the Court of Queen's Bench.

Before the Queen's Bench court could rule on the validity of Hicklin's decision to revoke the order to destroy the pamphlets, it had to define the word "obscene," which was part of Britain's 1857 Obscene Publications Act. The act authorized the destruction of obscene and pornographic materials, but without widespread agreement on how to decide what is obscene, future decisions would at best be inconsistent. Chief Justice Cockburn, the judge in charge of the case, thus wrote a statement that contained the now famous Hicklin test. In his final decision in the case, Cockburn ruled against Scott because he considered "The Confessional

Unmasked" to be obscene when judged against the standards of his new test. Under the Hicklin test, judges could ban any work if any portion had a tendency "to deprave and corrupt those whose minds are open to such immoral influences, and into whose hands a publication of this sort may fall."

In the 1870s, a few U.S. courts adopted the Hicklin test, and in 1879, it became even more powerful when Federal Judge Samuel Blatchford used it in the high-profile case *United States v. Bennett* to uphold the obscenity conviction of D. M. Bennett, a free-thinking journalist who sent a copy of a sexually explicit pamphlet through the mail. Finally, in the 1896 *Rosen v. United States* decision, the U.S. Supreme Court adopted the Hicklin test as the nation's standard for obscenity.

Although the judge in the *United States v. One Book Called Ulysses* (1933) case refused to use the Hicklin test, thereby allowing James Joyce's Ulysses to be imported into the country, the Hicklin test was not formally rejected by the high court until 1957. That year, in the case of *Roth v. United States*, the Supreme Court replaced the Hicklin test with the Roth test, which contained a more lenient standard for use in obscenity cases. Works in question could now be judged as a whole, whereas in the Hicklin test, small passages of material considered obscene meant books could be banned in their entirety.

Anthony Comstock was a notorious defender of public morality in the United States around the turn of the 19th century. His name has become synonymous with moralistic censorship. (Bettman/Getty Images)

AMERICA'S COMSTOCK LAW (1873)

The Comstock Law, named after its chief proponent, a devout Christian from New York City called Anthony Comstock, was a federal act passed by the United States Congress on March 3, 1873. Its formal title was an act for the "Suppression of Trade in, and Circulation of, Obscene Literature and Articles of Immoral Use." The act criminalized the use of the country's postal services to deliver the following materials and any published information relating to them: erotica, contraceptives, abortion-related items, and sex toys, as well as

the use of the mails to send personal letters that included sexual content. Further-more, the act outlawed the possession and sale of obscene materials in Washington, D.C., and any other place Congress had jurisdiction over. Under the Comstock law, postal service inspectors were those in charge of deciding what materials would be censored.

In its passage of the act, Congress reacted to public concern about the wide-spread availability of pornography during and after the American Civil War. Anthony Comstock was not a member of Congress, but he wielded tremendous power in Washington. Under his leadership, the New York Society for the Suppression of Vice became the main prosecutor of authors and others who were accused of violating the act. Comstock held paid positions with the vice society and the U.S. Postal Service.

The postal service's enforcement of the act seriously affected the dissemination of magazines and books. One of the most famous criminal trials based on the Comstock Act, which was decided in 1921, banned the U.S. publication and sale of James Joyce's literary classic *Ulysses*. Not until 1933 would it be legal to import the book into the United States.

CENSORSHIP OF WHITMAN'S *LEAVES OF GRASS* (1882)

Walt Whitman's *Leaves of Grass* is today considered to be one of America's most important collections of poetry. But when the collection was first published in 1855, its explicit sexual references engulfed it and its author in controversy. Whitman was fired from his job at the U.S. Department of the Interior, and the book was subjected to scathing reviews.

In 1882, not long after Whitman published the sixth edition of the volume, his Boston publisher, James R. Osgood, was notified that the New York Society for the Suppression of Vice had ruled that it was obscene. What offended the society were the representations of women in the collection's poem "To A Common Prostitute," and its group of poems "Children of Adam." After the censors ordered the poems removed from the volume, Whitman found a publisher in Philadelphia, where the climate was more sympathetic to the republication of *Leaves of Grass*.

DIME NOVELS TARGETED FOR CENSORSHIP
(LATE 19TH CENTURY)

In 1874, 15-year-old Jesse Pomeroy of Massachusetts was sentenced to death for the cruel mutilations and murders of two children. As the community struggled to understand his crimes, some people focused on Pomeroy's enthusiasm for "dime novel" westerns, which were filled with stories of scouts, Indians, renegades, and terrible cruelties. This added fuel to the firestorm of criticism already being directed at the publishers and readers of dime novels—cheap paperback books with melo-dramatic, sensationalistic storylines that were immensely popular in the late 19th

and early 20th centuries. Newspaper writers, preachers, and social crusaders carried out a campaign against dime novels based on the arguments that their consumption led to intellectual and moral degeneration, delinquency, and crime.

The dime novel industry emerged from the convergence of several developments, including rising literacy rates and the day's improved printing presses, which made it possible to print books more quickly and cheaply. In 1860, the first series of dime novels was released under the name Beadles Dime Novels. Based on tales of the West, the 321-issue series was popular from the start. Approximately 65,000 copies of its first title, *Malaeska: The Indian Wife of the White Hunter*, were sold within a few months. As new series of dime novels were released by publishers across the country, they developed devoted readerships among young working-class children.

The campaign against dime novels culminated in the enactment of laws and policies that affected readers' access to them. Some librarians banned them from their collections of early children's literature. In Massachusetts, the legislature passed a bill that forbade children from purchasing books and magazines that featured "criminal news, police reports, or accounts of criminal deeds, or pictures and stories of lust or crime." And in California, Connecticut, Maine, New Hampshire, South Carolina, Tennessee, and Washington, state legislators enacted bills that gave the mayors of their communities the power to outlaw sales of dime novels.

THE FREE SPEECH LEAGUE (EARLY 20TH CENTURY)

The Free Speech League was America's first organized group dedicated to the advancement of freedom of expression. It started in 1902, in New York City, two decades before the establishment of the American Civil Liberties Union (ACLU). According to Roger Baldwin, one of the founders of the ACLU, the league's members included "the anarchists, the agnostics or atheists, the birth-controllers and the apostles of a once slightly 'fashionable' cult on the left, the free lovers." A statement published in *Lucifer* identified the League as

> [a] nucleus around which to rally the opponents of a censorship, . . . [and] composed of men and women of every phase of opinion, who believed in preserving the freedom of speech, press, assemblage and mails, guaranteed to us by the constitution of the United States and essential to our existence as a free people.

Among the League's activities were campaigns to stop the censorship of books, pamphlets, and literature of any kind. Under the leadership of Theodore Schroeder, a libertarian attorney determined to stamp out censorship, it became a principled advocate for freedom of expression under a tradition of libertarian radicalism that originated in the early 19th century. League members publicized free speech disputes, printed and distributed pamphlets, organized protest meetings and demonstrations, corresponded and met with public officials, testified before government commissions, and lectured at scholarly and professional meetings.

One of the organization's chief targets was anti-obscenity zealot Anthony Comstock, who pushed for the Comstock Act and founded the New York Society for the Suppression of Vice. Although most of Comstock's anti-literature work sought to stamp out commercial pornography and works about sex by libertarian radicals who expressed controversial views, he also campaigned against more popular books by mainstream established authors. Walt Whitman's *Leaves of Grass* became one of his targets, as did Leo Tolstoy's *Kreutzer Sonata*. Comstock also argued that the day's popular dime novels had pernicious effects on the nation's youth and that only mature scholars should be permitted to read certain literary classics. The organization gradually disbanded between 1917 and 1919.

JAMES JOYCE'S *ULYSSES* ON TRIAL (1933)

Irish author James Joyce's *Ulysses* was one of the early 20th century's most controversial books. Joyce's book was published in several parts, beginning in 1918, in the U.S. literary magazine *The Little Review*. In 1921, the U.S. Post Office, under the authority of the Comstock Act, confiscated copies of the magazine and refused to deliver them on grounds that *Ulysses* contained obscene material—specifically, that one of the book's main characters engaged in masturbation. In 1921, the magazine went to trial to fight the government's charges of obscenity, but was not successful. Throughout the 1920s, the Post Office burned copies of the novel.

After Sylvia Beach published *Ulysses* in its entirety in France in 1922, it continued to attract scrutiny for its language and allusive references to sex. In 1933, Random House, a well-known New York City book publisher, had copies of the book shipped to the United States. As they were being unloaded, customs officials confiscated them. Once again, a trial ensued, but this one led to a better outcome for its author and publisher. In *United States v. One Book Called Ulysses,* U.S. District Judge John M. Woolsey refused to ban the book because he did not consider it to be obscene. The decision was appealed, but the Second Circuit Court of Appeals affirmed the ruling by Woolsey in 1934.

Literary critics rank Joyce's *Ulysses* among the best English-language novels of the 20th century. Written in the modernist tradition, its fans celebrate it across the world on June 16, which they have dubbed Bloomsday after its characters Leopold and Molly Bloom.

THE TRIAL OF LIBRARIAN RUTH BROWN (1950)

In Bartlesville, Oklahoma, a public monument has been dedicated to the life and work of Ruth Brown, a librarian who served the town's library patrons for three decades starting in the 1920s. What distinguished Brown's career were her tireless efforts to educate people of all ages and races about issues many considered unacceptable and her steadfast defense of their "right to read." In doing so, she ran afoul of library officials who condemned her as a negative influence on children and other community members.

Despite the fact that the "separate but equal" doctrine opened all public librarians to African Americans, a mere 99 of the South's 774 public libraries provided services to African Americans. As Brown worked to open more libraries, she attracted the attention of those in the community who did not share her views. In addition, she added more African American literature to the library's shelves, attempted to integrate its children's story time, and worked toward the installation of the educational exhibit *Negro Culture from Africa to Today*.

Bartlesville's leaders established a citizen committee to investigate Brown's activities in order to build a case for her dismissal. On July 25, 1950, she was dismissed from her position for providing "subversive" materials to librarian patrons, among other things. The Oklahoma Library Association, America Librarian Association, and American Civil Liberties Union protested her dismissal and sought to raise public awareness of her treatment. A group of supporters, Friends of Miss Brown, were unsuccessful in their efforts to take her case to court due to the lack of constitutional standing. After it was clear that her case was not going to be successful, she left Bartlesville to teach in an African American school in Mississippi, and later moved to Colorado, where she once again served as a librarian. She lived there until her death in 1975. On March 11, 2007, a bronze bust of Brown was unveiled at the Bartlesville Library, and a scholarship has been established in her honor.

THE DECENT READING MOVEMENT (MID-20TH CENTURY)

In the mid-20th century, Americans' concerns about the evils that would transpire if their children were allowed to read sexually explicit or violent literature coalesced into a movement designed to stop the sales of such publications. Many extant organizations joined the battle, and several new nationally based organizations were formed to push for the enforcement of local obscenity laws.

In 1958, a Cincinnati lawyer named Charles H. Keating Jr. established the first of the nation's new organizations designed to eliminate indecent reading material. Keating said he was inspired to form the organization, which he named Citizens for Decent Literature (CDL), upon visiting a Cincinnati newsstand where he noticed a group of youngsters snickering over a display of "girlie" magazines. On further exploration, he found other unwholesome materials, including explicitly sexual books and magazines. He was so concerned that he visited local police headquarters to complain. There he learned that a lack of citizen support made it difficult for police to enforce the city's obscenity laws. This experience inspired Keating to form the CDL, which he hoped would aid police and the city's prosecuting attorneys in their efforts to get convictions. It wasn't long before the CDL had helped authorities obtain several obscenity convictions in Cincinnati and elsewhere, and by mid-1967, Keating reported that approximately 300 CDL chapters had been formed around the nation. Keating later became a wealthy real estate developer and banker, but he became a central figure in the U.S. savings and loan crisis of the 1980s and 1990s. He was eventually convicted of fraud and racketeering and spent more than four years in prison.

A second organization that became a strong supporter of the country's decent reading movement was the National Organization for Decent Literature (NODL). Unlike the CDL, the Catholic-sponsored NODL was intended to be a service organization rather than an action group. Its chief activities were to monitor, evaluate, and report on the contents of comic books, magazines, and paperback books. The product of their work was called the "NODL List," which was primarily directed at parents seeking information about the content of material to which their children were being exposed. A Protestant version of the NODL, the Churchmen's Commission for Decent Literature, was formed to carry out a similar program.

In addition to the formation of new organizations whose sole purpose was to stamp out unwholesome literature, many extant organizations joined the fray. These included the Knights of Columbus, Federation of Women's Clubs, Daughters of the American Revolution, and Kiwanis International, among others. At their 1966 convention, for example, the Kiwanis International passed a resolution asking its members to impel distributors of children's literature to remove "smut" from their shelves, and to push for legal curbs on pornographic literature. At times, NODL and CDL joined with such organizations to make their voices even stronger. In 1954, for example, the NODL and the Daughters of the American Revolution combined efforts in a call for a ban on "crime comics."

"A NATIONAL DISGRACE"—COMIC BOOKS UNDER ATTACK (MID-20TH CENTURY)

American comic books descended from the cheap pulp magazines published during the Civil War. In 1933, Harry Wildenberg and Max C. Gaines published *Funnies on Parade*, the four-color, saddle-stitched newsprint publication that became the model for the modern comic book. In 1938, Jerome Siegal and Joseph Shuster's new comic book, *Superman*, spurred the growth of what historians have named the golden age of the comic book industry. As it grew, however, so also did its opposition.

The anti–comic book hysteria steadily grew in intensity across much of the nation, and in 1940 a scathing editorial in the *Chicago Daily News* asserted that comics were "A National Disgrace!" Its author, Sterling North, wrote:

Badly drawn, badly written and badly printed—a strain on young eyes and young nervous systems—Their crude blacks and reds spoil the child's natural sense of color; their hypodermic injection of sex and murder make the child impatient with better, though quieter, stories. . . . Unless we want a coming generation even more ferocious than the current one, parents and teachers throughout America must band together to break the "comic" magazine.

An organization dedicated to curbing the public criticism of comic books, the Association of Comic Book Publishers (ACMP) formed in 1948 to allay American's

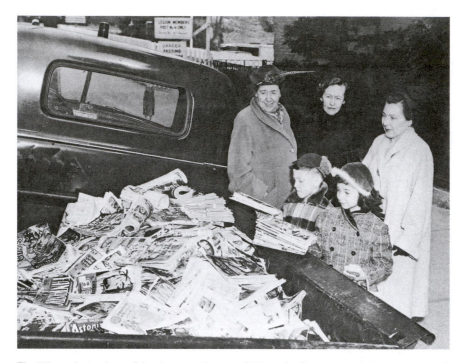

The Women's Auxiliary of the American Legion of Norwich, Connecticut, holds a comic book burning in 1955. The Auxiliary asked children to bring 10 comic books to burn, in exchange for one "clean" comic book. (AP Photo)

fears. The organization's code banned scenes of sadistic torture and many of the other depictions that troubled the most vociferous of the comic's critics. The code failed, however, because of a lack of uniform participation and standards of review.

Another chapter in the campaign against comics began in 1954 with publication of *Seduction of the Innocent*, a book by Fredric Wertham. The psychologist's claim that comics were one cause of juvenile delinquency was one of the reasons the U.S. Senate decided to form a Judicial Committee's Subcommittee to Investigate Juvenile Delinquency that essentially put comic books on trial. For two days, a series of expert witnesses and other concerned people weighed in on the question of whether comics required government regulation. Together with these hearings, Wertham's book had a significant negative influence on public perceptions of comic books.

On the state level, legislatures began enacting comic book censorship laws. In 1955, for example, New York passed a law that would punish violators with a year in jail and/or a $500 fine.

Confronted with an angry public and officials and experts bent on regulation, the comic book industry decided to establish a self-censoring body to monitor the

content in their publications. Thus began the Comic Magazine Association of America, which established a censorship code that satisfied the demands of the industry's most vociferous critics. Comics that lived up to the association's code were published with a stamp of approval.

These developments had a devastating effect on the comic book industry. Cartoonists lost their jobs, and the number of titles dropped from 650 in 1954 to 250 in 1956. The industry gradually recovered, though, as talented writers and artists introduced new superheroes and other storytelling innovations. Comic book aficionados informally call the period from 1956 to roughly 1970 the silver age of the comics; the period from 1970 to the mid-1980s, the bronze age of the comics; and the period from the mid-1980s to the present—in which comic book icons have become fixtures in movies and other realms of popular culture—the modern age of the comics.

CONGRESSIONAL BACKLASH AGAINST PAPERBACKS (1950s)

In 1952, the U.S. Congress established a committee to investigate paperback books and other published material considered by many Americans to be immoral. The committee's official name was the Select Committee on Current Pornographic Materials, but it was typically referred to as the Gathings Committee. Established in the midst of a period of intense moral panic, its mission was to

> determine, by investigation and study, the extent to which books, magazines, and comic books containing immoral, obscene, or otherwise offensive material, or placing improper advertising emphasis on crime, violence, and corruption, are being made available to the people of the United States through the United States mails and otherwise; and (2) to determine the adequacy of existing law to prevent the publication and distribution of books containing immoral, offensive, and other undesirable matter.

After a series of hearings that included the testimony of conservative religious figures and paperback book publishers, the committee issued majority and minority reports. The former claimed paperbacks were typically full of patently sexual material, condoned reprehensible behavior, and were detrimental to youth. Its authors recommended that Congress strengthen federal obscenity laws and gave the post more power to curtail the mailing of materials considered unwholesome.

The committee's minority report, the work of two of its nine members, argued that the authors of the majority report went too far, stating that they came "dangerously close to book burning." The nine-member committee was politically bipartisan, and the two members who wrote the minority report were from different political parties.

BANNED AND CHALLENGED BOOKS IN AMERICAN LIBRARIES (EARLY 20TH CENTURY TO THE PRESENT)

Historically, America's libraries have emerged as battlegrounds for public disputes over what books should be allowed in circulation. Today's libraries at times ban books because of their objectionable contents, and what often precedes these orders are book challenges from concerned community people to head librarians or library board members. The grounds for such challenges are typically objections to a book's perceived sexually explicit material, offensive language, or dangerous ideas. The American Library Association (ALA), reports that most of today's book challenges are unsuccessful.

American court records are one place to look for information about the history of challenged and banned books. In 1924, a California court heard a case that resulted from the state legislature's enactment of a statute requiring that public school libraries take the King James version of the Bible off their shelves because it was said to be a "publication of a sectarian, partisan, or denominational character." The California State Supreme Court ruled against the legislature, striking down its requirement.

In 1949, the Board of Education of New York City sought to ban Charles Dickens's *Oliver Twist* and Shakespeare's *Merchant of Venice* from its school libraries and classrooms because they believed that they promoted hatred of Jewish people. The Supreme Court of Kings County, New York, declared that the board's attempted suppression of the books was unlawful.

Dozens of additional book challenge cases have been heard in American courtrooms over a wide variety of published materials, including novels, poetry anthologies, and magazines, among others. One of the most important book-related court decisions was issued by the U.S. Supreme Court in 1982. In *Board of Education, Island Trees Union Free School District No. 26 v. Pico*, the Court ruled that local school boards have limited power to remove library books from junior and senior high schools, thus underscoring students' rights to read library books of their own choosing. Justice William O. Brennan, who wrote the case's plurality opinion, stated:

> We hold that local school boards may not remove books from school library shelves simply because they dislike the ideas contained in those books and seek by their removal to "prescribe what shall be orthodox in politics, nationalism, religion, or other matters of opinion."

Despite the *Pico* decision, book challenges continue to be an issue for American libraries. The ALA, which compiles data on contemporary book challenges, issues annual reports on the books that are challenged, who they received challenges from, and the types of libraries that receive them. Of the 275 challenges recorded by the ALA in 2015, the top 10 most challenged books were *Looking for Alaska*, by John Green; *Fifty Shades of Grey*, by E. L. James; *I Am Jazz*, by Jessica Herthel and

Jazz Jennings; *Beyond Magenta*, by Susan Kuklin; *The Curious Incident of the Dog in the Night-Time*, by Mark Haddon; the *Holy Bible*; *Fun Home: A Family Tragicomic*, by Alison Bechdel; *Habibi*, by Craig Thompson, *Nasreen's Secret School*, by Jeanette Winter; and *Two Boys Kissing*, by David Levithan.

According to the ALA's Office for Intellectual Freedom, many of the most respected novels of the 20th century have been the targets of ban attempts. Included on this list are literary classics such as F. Scott Fitzgerald's *The Great Gatsby*; John Steinbeck's *The Grapes of Wrath*; Harper Lee's *To Kill a Mockingbird*; William Golding's *The Lord of the Flies*; and George Orwell's *1984*.

Founded in 1876, the ALA has long sought to defend the literary arts. Although primarily founded to provide leadership for the development of the nation's libraries, the organization's Office for Intellectual Freedom, established in 1967, educates the general public and librarians about the importance of people's "right to read" and supports librarians, teachers, and readers whose intellectual freedom has been threatened.

In addition to keeping records and reminding the public of the book challenges received by schools and libraries, the organization publishes an updated list titled "The Top 10 Most Frequently Challenged Books." In addition, the ALA sponsors an annual event titled "Banned Books Week," which offers Americans in every community a chance to celebrate the right to read books and other materials that question mainstream political, social, and cultural values. Focusing on efforts across the country to restrict access to certain books, the event is effective in drawing national attention to the issue.

THE MILLER TEST FOR OBSCENITY (1973)

The First Amendment does not protect obscene speech, and this requires that U.S. courts have a guideline to use as they deliberate over cases involving controversial books, films, or other forms of communication accused of containing obscene content. From the 1870s until 1973, the legal test that the nation's courts used for deciding whether speech was obscene was based on a national standard. This changed when the majority in the U.S. Supreme Court decision *Miller v. California* decided to change the previous test's national standard into one that also catered to local and state values. Marvin Miller was part owner of a business that, in violation of a California statute, mailed advertisements promoting the sale of "adult" materials. The court intended that only the most blatantly offensive forms of hard-core pornography would be found to be obscene.

Today's Miller test, which after 1973 was slightly modified by subsequent decisions, requires that courts address three questions as they consider whether certain works should be banned as obscene.

1. Would an average person, in light of contemporary community values, find that a work, when taken as a whole, appeals to his or her prurient interests?

2. Does the work depict or describe, in a patently offensive way, sexual conduct or excretory functions defined by applicable state law?

3. Does the work, when taken as a whole, lack serious literary, artistic, political, or scientific value?

The test has always had critics, whose concerns have tended to cluster around three points. The strictest guardians of the First Amendment worry that the use of local and state standards will lead to more censorship. A well-known spokesman for this position was U.S. Supreme Court Justice William O. Douglas. Second, the Miller test's critics complain that the test's subjective nature will lead to bad decisions. And finally, in the age of the Internet, problems of jurisdiction arise because of the test's application of community and state standard.

Shortly after the Miller test was put into effect, federal authorities still bent on ridding communities of purportedly obscene books, magazines, and films, began devising ways to get around it. One method for doing so involved the mailing of suspect materials to places where federal prosecutors thought it would be easier to get convictions. An example involved the prosecution of New York pornographer Al Goldstein in a federal courtroom in Wichita, Kansas. Goldstein, a notorious New York publisher of pornographic materials, was arrested in 1974 after being indicted on obscenity charges for mailing one of his magazines, *Screw*, to several post office boxes it had established in Kansas. Goldstein was convicted, but the federal judge who presided over the case invalidated the court's decision because of improper statements the prosecuting attorney made to the jury. In 1977, federal prosecutors initiated a second trial against Goldstein, in another Kansas community, which ultimately ended with a hung jury.

ISLAND TREES BOARD OF EDUCATION v. PICO (1982)

In 1976, the Island Trees Board of Education, in Levittown, Long Island, New York, warned school staff about the dangers of nine books currently in their libraries. Not only did they order their librarians to remove these books from their shelves, but teachers were warned not to include them in classroom assignments. According to the board, the books were "anti-American, anti-Christian, anti-Semitic, and just plain filthy." Six years later, the United States Supreme Court issued a ruling in the legal dispute that arose in the wake of the school board's book order. The case, titled *Board of Education, Island Trees Union Free School District No. 26 v. Pico*, was decided on June 25, 1982. It is considered by First Amendment scholars to be significant because it is one of the only major public school book censorship cases the high court has ruled on. It is also notable because the books at the heart of the dispute were not considered dangerous by a good portion of the community.

The history of the Pico case started in 1975, when several members of Island Tree Board of Education attended a conference sponsored by Parents of New York United, a politically conservative organization of parents concerned about education

legislation. At the meeting, board members were given a list of 32 books the organization considered "objectionable" and "improper fare for school students."

After learning that 11 of the list's books were in the school district's libraries, the board appointed a committee of parents and school staff to review them. The committee considered most of the books acceptable. Nevertheless, the board issued an order banning nine of the books from the district's libraries and classrooms.

Thus began a series of confrontations between a group of five junior and senior high schoolers and the school district in state and federal courts. The New York chapter of the American Civil Liberties Union stepped in to advocate for the students. In its brief, the organization asserted:

> At the bottom of the clash between the school board and the students in this case is a classic First Amendment confrontation between a transient majority that seeks to deploy the forces of a government to censor unpopular expression and those who seek to express—or be exposed to—differing perspectives.

The students insisted that the school board should not impose a "pall of orthodoxy" over the classroom.

In a 2009 interview, Nassau County ACLU Executive Director Barbara Bernstein said school board members had merely skimmed the books, only looking for problematic words or descriptions. Because of this, they overlooked each book's broader values. Among them were award-winning books such as *The Fixer*, which had earned its author a Pulitzer Prize. The following books were considered dangerous by the board members:

- *Slaughterhouse-Five*, by Kurt Vonnegut Jr.
- *The Naked Ape*, by Desmond Morris
- *Down These Mean Streets*, by Piri Thomas
- *Best Short Stories of Negro Writers*, edited by Langston Hughes
- *Go Ask Alice*, of anonymous authorship
- *Laughing Boy*, by Oliver LaFarge
- *Black Boy*, by Richard Wright
- *A Hero Ain't Nothin' but a Sandwich*, by Alice Childress
- *Soul on Ice*, by Eldridge Cleaver
- *A Reader for Writers*, edited by Jerome Archer
- *The Fixer*, by Bernard Malamud

After losing the case at the federal level, the school district asked the U.S. Supreme Court to issue a ruling on the questions it raised. In a close decision, the court decided in favor of the students, arguing that the First Amendment limits the power of

local school boards to remove library books from junior and senior high schools simply because they find some of their contents unsuitable. When it remanded the case back to the local level, the school gave in and rescinded their bans of the books.

HIGH SCHOOL TEACHER FIRED OVER STUDENTS' SLAM POETRY (2003)

At Albuquerque, New Mexico's Rio Rancho High School, Bill Nevins, the advisor of the school's slam poetry team, was fired because of the contents of one of its presentations. In March 2003, one of the team's members read one of her poems at a Barnes & Noble bookstore, as well as over the school's closed circuit-television channel. School officials were shocked by the poem's supposedly "un-American" perspective. Not only did the poet criticize the war in Iraq and the Bush administration, but she questioned the effectiveness of the federal government's "No Child Left Behind" education policy.

In addition to firing Nevins, school officials banned any future readings of poetry by students. Later, at a school gathering, the principal told dissenters to "shut your faces" as a poem he considered more suitable for students and faculty was read aloud. After the media was called, the story of what happened at Rio Rancho High School was more widely publicized.

Nevins hired an attorney to pursue legal action against the school for breach of contract and violation of his First Amendment rights. In August 2004, the school settled the case and paid Nevins $205,000. Thus, Nevins's termination remained valid, and the poetry team was never reinstated. A documentary film titled *Committing Poetry in Times of War*, which tells the story of the incident, was released in 2007.

FURTHER READING

An Act Concerning Obscene Publications, Chapter 305, published in *Acts and Resolves Passed by the General Court of Massachusetts in the Year 1885*. Boston: Potter Printing Co., 1885.

American Civil Liberties Union (1955). "Censorship of comic books: a statement in opposition on civil liberties grounds." New York: ACLU.

Boyer, Paul S. (2002). *Purity in Print: Book Censorship in America from the Gilded Age to the Computer Age*. Madison: University of Wisconsin Press.

Cadegan, Una M. (2001). "Guardians of Democracy or Cultural Storm Troopers? American Catholics and the Control of Popular Media, 1934–1966," *Catholic Historical Review* (April): 252.

Charles, Douglas M. (2012). *J. Edgar Hoover and the Bureau's Crusade Against Smut*. Lawrence: University of Kansas Press.

"Free Speech of Slavery." *Lucifer: The Light Bearer*, June 22, 1905, 327.

Gataveckas, Nicholas (2011). "Why Do We Burn Books? or, The Burning of Our Movement." *Numéro Cinq*, Vol. II, No. 11. http://numerocinqmagazine.com/2011/11/01/why-do-we-burn-books-or-the-burning-question-of-our-movement-by-noah-r-gataveckas/.

"Gathings Committee: Select Committee on Current Pornographic Materials, 1952–1953." (n.d.). https://gathingscommittee.wordpress.com/the-gathings-committee/.

Haney, Robert W. (1974). *Comstockery in America: Patterns of Censorship and Control*. Boston: Da Capo Press.

Island Trees Sch. Dist. v. Pico by Pico, 457 US 853 (1982).

Keetley, Dawn (2013). "The Injuries of Reading: Jesse Pomeroy and the Dire Effects of Dime Novels," *Journal of American Studies*, 4(3): 673–97.

Miller v. California, 413 US 15 (1973).

North, Sterling (1940). "A National Disgrace," *Chicago Daily News*, May 8.

Regina v. Hicklin (1868). LR 3 QB 360.

Reminiscences of Roger Baldwin 115 (1954). Oral History Collection, Butler Library, Columbia University.

Smyth, Adam, and Gill Partington, eds. (2014). *Book Destruction from the Medieval to the Contemporary*. New York: Palgrave Macmillan.

Strub, Whitney (2006). "Perversion for Profit: Citizens for Decent Literature and the Arousal of an Antiporn Public in the 1960s," *Journal of the History of Sexuality*, 15(2): 258–91.

United States Court of Appeal for the Second Circuit, 1980 U.S. Briefs 2043.

TWO

Theater

INTRODUCTION

Theater is a form of art involving live performers who act out stories about real, or imagined, events before live audiences. Elements of these productions include gesture, speech, song, music, and dance. Such dramatic presentations are most often performed on stages erected specifically for such purposes, but some forms of theater are presented in the street or other natural settings. Theater is a highly collaborative venture that involves not just performers, but authors, directors, producers, and set and costume designers, among others.

Some believe theater is an elitist form of art far removed from the lives of people not counted among the wealthy and intellectual classes. But from the theater of Ancient Greece to the pagan festivals of the Medieval Ages, to today's Broadway plays and performance art, theater's myriad forms have touched the lives of all kinds of people. Indeed, if theater had not been so popular over the millennia, the many attempts by those in positions of power to suppress it would not have been considered necessary.

The fact that theater is performed "live and in person" has undoubtedly enhanced its reputation as a potentially dangerous form of entertainment. Plays considered by the authorities to be seditious, sacrilegious, or immoral have been seen as especially troublesome. Censorship has included the banning of theatrical performances, as well as demands that scripts be altered in ways that address the concerns of the authorities. Punishments of the offending artists have included arrest and imprisonment, fines, banishment, and even executions.

Examples of such harsh forms of censorship abound in the annals of theater history. In 398 BCE, for example, at the height of the Peloponnesian War, Aristophanes was banished for producing his satire *Lysistrata*, the parliament of women, because of its morally offensive material. And in France, in 1785, the playwright Pierre

Beaumarchais was arrested after the highly successful staging of his play *The Marriage of Figaro*. Beaumarchais had altered its script after being ordered to do so by King Louis XVI, who considered it immoral. Despite this, the king eventually had him jailed. In Great Britain, Parliament's enactment of the Licensing Act of 1737 was a crucial event in the history of theater in that country. Its purpose was to control and censor what playwrights and actors were saying about the British government. Supporters of the legislation argued that theater posed a threat to the government because it opened doors for revolutionists to spread their beliefs and opinions to the masses.

Since the earliest actors appeared on stage, theater has faced censorship at the hands of government leaders, the clergy, and other powerful people and groups. Particularly concerning was drama's potential to undermine religion or government by conveying potentially "dangerous" ideas to people considered by powerful individuals and institutions to be weak minded enough to be easily duped.

YE BARE AND YE CUBB (1665)

Even though at first they had no theaters in which to perform, early America's immigrants found places to hold plays. Scholars believe the first theatrical performance staged in the British colonies took place in 1665. Titled *Ye Bare and Ye Cubb*, it was performed in Fowkes's Tavern, a pub on the eastern shore of Virginia. Edward Martin, a local resident who historians believe may have been a Quaker, complained to the local court that the actors' lines were blasphemous. Because of this, they were ordered to appear before the local judge. Some accounts of the episode report that after the judge complained that he was unable to decide whether the play should be censored, because he hadn't seen it, the actors performed it for him. The judge found the men not guilty of the charges against them.

The story of the play and the actors' and playwright's arrests and acquittals remains a popular one in the small Virginia community. As no copy of the play exists, efforts to evaluate the supposed radicalness of the play's contents have been frustrated over the years. This, however, hasn't discouraged locals from coming to the conclusion that *Ye Bare and Ye Cubb* must have embodied troublesome political overtones. To honor the 400th anniversary of Jamestown, Eastern Shore of Virginia native Cartland Berge was commissioned to write a new version. It played to enthusiastic audiences in Pungoteague, Virginia, in 2015, approximately 350 years after the first play holding title that was initially performed.

PENNSYLVANIA'S FRAME OF GOVERNMENT
BANS THEATER (1682)

Theater was so controversial in the American colonies that only a few productions were staged, usually far away from places dominated by Puritans and others sensitive to the rhetorical powers of drama. Ironically, the first early American

immigrants to perform a play in the British colonies (*Ye Bare and Ye Cubb*) were exonerated after the local judge determined it was not dangerous. Other playwrights and actors were not as lucky. In 1682, in fact, some colonial governmental authorities began enacting laws that banned theater altogether.

The first colonial law to ban the staging of plays was drafted by Pennsylvania leader William Penn. Called the *Frame of Government of Pennsylvania*, the document would become the colony's constitution after it was approved by King Charles II. Although remembered as a great champion of liberty, like other staunch Quakers, Penn feared that theater and other forms of popular entertainment would corrupt not just audience members but society as a whole.

Section 37 of the *Frame of Government* forbade the enactment of stage plays, along with dice, cards, cock fighting, and a long list of other activities. The law said participating in such pastimes would "excite the people to rudeness, cruelty, looseness, and irreligion." Anyone who introduced such crimes could be fined 20 shillings or sentenced to 10 days of imprisonment at hard labor. These penalties reflected Penn's belief that God's subjects should live in temperance and moderation by divesting themselves of luxury and excessive indulgences.

Penn's great experiment began to crumble within a decade as people outside the Society of Friends moved to the colony and began to challenge its strict rules. In 1700, in hopes of reestablishing the Friend's influence, Penn summoned the colony's General Assembly to revise and consolidate its penal code. One of the new laws enacted by Penn and his Assembly was titled "An Act Against Riots, Rioters, Riotous Sports, Plays and Games." Pastimes considered harmless, such as ice-skating, sleighing, and swimming, as well as activities such as hunting and fishing that helped people feed their families, were allowed.

A MASSACHUSETTS "ACT FOR PREVENTING STAGE-PLAYS AND OTHER THEATRICAL ENTERTAINMENTS" (1750)

The colony of Massachusetts, and particularly its thriving city of Boston, were places anyone in pre–Revolutionary War America with an interest in staging theater productions would likely stay away from.

New England's Puritans followed the teachings of William Prynne and others who considered theatrical performances as poisonous. In a 1633 treatise of more than a thousand words, Prynne railed against stage plays, actors, and court masques, among other activities he considered uncivilized and dangerous. In 1686, New England Puritan leader Increase Mather published a treatise claiming theaters were the "Devil's Temples," and that anyone involved, including audience members, risked losing their souls. He wrote, "When. . . . [audiences] have seen a lively representation of wickedness on the stage, their minds have been vitiated, and instead of learning to hate vice . . . they have learned to practice it." The following year, after Boston tavern owner John Wing "fitted up a room with seats where he proposed to allow a magician to perform his tricks," Judge Samuel Sewall warned him not to follow through with such performances.

With the arrival of the Murray-Kean Company in nearby Philadelphia in 1748, and a play in a State Street coffeehouse, the Massachusetts General Court was moved to action. To prevent "the many and great mischiefs which arise from public stage-plays," that "tend to increase immortality, impiety, and a contempt of religion," in 1750, the General Court's passed "An Act for preventing Stage-Plays and other Theatrical Entertainments."

Massachusetts's anti-theater movement gained further strength during the Revolutionary War, when the British staged theatrical performances in the midst of the hostilities. One of the plays, written by British General John Burgoyne, was an attack on their American foes, titled *The Boston Blockade*. It characterized George Washington as "an uncouth figure, awkward in gait, wearing a large wig and a rusty sword." After the war, however, Boston's elite merchant class went up against those who wished to continue the ban on drama by urging that a theater be established in the city. Part of the group promoting theater and calling for the abandonment of the 1750 theater ban was the Tontine Association, which was founded in 1791 to fund and encourage private and public ventures. In 1792, the Tontines illegally established Boston's first theater in Board Alley. When local authorities arrived to shut it down, a riot broke out among audience members. After the law was repealed in 1793, the Tontines opened a 1000-seat theater at the intersection of Federal and Franklin streets. Called the Federal Street (or Boston) Theater, it was the city's major playhouse.

ARTICLES OF ASSOCIATION (1774)

A little-known part of the American Continental Congress's 1774 Articles of Association dealt with theater and other popular forms of entertainment. Although most of the document's contents dealt with trade issues, Article 8 stated:

> We will in our several stations, promote economy, frugality and industry, and promote agriculture, arts and the manufactures of this country, especially that of wool; and we discountenance and discourage every species of extravagance and dissipation, especially all horse-racing, all kinds of gaming, cock-fighting, exhibitions of shows, plays, and other expensive diversions and entertainments.

This anti-theater stricture was mimicked by a number of the fledgling nation's new states, whose leaders likewise sought to outlaw the performance of plays. Most of these anti-theater laws were in effect until the early 1790s.

THE AFRICAN THEATER, NEW YORK CITY (1820s)

The African Theater was an African American acting troupe established in the 1820s by producer and playwright William Henry Brown. Brown was the first New York City theater producer to stage plays involving all–African American casts.

Brown's troupe performed in various city theaters as well as in his backyard at 38 Thomas Street. Their fare included plays from the standard white repertoire, including Shakespeare. Brown also staged a play that dealt with slavery, and in 1823 he wrote and produced *The Drama of King Shotaway*. Among his performers were James Hewlett and Ira Aldridge, who were among the first notable African American actors. Brown's productions attracted the attention of African Americans with a penchant for theater, along with curious Caucasians.

When Brown leased a performance space on Broadway, he attracted the negative attention of the city's theater owners. Disturbed by the unwanted competition and racial hostility, members of the theater community hired street thugs to break up one of his productions. When police arrived, they arrested the performers rather than those who started the trouble. The judge who presided over the trial held to resolve the dispute ordered the company to stop performing Shakespearean plays, and to stick to lighter fare. But after Brown returned to his 38 Thomas Street backyard theater, the harassment continued, and in 1823 he was forced to shut down. This was the end of African American performances on New York's stages until after the Civil War, and not until the early 20th century would all–African American productions open on Broadway.

"LIVING PICTURE" SHOWS (1840s)

On March 22, 1848, New York City police raided five theaters across the city and demanded that the owners close their "living picture" shows. Similar to the French shows called *tableaux vivants*, these productions portrayed seemingly nude performers through picture frames. The topics of the portrayals included famous paintings, sculptures, and scenes from classic literary works, among other things. The shows became better known when they began attracting large audiences willing to pay a dollar or more to see their "immoral" exhibitions.

The day after the raids, a *New York Herald* newspaper writer who happened to be in the audience when the theater was raided wrote:

> On the mantelpiece of this room was a glimmering lamp, reflecting a miserable light; and near the folding door were arranged three or four benches, which were occupied by the grey and bald headed old men adjusting their pocket telescopes and enormous opera glasses, in order to view more clearly the well made proportions of the fair artists. . . . The two parlors were separated by folding doors, in the front of which was a large gauze nailed up, through which the females were shown—the doors being closed and opened formed the drop curtain. Several tableaux were then shown, the females being nude, holding across their figures a gauze scarf thrown over them in a negligee manner, so as to create the greatest excitement possible in the audience. The last tableau was a tall, well-formed young woman, with long hair representing Venus rising from the sea.

Just after Venus arose from the sea, police rushed onto the stage and arrested five female performers and the doorkeeper.

These arrests were the first-known legal actions against such productions, although living picture shows had been staged in the United States since 1831. In the late 1840s, however, living picture producers began to make their shows more titillating. As newspaper coverage of the shows' shocking contents grew, so also did their audiences. In addition, community leaders became even more demanding in their calls for censorship.

Although the shows at the five theaters were shut down, new versions of living picture shows were seen in New York within a month, and productions of this type were seen in the United States during the rest of the century and into the next.

THE CAMPAIGN FOR DECENCY IN AMERICAN THEATER (1920s)

In the 1920s, New York became the center of a movement to stop the American theater community from staging "immoral" productions. Leading the call to clean up plays were New York City and state officials, and religious organizations. Also at the forefront of the campaign were concerned members of the theater community, including the Actors' Equity Association and the newly formed Actors' Association for Clean Plays. In 1924–1925, the campaign intensified as New York authorities received word that a number of current plays contained such reprehensible material that they should be altered or shut down.

A Good Bad Woman, which tells the story of the return home of a former burlesque performer and street prostitute, was one of the plays that brought the crisis to a head. After its early February 1925 opening, the production was universally panned by critics. But its tawdry storyline attracted attention, and curious New Yorkers flocked to see it. In line with a *New York World* editorial campaign against *A Good Bad Woman* and other plays considered immoral, the city's ministerial community, police, district attorney, and theater leaders were galvanized into action. New York City District Attorney Joab Banton, who became one of the movement's primary crusaders, claimed *A Good Bad Woman* topped a list of 13 stage productions across the city that should be rewritten or closed altogether. Officials informed its owners that the show must be closed because of its great amount of objectionable material.

This wasn't enough to satisfy those seeking to purify theater, and a meeting was called to discuss the revival of the city's play-jury system. Originally established in 1922 in hopes of avoiding outright police censorship, New York City's play juries were created by the Joint Committee Opposed to Political Censorship of the Theatre, which represented the Dramatists Guild, Actors' Equity Association, and the Producing Manager's Association in conjunction with the Better Play Movement. It consisted of 12 citizens whose names were drawn from a pool of 300 volunteers. When government officials received a complaint that a play was objectionable because of obscene language or immoral situations, the 12 jury members attended

the production and voted on whether part of it should be censored, or whether it should be closed.

The jury system was not completely panned by the theater community, for members hoped it would help producers, directors, playwrights, and actors avoid arrests and lengthy legal battles. For example, in 1925, police raided a production of Stalling-Anderson's *What Price Glory?* A year later, actress Mae West was held for 10 days at the New York Women's Workhouse at Welfare Island after the play she was starring in, *Sex*, was ruled to be obscene. But while many theater people supported the jury as a way to stop such incidents from harming their industry, complaints were also voiced. Playwright Elmer Rice stated his objections to the jury in a letter that was published in the *New York Times*:

> One censorship board is precisely like another, regardless of the manner of its selection. It is composed of fallible individuals whose judgments are determined by their particular prejudices ... Censorship boards begin always with the avowed purpose of barring salacious plays. They end inevitably as persecutors of the innovator and the iconoclast in art.

Shortly after the 1925 revival of the play-jury system, it was announced that 48 jurors were being sent out to rule on the morality of various productions currently being performed on the New York stage. On March 14, 1925, authorities revealed that the plays *Desire Under the Elms* and *They Knew What They Wanted* had been acquitted by unanimous decisions. Later, the manager of *The Firebrand* reduced the length of an on-stage kiss after a jury ordered them to do so. Theater historians have learned that the jury system was abandoned in 1927 because it simply didn't work.

VAUDEVILLE UNDER SCRUTINY (1920s)

In the long debate over the alleged immorality of theater, vaudeville was under scrutiny along with all of its other forms. American vaudeville was a type of entertainment popular in early 20th-century America. Its shows featured a mixture of specialty acts such as burlesque comedy and song and dance. It originated in New York City in 1827, with the opening of an all-variety show at the Lafayette Theatre. A century later, E. F. Albers, the editor of *Vaudeville News*, claimed in his paper's February 10, 1922, issue that the industry held "the hundred-year record of never having been censored, or even threatened with censorship, from the outside."

But Albers was worried, because some vaudeville performers had begun to weave controversial material into their acts. As one of the authors of the paper's letters to the editor section put it:

> If the artists continue to insist upon singing blues songs and using material which calls for censorship, they are not only disgracing the ninety-five percent of the vaudeville artists of this country who use clean material, but

are putting themselves in the position of being tabooed by the managers as irresponsible. . . .

Albers feared that too many vaudeville performers of the 1920s were ignoring the current backlash against theater led by those concerned about content they believed to be immoral. To give further credence to his position, he reprinted this warning from the Chief City Magistrate of the City of New York originally published in 1922 by the *Saturday Evening Post*.

CLEAN UP OR BE CLEANED

The good standing of a manager among his colleagues does not seem to be in any wise endangered when he persistently produces obviously indecent, salacious, coarse and vulgar plays solely for the profit he can make out of them, although they must know that such conduct tends to bring theaters in general into disrepute and makes a rigid censorship inevitable.

Actors and actresses, belonging to organizations or acting individually, seem to have no hesitancy in prostituting very considerable talent to the production of atrociously offensive, indecent and vulgar plays and farces. I must assume in defense of the stage that this is occasioned either directly by the attitude of the managers in general or by some sort of unwritten law which compels an actor to take any part assigned to him or her without regard to his own feelings or opinions with reference to the play itself or else be boycotted by the managers without any support from his fellow artists. Otherwise it would be to me incomprehensible that a decent, clean minded woman would consent to appear night after night in revolting and disgusting scenes in which the family and the marital relation are especially rendered ridiculous and brought to contempt.

People of the theatre, if you can't check yourselves in your race toward indecency you will surely bring about a censorship to check you.

Make no mistake about that.

WALES PADLOCK LAW (1927)

World War I ushered in an era of experimentation in the dramatic arts that led to the production of plays that explored themes that some considered taboo. Sex, racial mixing, and homosexuality were among the topics that disapproving government leaders sought to put a stop to by imposing strictures such as New York City's Wales Padlock Law. Enacted in 1927, the law allowed police to arrest actors, producers, and playwrights if the authorities disapproved of the play. If the courts found the play obscene, immoral, or indecent, the theater doors could be padlocked for as long as a year.

Mae West's 1925 production on Broadway of a play titled *Sex*, for example, was so shockingly entertaining that it became one of the year's most successful shows. Also a popular success was playwright John Colton's 1926 melodrama *The Shanghai Gesture*. Set in a brothel, the story's frank portrayal of the Chinese sex industry was considered highly inflammatory. Edward Sheldon and Charles McArthur's *Lulu Belle* attracted audiences fascinated by its taboo subject matter and racially mixed cast. Lulu Belle is a blues singer, dancer, and vamp, who convinces a married man to live with her in a furnished room in Harlem.

FEDERAL THEATRE PROJECT (1930s)

In the midst of the Great Depression, the federal government started the Works Progress Administration (WPA), one of the flagship programs of President Franklin D. Roosevelt's New Deal. Conceived of as a way to help get Americans back to work, one of WPA's programs was the Federal Theatre Project (FTP). Like people from all walks of life, actors and other theater people had been thrown out of work by the nation's ruined economy. The FTP was not only seen as a vehicle for creating jobs but also as a way to satisfy citizens hungry for entertainment. At the peak of its popularity, the FTP's 11,000 workers welcomed 150,000 audience members to its shows, which were held at 22 locations across the country.

Throughout it history, however, the agency's alleged political radicalness made it a target of conservative critics worried about the spread of communism and other ideologies they believed were dangerous to the American way of

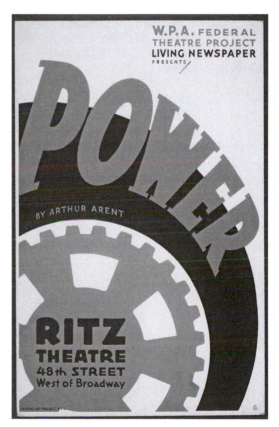

Poster for the Federal Theatre Project Living Newspaper presentation of *Power*, by Arthur Arent, at the Ritz Theatre on Broadway, New York City, between 1936 and 1939. The popular production focused on the electric utility industry's development, along with the struggle to control the technology. (Library of Congress)

life. Socially and politically relevant productions, such as a play based on Sinclair Lewis's novel *It Can't Happen Here*, opened across the country. And the project had a series of production units for African Americans, including its New York City production of *Swing Mikado*, based on a Gilbert and Sullivan show.

Among the FTP's most controversial productions were its Living Newspaper plays, which explored current events through the eyes of a main character whose curiosity about a particular common problem had been aroused. The scripts were designed to take audiences through a topic's history and current developments. The FTP's first Living Newspaper project, scheduled to open in January 1936, was so controversial, it was never performed. Titled *Ethiopia*, its main character portrayed Ethiopia's leader, Haile Selassie, a world figure whose actions and visionary ideas were not universally appreciated. When government leaders learned about the play, they immediately ordered that no current ministers or heads of stage could be portrayed in any FTP production. Such censorship illustrates the power the government could wield over activities paid for out of taxpayer coffers.

Living Newspaper productions to open across the country included *Triple-A Plow Under* (1936), which was about the Agricultural Administration Act, a government program that paid farmers to ruin their own crops in order to reduce crop surpluses in hopes of raising the value of those that remained; *Power* (1937), about the monopolies held by the nation's power companies and the Tennessee Valley Authority; *Spirochete* (1937), about the threat of syphilis; and *One-Third of a Nation* (1938), about a pledge President Franklin Delano Roosevelt made to the nation in his second inaugural address to feed and house its people.

The play *Triple-A Plow Under* attracted considerable negative attention because it criticized the Supreme Court's nullification of President Roosevelt's Agricultural Adjustment Administration. Critics of the play considered it friendly to communism. Scathing editorials were published about the play, which was threatened with closure. The House Un-American Activities Committee (HUAC) launched an investigation of the FTP for its alleged anti-American propaganda. Flanagan defended the program and its Living Newspapers, but Congress shut it down in 1939.

HOLLYWOOD BLACKLISTING (1940s–1950s)

The intense fear of fascism and communism that gripped the United States through much of the 20th century inspired the establishment of a series of Congressional committees charged with investigating whether advocates of such ideologies were working undercover in American society to spread their dogmas. The first of these investigative bodies, the Overman Committee, was formed in 1918 to investigate alleged pro-German and pro-Bolshevik elements in American society. The last, HUAC, was a standing committee with a self-described mandate to root out communists wherever they were hiding. HUAC operated from 1945 to 1975.

Among the HUAC's most notorious activities was its creation of the Hollywood Blacklist, which during its heyday targeted more than 300 actors, directors, screenwriters, and radio commentators. Some lawmakers and government

officials considered these individuals a danger to the country because of their alleged membership in the Communist Party or sympathy for its ideology. Those blacklisted by the committee were typically boycotted by Hollywood's studios and related industries. Among them were actors Charlie Chaplin, Orson Welles, Paul Robeson; lyricist Yip Harburg; and screenwriter Dalton Trumbo. Some left the United States to find work, and others wrote under pseudonyms or the names of colleagues. The committee continued the blacklist until 1960, when it was learned that some of its victims had been working under assumed names.

In 1947, a group of 10 Hollywood film industry people stood up to the committee in a dramatic denouncement of its tactics by refusing to answer questions about their alleged involvement with the Communist Party. In addition, they treated the Committee with open hostility. After being charged with contempt, all were fined $1000 and sentenced to prison terms of six months to one year. In addition, they were banned from working for the major Hollywood studios. One of the 10 decided to cooperate with the government by providing the names of more than 20 industry colleagues he claimed were communists.

In addition to its blacklisting activities, the committee pressured Hollywood film moguls to produce anti-communist and anti-Soviet movies. Among them were John Wayne's *Big Jim McLain* as well as *Guilty of Treason, The Red Menace, The Red Danube, I Married a Communist, Red Planet Mars*, and *I Was a Communist for the FBI.*

THE TRIAL OF LENNY BRUCE (1964)

Throughout American history, jokes, satire, parody, and other forms of humor have been used to comment on politics, culture, events, and individuals in the United States and around the world. In some cases, humor has helped shape public thought, and in some cases, even influenced public policy. That said, humor's power has also at times made it a target, especially if it is laced with irreverent, iconoclastic, or other material deemed to be unsuitable for public consumption. Stand-up comedians whose acts have been described by critics as outside the bounds of legally acceptable material have often paid a stiff price for refusing to kowtow to those seeking to silence them.

One American stand-up comedian who was prosecuted for using foul language was George Carlin. He was arrested by Wisconsin police in 1972 and charged with public indecency. He was not convicted, but in 1978, the U.S. Supreme Court outlawed use on public airwaves of the seven "dirty" words that led to his arrest. Another stand-up comic who became famous in part because of his run-ins with the law was Lenny Bruce. Bruce began his career in the mid-1950s in the strip clubs of southern California. In his autobiography, he describes the freedom such venues gave him.

Four years working in clubs—that is what really made it for me—every night: doing it, doing it, doing it, betting board and doing different ways, no pressure on you, and all the other comedians are drunken bums who don't show up, so I could try anything.

A policeman searches comedian Lenny Bruce after Bruce's arrest for allegedly using obscene language during his act in a North Beach nightclub, the Jazz Workshop, San Francisco, California, October 4, 1961. Bruce's routine was mild compared to those of many of today's comedians. (Bettmann/Getty Images)

Bruce's routines were full of biting social and political satire laced with offensive language. In 1959, he appeared on national television's popular *Steve Allen Show*, and in 1961, critics lauded Bruce's performance at New York City's famous Carnegie Hall. But within a few years, Bruce's drug use began to take a toll, and his career began to slide. In 1964, at an appearance at New York City's Café au Go Go, city official and former CIA agent Herbert Ruhe was in the audience. After Ruhe told police about Bruce's act, they arrested and indicted him under the city's penal code, which prohibited "obscene, indecent, immoral, and impure drama, play, exhibition, and entertainment. . . ."

Bruce's situation stirred up a firestorm of criticism, and those working on his behalf launched a petition drive to protest his treatment. The group's statement read: "Whether we regard Bruce as a moral spokesman or simply as an entertainer, we believe he should be allowed to perform free from censorship or harassment." Among those who signed were Paul Newman, Bob Dylan, Elizabeth Taylor, Richard Burton, Norman Mailer, Susan Sontag, John Updike, James Baldwin, George Plimpton, Henry Miller, Joseph Heller, Gore Vidal, and Woody Allen.

The trial of Lenny Bruce, which began on June 16, 1964, was moved to a different venue to make room for the crowds of curious people who hoped to attend.

After Bruce's attorney mounted a strong defense through use of expert witnesses who argued persuasively on his behalf, the prosecution presented its case, which rested largely on Bruce's use of word and images they deemed to be offensive, hostile, and worthless.

Bruce was convicted and sentenced to four months in the workhouse. Although he remained free on bond during his appeal, Bruce's health began to fail, and in 1966, he died of a morphine overdose. In 2003, New York Governor George Pataki pardoned Bruce.

THE MUSICAL *HAIR* (1968)

One of the New York theater scene's most controversial shows was *Hair: The American Tribal Love-Rock Musical*, which opened on Broadway in January 1968. It ran there for 1750 performances while simultaneously touring the nation and Europe. Since then, numerous productions have opened across the world; a successful film version was released in 1979; and some of the show's songs became Top 10 hits. In 2008, *Time* magazine stated, "Today 'Hair' seems, if anything, more daring than ever."

Hair tells the story of a tribe of politically active, long-haired hippies who sang about the dawn of "The Age of Aquarius." The play is set in the time of the Vietnam War, when young American men were being drafted to fight in Southeast Asia. The main characters are war protesters, and when a recently drafted man happens across them in Central Park, they encourage him to refuse to be inducted. Among the themes explored in the musical are race, sexual freedom, drug use, nudity, pacifism, religion, and astrology.

As productions of the play were staged across the country, a brief nude scene at the conclusion of the play's first act drew the attention of local censors in several cities. Police

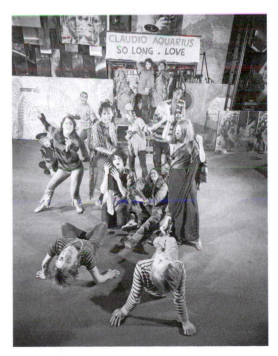

Scene from a 1968 production of the Broadway rock musical *Hair*. The show's brief nude scene and flag desecration resulted in protests and police raids in some communities. (Ralph Morse/Time Life Pictures/Getty Images)

would stand in the wings, waiting for the right moment to stop the actors from appearing without clothing, in violation of local laws. One of these cities was Boston, where the show was scheduled to open in February 1970. At the time, Boston had a censor who attended plays and films before they opened to determine if their contents violated the municipality's penal code. The censor claimed that *Hair* was so "lewd and lascivious" that if he had the power to stop it from opening he would do so. His concerns led to a series of trials and appeals that eventually made its way to the United States Supreme Court, which ruled on May 22, 1970, that the actors could appear without clothing without fear of prosecution.

MY NAME IS RACHEL CORRIE (2006)

In February 2006, the New York Theatre Workshop announced the suspension of the U.S. premiere of Alan Rickman and Katherine Viner's play *My Name is Rachel Corrie*. Rickman and Viner created the production by mining the journal entries and e-mails of Ms. Corrie, a 23-year-old Washington State native who, while in Gaza in 2003, had been crushed to death by an Israeli-operated bulldozer. Corrie was an American activist and member of the pro-Palestinian group called the International Solidarity Movement. The production had received much praise during its successful 2005 run in London.

After postponing the play indefinitely, the New York company denied they did so because of pressure from donors, artists, or potential business partners with pro-Israeli sympathies. Reverberations from the cancellation of the play were felt in the theater community and mainstream media and blogosphere. The play's cancellation was criticized by such theater luminaries as Harold Pinter, Vanessa Redgrave, and Tony Kushner, but praised by others. A few months later, the play was cancelled once again, this time by CanStage, Canada's largest nonprofit theater. The play finally had its U.S. premiere at New York's Minetta Lane Theater in October 2006.

REFERENCE TO MOHAMMED SHUTS DOWN PLAY (2015)

Ironically, there are times when people and organizations seeking to discourage censorship decide to muzzle themselves. This is what happened in New York City in 2015, when the Greenwich Village's Sheen Center for Thought and Culture cancelled the opening of *Mohammed Gets A Boner*, one of a quartet of plays it had scheduled to speak out against the growth of censorship in contemporary arts and culture. The play's writer, Neil LaBute, designed the show as a platform for the discussion of whether it is acceptable to poke fun at religion or religious figures. The Sheen Center cancelled the play because it feared it would be highly offensive to people of the Muslim faith. LaBute condemned the center's decision, declaring:

> This event was meant to shine another light on censorship and it was unexpected to have the plug pulled, quite literally, by an organization that touts

the phrase "for thought and culture" on their very website. Both in life and in the arts, this is not a time to hide or be afraid; recent events have begged for artists and citizens to stand and be counted.

Playbill noted that in response to the play's cancellation, the executive director of the National Coalition Against Censorship issued the following statement:

It's hard to imagine a more ironic outcome: a venue attempts to alter, edit, and censor the works that are being performed at an anti-censorship event. And when the artists won't compromise their vision, the venue cancels the show.

CONTROVERSY OVER *AMERICAN IDIOT* AND OTHER HIGH SCHOOL PLAYS (2016)

In the spring of 2016, Billie Joe Armstrong, the singer of the punk rock band Green Day, spoke out about a Connecticut high school's cancellation of a students' production of the musical *American Idiot*. After hearing complaints from parents and other community members about its explicit language and scenes portraying sex and drugs, school's officials justified the action by claiming the production was dividing their students.

In response, Armstrong wrote a letter to the school board (and posted it on Instagram) expressing his disappointment.

It would be a shame if these high schoolers were shut down over some of the content that may be challenging for some of the audience, but the bigger issue is censorship. This production tackles issues in a post 9/11 world and I believe the kids should be heard and most of all be creative in telling a story about our history. I hope you reconsider and allow them to create an amazing night of theater! As they say on Broadway—"The show must go on!"

His words are a reminder that theater has long been a part of American students' educational experiences. In 1929, drama's popularity as a student activity began to grow when three theater adherents formed an organization called National Thespians. Their success was immediate, and today the organization has 4600 professional members, and approximately 100,000 active high school thespians in more than 3900 affiliated high schools and middle schools.

Today named the Educational Theater Association, one of the organization's missions is to monitor situations in which nervous educators, parents, and community members seek to influence what plays are presented at U.S. schools. Its website publishes lists of "hot-button titles" in the school repertory. Its list includes such plays as *The Bad Seed, Spamalot, Sweeney Todd, The Laramie Project, Rent, Legally Blond, Joe Turner's Come and Gone, Sister Mary Ignatius Explains It All for You, The Tender Yellow Sky, Higher Ground, Blithe Spirit, Catcalls, And Then There Were None, Voices in Conflict, The Vagina Monologues, The Crucible, Bang Bang You're Dead,*

and *Godspell*. The topics and content that have prompted challenges include swearing or other types of language usage; references to smoking, drugs, alcohol, and sex; and stories that explore content involving gays, race, religion, and suicide.

FURTHER READING

Albers, E. F. (1922). *Vaudeville News*, February 10.

Bruce, Lenny (1967). *How to Talk Dirty and Influence People*. Playboy Publishing.

Clement, Olivia (2015). "Venue Cancels Anti-Censorship Benefit Due Over LaBute *Mohammed* Play; Playwright Responds," *Playbill*, May 14.

Hill, Anthony D., and Douglas Q. Barnett (2008). *Historical Dictionary of African American Theater*. Lanham, MD: Scarecrow Press.

Houchin, John (2003). *Censorship of the American Theatre in the Twentieth Century*. New York: Cambridge University Press.

Livingston, Guy (1970). "Nudity and Flag 'Desecration' Figure in Appeal Against Hair Foldo in Hub," *Variety*, April 15.

Malinsky, David (2013). "Congress Bans Theatre!" *Journal of the American Revolution*. December 12, 2013. https://allthingsliberty.com/2013/12/congress-bans -theatre.

Mather, Increase (1687). *A Testimony Against Several Profane and Superstitious Customs, Now Practiced by some in New-England*. London.

McCullough, Jack W. (1983). "Model Artists vs. the Law: The First American Encounter," *Journal of American Culture*, 6(2): 3–8.

"On Censorship" (1922). *Vaudeville News*, February 10.

"Police Intelligence," (1848). *New York Herald*, March 23.

Prynne, William (1633). *Histrio-mastix: The Players Scourge; or Actor's Tragedy*. London.

Rice, Elmer L. (1911). "To the 'Public' Censorship," in "To the Mail Bag," *New York Times*, January 29.

Sova, Dawn B. (2004). *Banned Plays: Censorship Histories of 125 Banned Stage Dramas*. New York: Facts on File.

Wilmeth, Don B., and Christopher Bigsby (2000). *Cambridge History of American Theatre*. Cambridge, UK: Cambridge University Press.

Witham, Barry (2003). *The Federal Theatre Project: A Case Study*. New York: Cambridge University Press.

Wright, Hayden, "Billie Joe Armstrong Pens Open Letter Over High School's 'American Idiot' Cancelation," *Radio.com*, January 27, 2016, http://radio.com /2016/01/27/billie-joe-armstrong-pens-open-letter-over-high-schools-american -idiot-cancelation/.

THREE

Games and Sports

INTRODUCTION

Games are forms of competitive play or sport, bound by rules and decided by skill, strength, and luck. Games always involve more than one person, whereas sports, even when played by teams, depend on individuals' skills and performance. They are played informally with family and friends, and at work and school. Sports and games are so popular that many of their tournaments and matches are televised across the globe. The World Cup, International Summer and Winter Olympics, car racing, and poker are examples of sports and games so popular that they attract worldwide television audiences.

That games and sports are integral parts of our lives is captured in the words of American sports journalist Howard Cosell, who said, "Sports is human life in microcosm." Athlete and activist Aimee Mullins, meanwhile, asserted that "[t]he power of the human will to compete and the drive to excel beyond the body's normal capabilities is most beautifully demonstrated in the arena of sport."

Public officials' stated concerns about the health and well-being of citizens have, at various times in U.S. history, led them to ban games and sports deemed harmful to the public. But are such limits violations of the speech rights of those who participate in them? It's doubtful that James Madison, "the Father of the Constitution," had games and sports in mind when he conceived of the First Amendment. U.S. federal courts have not typically defined sporting activities as speech for purposes of the First Amendment. However, some have argued sports are activities that warrant protection under the free speech clause. In a 2014 law journal article, Genevieve Lakier wrote:

> Today, nude dancing, begging, and making a movie or violent video game are all activities that trigger First Amendment scrutiny. Yet football or

baseball, or performing an artistic non-team sport like gymnastics or figure skating is not. . . . [T]he denial of free speech protection to spectator sports . . . is wrong. . . .

Rules and rulemaking are inherent aspects of games and sports, and what they are and who makes them often become mired in controversy. Rules not only bind how games and sports are played but also impose strictures on players that limit them in other ways. In today's highly bureaucratized, technological, corporate society, rulemaking in sports is the domain of a maze of private and public institutions, associations, and corporate entities. Some maintain that the rules imposed on those who play games and sports are unfair or otherwise harmful.

ANTI-GAMBLING LAWS (1600s–PRESENT)

Games of chance have a long and complicated history in America. Christopher Columbus's sailors gambled on the shores of the New World, and immigrants who took up residence in the American colonies partook of such activities as well. Lotteries were organized in early American communities to raise revenue to support various projects, such as the establishment and maintenance of universities and secondary schools. Hollywood westerns' ubiquitous saloon poker games are not much of an exaggeration, as gambling in such establishments was a popular pastime during the 19th century.

Today, gambling is a crucial component of popular culture and is one of the fastest growing segments of the hospitality industry. Americans enjoy pari-mutuel horse wagering, cards, bingo, sports betting and other games at the track, casinos, bingo halls, at work, and with friends and families and at bars and gambling establishments. Statistica.com reports that 53 percent of Americans bought at least one lottery ticket in 2012, that 32 percent gambled at a casino, and that gambling revenues surpass other popular forms of entertainment.

But Americans' proclivity for gambling has always been a love-hate relationship. To counteract the excesses that games of chance contribute to, in 1638, Massachusetts' Puritans prohibited gambling, and in 1769, the British attempted to outlaw lotteries in the colonies. The popularity of saloon gambling precipitated a backlash that drove gaming onto Mississippi River boats and toward remote Western communities, and waves of anti-gambling pressure pushed some of these facilities underground.

Today, the business of gambling is one of the most heavily regulated industries in the United States. All levels of government have enacted laws that limit gambling, both on-site and online. State governments impose the country's most rigorous anti-gambling laws, although they vary widely in strength and the kinds of gambling they target. In addition, some states defer to county and municipal laws that restrict gaming. Other states, such as New Jersey and Nevada, outlaw most Internet gambling in order to protect economically important gambling establishments within their borders.

Municipal and county governments impose a variety of limits on gambling within their areas of jurisdiction, largely out of concern for the social, monetary, and health problems it can lead to. Cook County, Illinois, officials, for example, require all operators of gaming machines to register them and to pay taxes on their receipts. "Pathological gambling" was added to the American Psychiatric Association's Diagnostic and Statistical Manual of Mental Disorders (DSM) in 1980.

Three federal laws apply to gambling in general and online gambling more specifically. The Interstate Wire Act (IWA, 1961) was passed to outlaw the placement of bets "using a wire communication facility." Until 2006, when the Unlawful Internet Gambling Enforcement Act (UIGEA) was enacted, the U.S. Department of Justice claimed the IWA made Internet sports gambling unlawful. The law was not established to reign in bettors, but to dampen the profits of organized crime families. Although technically, it may be illegal under this law to place a bet over the phone on a sports team, no federal law enforcement infrastructure exists to punish individuals for doing so.

The purpose of the Professional and Amateur Sports Protection Act (PASPA, 1992) is to stop state governments from allowing people to bet on amateur or professional sports. It has only rarely been enforced, although state officials have occasionally attempted to use it to stop some state governments from allowing certain kinds of gambling.

Enacted to quell the growing popularity of Internet gambling, the UIGEA has had considerably more impact on gambling than IWA or PASPA. An October 23, 2006, FoxNews.com news story estimated that approximately 15 to 20 million United States gamblers had placed online bets during the previous year. Rather than targeting individual online gamblers, UIGEA is meant to stop banks and credit card companies from processing gambling payments.

The government's restriction of advertisements designed to encourage gambling in places where it is legal has raised First Amendment questions from time to time. In 1999, the U.S. Supreme Court struck down a 65-year-old ban on broadcast advertising of casino gambling in *Greater New Orleans Broadcasting Association v. United States* (527 U.S. 173). The ban was part of the original Communications Act of 1934. Using the First Amendment, the decision's opinion stated that the federal law "sacrifices an intolerable amount of truthful speech about lawful conduct."

Ironically, in 1986, in *Posadas de Puerto Rico Associates v. Tourism Co. of Puerto Rico* (478 U.S. 328), the U.S. Supreme Court ruled in favor of restrictions on casino advertising imposed by the Puerto Rican government. Because Puerto Rico is a United States protectorate, its legal system operates under the jurisdiction of the U.S. federal court system. When a Puerto Rican law forbidding the advertising of casino gaming was challenged as a violation of the First Amendment, the U.S. Supreme Court issued a ruling in the case. Even though casino gambling is legal in Puerto Rico, and authorities allowed casino operators to advertise to international tourists, they banned advertising that targeted Puerto Ricans.

In a 5–4 vote, the Court supported the restriction on the targeting of the residents of Puerto Rico by certain casino gaming advertising. The author of the majority

decision, Chief Justice William Rehnquist, explained that because the island's law-makers could have chosen to make it unlawful for its citizens to gamble, at the very least they have the power to ban casino gambling advertising designed to attract such citizens.

MUHAMMAD ALI: CONSCIENTIOUS OBJECTOR (1967)

In 1999, *USA Today* named Muhammad Ali "Athlete of the Century." Among his many achievements, Ali won a gold medal at the 1954 Summer Olympics, in Rome, and was crowned Heavyweight Champion of the World three times between 1964 and 1979. But Ali stands out as a great American not just because of his achievements as a boxer but also for his willingness to make great sacrifices to stand up for his beliefs.

Ali was named Cassius Marcellus Clay Jr. when he was born in 1942, but he assumed the name Muhammad Ali on March 6, 1964. In 1966, as the war escalated in Vietnam, Ali attempted to have his draft status changed to exempt because of his nonviolent Muslim faith and membership in the Nation of Islam. After the draft board refused to do so, he stated, "I ain't got no quarrel with them Viet Cong. No Viet Cong ever called me nigger."

On April 28, 1967, Ali appeared before the draft board after being ordered to do so, but refused to step forward when his name was called. After being convicted of draft evasion, he was sentenced to five years in prison, fined $10,000, banned from boxing for three years, and stripped of his boxing titles. Ali was among the first Americans to stand up against the waging of war in Vietnam, and the publicity his case generated had an impact on public opinion. Many condemned him, but others were moved by his sacrifice.

Ali challenged the government's actions, and in 1971, in *Clay v. United States*, the U.S. Supreme Court unanimously overturned his conviction. The court's opin-ion stated, "[T]he Department [of Justice] was simply wrong as a matter of law in advising that the petitioner's beliefs were not religiously based and were not sin-cerely held."

Along with many other Americans, many news journalists criticized Ali. One of his fiercest critics was sportswriter Red Smith, who some considered to be one of the greatest American sportswriters of the mid-20th century. Before Ali's arrest, in a February 22, 1966, *New York Herald Tribune* story, Smith wrote:

> Squealing over the possibility that the military may call him up, Cassius makes as sorry a spectacle as those unwashed punks who picket and demon-strate against the war. Yet in this country they are free to speak their alleged minds, and so is he. . . . Clay needs no help from the headlines to look bad.

After Ali refused induction, many sports fans and journalists castigated him for his stand. But others, such as legendary sportswriter Howard Cosell, backed Ali throughout his career, both as a boxer and controversial American. In 1967, after

Ali's draft evasion conviction led the New York State Athletic Commission to suspend his boxing license, and the World Boxing Association stripped him of his heavyweight boxing title. Cosell stated that what they did to him was "an outrage, an absolute disgrace."

OLYMPIC ATHLETES RAISE THEIR FISTS IN MEXICO CITY (1968)

The International Olympics Committee's (IOC) Charter includes a rule that warns athletes that if they make political statements, they may face disciplinary sanctions. One of the most famous examples of the punishment of Olympic athletes for speaking out happened at the 1968 Summer Olympics, in Mexico City. Standing on the podium during the playing of "The Star Spangled Banner," gold medalist Tommie Smith and bronze medalist John Carlos raised their fists and bowed their heads. In addition, the two American medal winners wore no shoes, to symbolize African American poverty; Smith wore a black scarf around his neck, to express Black pride; and Carlos unzipped his jacket, to express his solidarity with blue-collar workers, and wore a necklace with beads he said were "for those individuals that were lynched, or killed that no one said a prayer for, that were hung and tarred." Along with the third medalist, Australian Peter Norman, Smith and Carlos wore Olympic Project for Human Rights badges after Norman expressed support for their ideals.

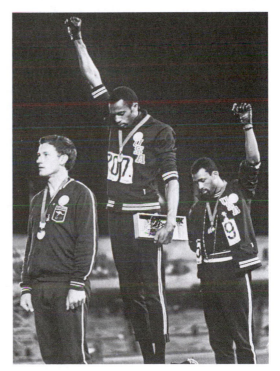

The athlete's actions led the IOC, headed by its president, Avery Brundage, to expel them from the Games. The IOC issued a statement that accused the two of "a deliberate and violent breach of the fundamental principles of the Olympic spirit."

Smith and Carlos faced heavy criticism in the U.S. press, although there were

At the 1968 Summer Olympic Games in Mexico City, runners Tommie Smith and John Carlos outraged the U.S. Olympic Committee by giving a black power salute during the medal ceremony. Smith wrote in his autobiography, *Silent Gesture*, that his gesture was a "human rights salute." (AP Photo)

exceptions. A writer for *The Crusader*, an African American newspaper in Rockford, Illinois, stated that "far from being discredited, the courageous act of Carlos and Tommie Smith, champion sprinter, was seen throughout the world as giving new dignity and nobility to Black athletes."

ANIMAL FIGHTING AND *UNITED STATES v. STEPHENS* (2010)

Animal fighting events pit two or more animals against one another in violent contests in front of spectators, some of whom place bets on the outcome. Dog- and cockfighting are the most commonly known versions of such contests. Such activities have been popular for centuries in the United States. However, animal fighting matches have been driven underground, as coalitions of animal rights activists, crime fighters, and elected and appointed officials have worked together to stop them. Laws prohibiting dog fighting (passed independently of broader animal-cruelty regulations) exist in all 50 states. Arrests for violations of these laws often result in felonies with punishments much stiffer than in the animal-cruelty category.

On the federal level, three major pieces of legislation in this area have been passed over the years. These laws outlaw "crush videos," that is, the commercial production, sale, or possession of depictions of cruelty to animals to gratify bizarre sexual fetishes, as well as the sponsorship, exhibition, purchase, sale, delivery, possession, training, or transport of animals for participation in animal fighting; and the bringing of a minor under the age of 16 to a dog- or cockfight.

Considering the negativity surrounding animal fighting, it's counterintuitive to suggest that someone could have his or her conviction overturned because of the First Amendment. But this is what happened in *United States v. Stevens*, a 2010 United States Supreme Court decision that nullified the conviction of Robert J. Stevens, who was clearly guilty of violating the federal government's 1999 Animal Crush Video Prohibition Act because he made and sold videotapes of dogfights. In 2004, Stevens was sentenced to seven months in prison. He appealed his conviction, and the U.S. Court of Appeals for the Third Circuit held that the law he had been convicted under violated the First Amendment. The government appealed the circuit court's decision, and the Supreme Court stepped in to settle the disagreement over the law under which Stevens had been convicted. The *Christian Science Monitor* noted that Stevens's attorney, Patricia Millett, emphasized in the brief she submitted to the court that the First Amendment protects the creation and dissemination of video unless it is obscene:

> The notion that Congress can suddenly strip a broad swath of never-before-regulated speech of First Amendment protection and send its creators to federal prison, based on nothing more than an ad hoc balancing of the "expressive value" of the speech against its "societal costs" is entirely alien to constitutional jurisprudence and a dangerous threat to liberty.

The government and its supporters, however, argued that animal fighting videos are so heinous that they should be considered a category of speech, similar to obscenities, that is not worthy of First Amendment protection.

In 2010, the court announced an 8–1 ruling in support of Stevens. Its rationale was that Section 48 of the U.S. code was overbroad, and therefore invalid, under the First Amendment. The constitutionality of laws that are overbroad can be challenged based on the contention that they punish protected speech or conduct along with speech or conduct that the government may limit to further a compelling government interest. Under this doctrine, Stevens was successful in arguing that the government's crush video law was written in a way that cut off more speech than was necessary to solve the problem it was intended to alleviate.

On December 9, 2010, Congress enacted a new crush video law, the Animal Crush Video Prohibition Act of 2010. The new law was written to avoid the complications posed by the overbreadth doctrine, which can be used to nullify laws that ban speech that should remain legal along with the speech that it means to restrict.

NASCAR TANGLES WITH DRIVER DENNY HAMLIN OVER FREE SPEECH (2013)

Auto racing, according to a 2016 Harris Poll, is the fourth most popular spectator sport in the United States, behind professional football, baseball, and men's college football. There are myriad kinds of auto racing, but in the United States, the four big auto racing organizations are Formula One, IndyCar, NASCAR, and the Federation Internationale de l'Automobile (FIA) World Endurance Championship.

NASCAR stands for the National Association for Stock Car Auto Racing, and is an American family-owned business that attracts huge audiences at its racing venues and on television. Stock car races are held predominantly in the United States and Canada. Originally, stock cars were not custom built, but came off auto manufacturers' assembly lines. Today's American stock cars resemble the ones driven by everyday people, but are built according to strict sets of guidelines ensuring that every car is mechanically identical.

Because of the tremendous financial rewards at stake, NASCAR is highly motivated to protect the industry's positive image and please its sponsors. As a result, its officials tell drivers what to say in public, and fine them if they break the rules. Winning drivers, for example, are told to thank sponsors in their on-air interviews in the winner's circle. Because NASCAR is a privately owned business, the First Amendment doesn't protect drivers from its controls, but the punishments imposed by NASCAR against drivers who fail to follow their media relations' directives can backfire.

In 2013, for example, NASCAR fined driver Denny Hamlin $25,000 for violating the section of its rule book titled "actions detrimental to stock car racing." Hamlin was punished for making critical comments about the new Sprint Cup car following the March 3 NASCAR Sprint Cup Series race at Phoenix International Raceway.

According to *Sporting News* writer Bob Pockrass, "Fining Hamlin $25,000 was a gross overreaction that could damage NASCAR's credibility." He added:

> The people hurt by such actions are the fans, who want to hear and read unfiltered emotion and analysis from the drivers. Fans for years have complained that most drivers are too bland and don't show enough personality and offer enough honest opinions about the sport. NASCAR officials have said that they want to see more raw emotion and personality from the drivers. This fine curtails that.

As *Autoweek* reported, former driver Kyle Petty was among the first to defend Hamlin. In defense of Denny, he commented:

> I'm going to stand behind Denny on this one. Just because it's NASCAR's ball and their ballpark and they make the rules doesn't necessarily mean there can be censorship. There appears to be a lot of censorship in this fine. NASCAR wants drivers to have personalities and character and to express themselves, but only if they say positive and not negative things. I don't know anyone who can do that.

VIOLENT VIDEO GAMES (1976–PRESENT)

Video games are interactive computer program-driven competitions involving the manipulation of images on television screens and other display devices. The video game era dawned in 1940, at the Westinghouse display at the New York World's Fair. Tens of thousands of fair visitors played the game, a primitive computer version of Nim, a mathematical game of strategy in which players take turns removing objects, often matchsticks, from heaps. The player who removes the last object is the winner.

From this innocuous start came the eventual growth of a giant video game industry. A Pew Research Center report published in December 2015 states that half of all American adults play video games, and 10 percent consider themselves "gamers." Although many video games are made for families and individuals interested in games and sports competitions suitable for people of all ages, other products in the marketplace are notorious for glorifying over-the-top violence and sexism. The Pew Research Center's research indicated that 40 percent of America's adults believe that there is a connection between violent video games and violent behavior. This has led to much controversy, public debate, government-imposed censorship, and self-regulation by video game industry representatives.

The National Coalition Against Censorship (NCAC) identifies *Death Race*, which was released in 1976, as the first controversial video game. Video game historian Steve L. Kent wrote, "What got everyone upset about Death Race was that you heard this little 'ahhhk' when the person got hit, and a little gravestone came up." Soon after its release, complaints about *Death Race* led stores to take it off their shelves and the manufacturer to subsequently pull it off the market.

Another early video game that sparked protest was released in 1983. The day the game *Custer's Revenge* was released, more than 200 protesters gathered to express their concerns about its violent, sexist, anti–Native American bent. To earn points, for example, players assume Custer's persona and run from "enemy" arrows toward a Native American woman strapped to a pole. Once there, players vanquish the woman. Critics complained that players' actions against the woman essentially were simulations of rape.

By 1993, enough concern over video game violence was being expressed that the U.S. Congress held a joint Senate Judiciary and Government Affairs Committee hearing. *Mortal Kombat*, which is considered the first video game to feature explicit, realistic violence, became a subject of particular concern at the hearing. In addition, the game *Night Trap* was called "shameful," "ultra-violent," "sick," and "disgusting." Its critics claimed it encouraged the trapping and killing of women, even though its makers said the game's goal is to save them from harm. After the hearing, Toys "R" Us, and F.A.O. Schwarz U.S., took the Sega CD version of *Night Trap* off their shelves.

Pressure to stop violence in video games intensified after the hearing. To deflect possible government regulation, in 1994, the video industry formed the Entertainment Software Rating Board (ESRB), a self-regulatory body that assigns and publicizes age and content ratings for game producers who submit their games for review. A strictly volunteer program, nearly all manufacturers submit their new products for rating because merchants are so careful about not stocking games that will attract negative attention.

The first in a series of lawsuits against video game manufacturers commenced in 1997, when Florida attorney Jack Thompson filed suit on behalf of the parents of three children killed in a Heath High School shooting. According to authorities, the shooter was an avid player of *Doom, Quake, Castle Wolfenstein, Redneck Rampage, Nightmare Creatures, MechWarrior*, and *Resident Evil*; frequented pornographic websites; and owned a copy of the film *The Basketball Diaries*. Thompson claimed the producers of the games, websites, and film should be punished for their negligence through their distribution of this material to minors, because such products desensitize and encourage their users to commit acts of violence. The lawsuit was dismissed by the federal district court for its failure to mount a claim that was legally recognizable.

Over the past two decades, lawmakers in nearly a dozen cities, counties, and states, have voted to limit video games in various ways. Federal lawsuits challenging these laws and ordinances on First Amendment grounds have always resulted in defeat for their enactors. The most significant of these decisions was *Brown v. Entertainment Merchants Association* (564 U.S. 08-1448), a 2011 decision of the United States Supreme Court that struck down a 2005 California statute banning the sale of certain violent video games without parental permission. The court ruled that video games are protected speech under the First Amendment.

COLLEGIATE MASCOT AND NICKNAME DISPUTES

To suggest that a college or university change its nickname or mascot is akin to committing heresy to some students, faculty, and alumni. Evidence of this resistance existed long before some state legislatures attempted to enact statutes that banned mascots considered racist, as did the State of California in 2005, before the National Collegiate Athletics Association (NCAA) announced in 2005 that it would soon ban the display of "hostile and abusive" terms and images at their championship tournaments. As a state action, the California legislative action raised First Amendment implications, whereas the NCAA rule does not because it is not a public entity. Regardless, fans of the old mascots consider any efforts to remove them to be censorship.

In 2005, after California's state legislature passed a bill that banned the name "Redskins" and other offensive team names, Governor Arnold Schwarzenegger vetoed it. The author of an article in *Villanova Sports and Entertainment Law Journal* stated that if the bill had gone into effect, it would likely have faced a constitutional challenge. Brian R. Moushegian wrote, "Assuming a statute bans public university use of offensive team names, the vast majority of names are protected under the First Amendment."

The same year California's legislature attempted to outlaw offensive mascots, the NCAA announced its new rule, which targeted 18 collegiate mascots and nicknames across the country that had been criticized as insulting to Native Americans. The organization said the action supported its goals of diversity and inclusion, in line with the many people who have argued that the use of such images and names leads to harm. Anthropologist Michael Taylor, for example, argues that schools that misuse Native American imagery perpetuate stereotypes that create a "hollow" educational mission. The National Congress of American Indians stated in an October 2013 position paper that such mascots and nicknames are harmful because they contribute to "the myth that Native peoples are an ethnic group 'frozen in history.'"

Although some of the schools targeted by the NCAA's new rule had little difficulty complying with changing their mascots or team names, a few found it exceptionally difficult to give up their old identities. The University of Illinois at Urbana-Champaign is one of the campuses where the NCAA's "Out with the old, in with the new" rule was met with fierce resistance. The university appealed the rule, contending that its mascot, Chief Illiniwek, was meant to honor rather than disparage Native Americans. The NCAA denied the appeal, although it agreed that the nickname "Fighting Illini" was acceptable. According to *Inside Higher Ed*, "Six years after the chief's retirement, apparel emblazoned with 'chief' continues to be ubiquitous on campus." A number of companies that market college sports merchandise still offer "Chief Illiniwek" shirts and other gear for sale.

After decades of controversy, on November 18, 2015, the University of North Dakota (UND) replaced its "Fighting Sioux" nickname with "Fighting Hawks." The NCAA's 2005 rule was just one of a series of upheavals related to the school's use of the name. In 1999, a North Dakota House of Representatives bill to replace the

nickname was never enacted. Two years later, Ralph Engelstad, a former UND hockey player, donated $100 million to the school for the construction of a new arena with the stipulation that the "Fighting Sioux" name would never be dropped. The arena opened in 2001, festooned with thousands of "Fighting Sioux" images.

In 2005, after the NCAA announced its new names and mascots policy, the "Fighting Sioux" debate was reignited. UND had been unsuccessful in previous efforts to coax the state's three Sioux communities into agreeing to support their continued use of the nickname. In June 2006, North Dakota Attorney General Wayne Stenehjem's request for a preliminary injunction barring the NCAA from enforcing the rule was granted. The university and the NCAA reached a settlement that gave the school three years to gain the support of the Sioux. After the school was unable to do so, in April 2010, the North Dakota State Board of Higher Education announced it would adopt a new nickname after the 2010–2011 athletic season. A series of continuing complications further delayed the process an additional four years. Reportedly, a number of UND students, alumni, and community boosters have not been gracious in their acceptance of the new nickname.

SOCIAL MEDIA AND FREE SPEECH IN HIGH SCHOOL AND COLLEGE ATHLETICS (2010–PRESENT)

High school and college sports don't mix well with social media, as is seen in the numerous cases involving the punishment of players and programs over wayward tweets. In an April 15, 2012, *USA Today* column on free speech and the banning of college-athlete tweets, Ken Paulson reported:

- In October 2011, Western Kentucky University suspended running back Antonio Andrews for tweeting critical comments about the team's fans.
- Two months later, Lehigh University suspended wide receiver Ryan Spadola for retweeting a racial slur.
- In January 2012, high school football player Yuri Wright was expelled from his high school and lost a Michigan football scholarship offer for sharing sexually graphic and racially insensitive tweets.

Coaches, school leaders, and administrators impose such strictures because they are embarrassed, and afterward some impose outright bans on players' use of social media, arguing Twitter and Facebook lead to too many distractions. If such bans are imposed beyond the season, players can suffer. As blogger Kristi A. Dosh wrote in *Outkick the Coverage*, on August 11, 2015, "In banning student athletes from social media in an attempt to prevent them from making mistakes, you're also preventing them from achieving positive results." She argues that players who can't use Twitter, which is used by employers in recruitment, will be unfairly disadvantaged by such bans.

A second argument against off-season player social media bans relates to their rights to free expression. As Paulson stated in his *USA Today* article, wherein he warned schools about the possibility of court challenges:

> Some [schools] . . . don't understand the basic tenets of the First Amendment. In a private program, coaches can make the rules and private institutions are not subject to restrictions. Public universities, on the other hand, are government institutions, and college students have a right to freedom of speech, just as all citizens do.

To avoid the difficulties that bans can lead to, some schools are contracting with companies such as Varsity Monitor and UDiligence to review the posts of student athletes. If the companies report that a student has used a questionable word or topic, coaches are notified. The athletes are required to provide the monitoring companies access to their accounts.

Some critics believe such activities violate student-athletes' right to privacy. In 2011, Maryland State Senator Ronald Young introduced the first of several bills that, if enacted, would bar Maryland schools at both public and private high school and colleges from requiring players to provide monitoring companies with their passwords and usernames. Young told sportswriter Pete Thamel of the *New York Times* that "I think it's violating the Constitution to have someone give up their password or user name. It's like reading their mail or listening to their phone calls."

"CHEERING SPEECH" AND THE FIRST AMENDMENT

Sports arenas, stadiums, and athletic fields are places where it's expected that people will be loud. But are there limits on fan behavior? And if so, do such limits violate the First Amendment rights of those who run up against them? Legal scholars and others who follow this area of the law refer to free-speech controversies related to fans as "cheering speech." Sports journalist Bill Pennington asked in the *New York Times*, "Do fans have the right to bellow at referees all game long, as long as they do not run on the court or menace the officials? Even if the fan is seated in the front row and the referee can hear every word?" Like all questions about free speech, the answer is anything but cut and dried. Pennington continued:

> The question is apparently still open to debate, despite more than 150 years of American public sporting events . . . Hostile or excessively disorderly fan behavior is not tolerated by security officials at games, or for the most part by the court system, because it is deemed dangerous or disruptive to the group. But in the middle of a sporting event as fervent as the N.C.A.A. tournament, with passionate crowds and high stakes, what exactly defines disruptive?

Disputes over the conduct of fans arise at all levels and kinds of sporting events, even those for children, where parents, coaches, and managers are prone

to unsuitable conduct when things don't go their way. As Zack Hedrick, a Fox San Antonio news writer, put it:

> Baseball is a sport that helps build confidence and teaches teamwork. But that's not all some kids are learning. Curse words, arguing and threats are playing out on the field at local games. . . . Parents say ball games are being halted more often now because tempers from coaches on the field and even parents in the stands are reaching a fever pitch.

To discourage and hopefully eliminate such behavior, organizers of children's sports leagues and teams often ask parents, coaches, and managers to read and sign codes of conduct. The Little League's code of conduct for parents, for example, asks that parents refrain from, among other things, "unsportsmanlike conduct with any official, coach, player, or parent such as booing and taunting; refusing to shake hands; or using profane language or gestures."

At the high school level, unsportsmanlike behavior is also a problem. A step taken by the Wisconsin Interscholastic Athletic Association (WIAA), in December 2016, to discourage unsportsmanlike behavior, was the distribution of a group of cheers considered off limits. Among them were "Fundamentals," "Sieve," "We can't hear you," "Air ball," "You can't do that," "There's a net there," "Season's over." A student athlete who tweeted her criticism of the WIAA's list was suspended for five games.

Disputes over the behavior of fans at college sporting events also raise difficult First Amendment dilemmas. In a 2005 law journal article, "Cheers, Profanity, and Free Speech," Howard M. Wasserman wrote:

> Free speech controversies on college campuses often are grounded in concerns for civility, politeness, and good taste. They also tend to follow the same path: The government regulates speech in an effort to alter the level of discourse, limit the profane, and protect public and personal sensitivities; courts strike down the regulations as violating the First Amendment freedom of speech, and we end up right where we started.

In January 2004, University of Maryland officials were embarrassed by the behavior of some of their students at a game against Duke University. Some of their students had worn "Fuck Duke" T-shirts and yelled disparaging epithets at Duke players. In the aftermath of this event, Maryland officials were advised that a written code of fan conduct, if appropriately written, would not violate their students' First Amendment rights.

Professional sporting events are also places where fans at times act in ways that lead to disputes over freedom of speech. Although security and police seeking to maintain order at professional sporting venues can clamp down on alcohol-induced, overzealous fan heckling and diatribes, and offensive and profanity-laden signs, can they go even further in their censorship of fan behavior? In 2008, at a

New York Yankees game, at Yankee Stadium, Bradford Campeau-Laurion decided to go to the men's room during the seventh-inning stretch during the singing of "God Bless America." After 9/11, however, such trips to the restroom were impossible because New York City Police officers, ushers, stadium security, and chains blocked the way. Campeau-Laurion refused to return to his seat when he was told to do so. He was subsequently forced to leave the stadium. In April 2009, Campeau-Laurion sued the New York Yankees, the Commission of the NYPD, and two uniformed police officers, claiming they violated his First, Fourth, and Fourteenth Amendment rights. Campeau-Laurion and those he sued eventually settled the dispute out of court.

In light of the fact that Campeau-Laurion's case was settled, Nick DeSiato, in a 2010 law journal article, "Silencing the Crowd," commented:

> Because the "God Bless America" suit was eventually settled, it remains unclear as to what extent professional clubs may legally regulate, or even restrict, such forms of expression. In many cases, the expression is from the patrons, such as an overzealous fan with an offensive sign, or an alcohol-induced heckler in a profanity-ridden diatribe. Yet, the expression is sometimes through the club, such as the Yankees' "God Bless America" policy or a faith night featuring the club's star player professing his or her faith immediately preceding or following a game. In both situations, free speech rights are implicated and deserve attention.

PROFESSIONAL SPORTS AND POLITICAL SPEECH

The fact that the political perspectives of professional sports figures and those they play for don't always mesh well has been demonstrated time and again. This was demonstrated in 2016, when San Francisco 49er player Colin Kaepernick opted to kneel rather than stand during the national anthem just before the opening kick at an August 26 preseason game. Kaepernick decided to embroil himself in the controversy to protest the treatment of African Americans and other minorities in the United States.

Since the National Football League (NFL) and other professional sports teams are not government entities, they don't have to abide by the First Amendment. That said, if team owners punish players for expressing their political beliefs, they run the risk of sparking a backlash that might hurt their business interests. The NFL, which didn't fine Kaepernick, responded, "Players are encouraged but not required to stand during the playing of the national anthem." Some of his fans defended his right to speak his mind, but others severely criticized him on social media. In reference to the recent killings of individual African Americans by police officers and the deaths of police officers in Dallas, he later said:

> I am not going to stand up to show pride in a flag for a country that oppresses black people and people of color. To me, this is bigger than football and it

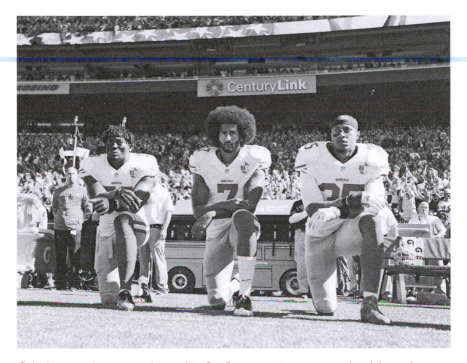

Colin Kaepernick, center, and two of his San Francisco 49ers teammates, kneel during the national anthem before a game in Seattle, Washington, in 2016. According to Kaepernick, his protest of "The Star Spangled Banner" was due to his unwillingness to show pride in the American flag because he believes the United States oppresses people of color. (AP Photo/ Ted S. Warren)

would be selfish on my part to look the other way. There are bodies in the street and people getting paid leave and getting away with murder.

Kaepernick's action encouraged other athletes to call attention to their political beliefs. In the weeks following the August 26 incident, several other NFL players joined him as he continued to kneel during the anthem. And on September 15, 2016, prior to the U.S. women's national soccer team's exhibition game against Thailand, in Columbus, Ohio, U.S. soccer star Megan Rapinoe knelt during the playing of the national anthem in opposition to social injustice.

On a number of earlier occasions, professional sporting celebrities have refused to keep their political thoughts to themselves. For example, the *Washington Post*'s Justin Moyer noted that in a press conference after a 2015 game, Green Bay Packer Aaron Rodgers criticized a fan for shouting an anti-Muslim remark during the moment of silence before the game. "I think it's important to do things like [the moment of silence]. We're a connected world, you know—six degrees of

separation. . . . I was very disappointed with whoever the fan was who made a comment that I thought was really inappropriate, during the moment of silence. It's that kind of prejudicial ideology that I think puts us in the position that we're in today as a world."

FURTHER READING

Crusader [Rockford, Illinois], November 8, 1968.

DeSiato, Nick (2010). "Silencing the Crowd: Regulating Free Speech in Professional Sports Facilities," *Marquette Sports Law Review*, 20(2): 411–39.

Dosh, Kristi A. (2015). "Clemson and Florida State Ban Football Teams from Twitter," *Outkick the Coverage*, August 11, http://www.outkickthecoverage.com/clemson-and-florida-state-ban-football-teams-from-twitter-081115.

Dunstan, Roger (1997). "History of Gambling in the United States," in *Gambling in California*. California Research Bureau, California State Library, http://www.library.ca.gov/crb/97/03/crb97003.html#toc.

"Ending the Legacy of Racism in Sports and the Era of Harmful 'Indian' Sports Mascots" (2013). NCAI, October 13, http://www.ncai.org/resources/ncai_publications/ending-the-legacy-of-racism-in-sports-the-era-of-harmful-indian-sports-mascots.

Fatsis, Stefan (2016). "No Viet Cong Ever Called Me Nigger: The Story Behind the Famous Quote," *Slate*, June 8, http://www.slate.com/articles/sports/sports_nut/2016/06/did_muhammad_ali_ever_say_no_viet_cong_ever_called_me_nigger.html.

Ferguson, Christopher J. (2013). "Violent Video Games and the Supreme Court," *American Psychologist*, 68(2) January–March: 57–74.

Gibson, Hanna (2005). "The Culture of Dogfighting," Animal Legal and Historical Center, Michigan State University of Law, https://www.animallaw.info/article/detailed-discussion-dog-fighting#culture.

Hauser, Christine (2016). "Why Colin Kaepernick Didn't Stand for the National Anthem," *New York Times*, August 27.

Hedrick, Zack (2016). "Parents: Cursing, Yelling, Playing out on Youth League Baseball Fields," Fox San Antonio, February 18, http://foxsanantonio.com/news/local/parents-cursing-yelling-playing-out-on-little-league-fields.

Kent, Steven (2001). *The Ultimate History of Video Games: From Pong to Pokémon*. New York: Three Rivers Press.

Lakier, Genevieve (2014). "Sport as Speech," *University of Pennsylvania Journal of Constitutional Law*, 16: 1109.

Miller, Patrick B., and David K. Wiggins (2005). *The Unlevel Playing Field: A Documentary History of the African American Experience in Sport*. Carbondale, IL.

Moushegian, Brian R. (2006). "Native American Natives' Last Stand," *Villanova Sports and Entertainment Law Journal*, 13: 2.

Moyer, Justin W. (2015). "Aaron Rodgers Praised for Criticizing Fan's Anti-Muslim Sentiments," *Washington Post*, November 16.

Murray, Jim (1967). "Louisville Loudmouth Secedes from the Union," *Los Angeles Times*, April 27.

"On This Day: October 17, 1968," BBC, http://news.bbc.co.uk/onthisday/hi/dates/stories/october/17/newsid_3535000/3535348.stm.

Paulson, Ken (2012). "Free Speech Sacks Ban on College Athlete Tweets," *USA Today*, updated April 15, http://usatoday30.usatoday.com/news/opinion/forum/story/2012-04-15/twitter-social-media-college-sports-coaches-ban/54301178/1.

Pearce, Al (2013). "Kyle Petty Supports Denny Hamlin," *Autoweek*, March 6, http://autoweek.com/article/nascar-sprint-cup/kyle-petty-supports-denny-hamlin-not-fan-nascar-censorship-drivers.

Pennington, Bill (2012). "Examining Fans' Right to Jeer at Games," *New York Times*, March 28, http://www.nytimes.com/2012/03/29/sports/examining-fans-rights-to-jeer-at-games.html.

Pockrass, Bob (2013). "Denny Hamlin Fine an Overreaction that could Damage NASCAR's Credibility," *Sporting News*, March 7, http://www.sportingnews.com/nascar/news/4483244-denny-hamlin-fine-overreaction-censorship-nascar-credibility-new-sprint-cup-car.

Richey, Warren (2009). "Supreme Court to Decide Case on Animal Cruelty and Free Speech," *Christian Science Monitor*, October 5, http://www.csmonitor.com/USA/Justice/2009/1005/p02s01-usju.html.

Rogers, Megan (2013). "Mascot Makeover," *Inside Higher Ed*, December 10, https://www.insidehighered.com/news/2013/12/10/most-colleges-adjust-moving-away-native-american-mascots.

Ross, Christopher (n.d.). "Cosell Backed Ali from the Start," ABC Sports Online, http://www.espn.com/abcsports/wwos/objector.html.

Smith, Red (1966). "Folk Hero," *New York Herald Tribune*, February 21, 1966.

Taylor, Michael (2013). *Contesting Constructed Indian-ness: The Intersection of the Frontier, Masculinity, and Whiteness in Native American Mascot Representations*. Lanham, Maryland, Lexington Books.

Thamel, Pete (2012). "Tracking Twitter, Raising Red Flags," *New York Times*, March 30, http://www.nytimes.com/2012/03/31/sports/universities-track-athletes-online-raising-legal-concerns.html?_r=1&ref=facebookinc.

Wasserman, Howard M. (2006). "Fans, Free Expression, and the Wide World of Sports," *University of Pittsburg Law Review*, 67: 525.

FOUR

Music

INTRODUCTION

Music is at the heart of popular culture because of its diversity, cultural and social bonding capabilities, lyrical impact, and escapism. Most people listen to music multiple hours each day at work, while driving, and in a host of other situations and settings. The proverb "Music soothes the savage beast" isn't an exaggeration. According to neuroscientists, music affects deep emotional centers in our brains. The author of "Why We Love Music," Dr. Valorie Salimpoor, wrote, "A single sound tone is not really pleasurable in itself; but if these sounds are organized over time in some sort of arrangement, it's amazingly powerful."

But music—and especially the lyrics of some songs—has also been the source of controversy in America, in some cases even prompting calls for censorship. If government is involved, the First Amendment to the United States Constitution, in conjunction with the Fourteenth Amendment, is called into play. In *Ward v. Rock Against Racism* (1989), the author of the majority opinion in the U.S. Supreme Court stated, "Music, as a form of expression and communication, is protected under the First Amendment."

Most perpetrators of music censorship, however, aren't government officials, but the owners and management personnel of the giant music and entertainment industries. Contributing to the nervousness of music industry leaders are grassroots movements, such as the backlash against rock 'n' roll. Averse to risking the profits they hope to earn from their investments in the creative output of composers and performers, many music industry entities shy away from distributing material they fear will offend potential customers or the government so much that they will suffer for it. As the cases covered here demonstrate, music that deals with politics, taboo subjects, violence, religion, and other touchy subjects has at times perpetrated backlashes that have been difficult to control.

Federal copyright and trademark laws also affect musicians and the music and entertainment industries, and in addition, lawmakers have enacted statutes and rules concerned with royalty issues, compulsory cover licenses, and recording contracts. Together this bundle of regulations is often referred to as the field of "music law." Because of the prominence of the entertainment industries in the states of California and New York, music law is of particular importance there.

The stories of those who have been caught up in disputes over the performance and sales of musical works speak to the great aesthetic and rhetorical power they hold. The major argument of those who justify music censorship is a strong one: we have a responsibility to protect children and other vulnerable demographic groups from its excesses. In contrast, some contend that music isn't as harmful as critics claim and that leaders go too far in their efforts to censor it. As First Amendment Center Executive Director Ken Paulson stated in an organization publication called *Free Speech and Music*, "The First Amendment allows us to say what's on our minds. That freedom doesn't disappear just because the message has a backbeat."

SONG BANNED FOR OFFENDING BRITISH AUTHORITIES (1733)

In 1733, John Peter Zenger was arrested for operating a printing press in defiance of New York Governor William Cosby. Placed on trial on charges of printing anti-British materials that qualified as seditious libel, in 1735 Zenger earned a place in the history of colonial America by unexpectedly winning his trial.

Not commonly mentioned in the histories of the episode is the fact that one of the acts that Zenger was arrested for was his publication of sheet music to "A Song Made Upon the Election of New Magistrates To the City." In addition to publishing *The New York Weekly Journal*, Zenger published sheet music, some of which mocked British leaders. Zenger was acquitted of all charges after his lawyer convinced the court that what he had printed was true. Today, libels are never considered punishable if they are true, but in the early 18th century, truth was not a defense against such charges.

POST-CIVIL WAR CONFEDERATE SONGS

During the post-Civil War reconstruction era, Southerners were ordered not to perform Confederate songs such as "I'm a Good Ol' Rebel" or "Bonnie Blue Flag" in public. According to music censorship historian Eric Nuzum, "Bonnie Blue Flag" was a "wildly popular" song in the South during the war. Its lyrics offer insight into the perspectives and arguments employed by many of those who fought for the South.

We are a band of brothers, and native to the soil.
Fighting for the property we gained by honest toil;
And when our rights were threatened, the cry rose near and far;
"Hurray for the Bonnie Blue Flag that bears a single star!"

Hurrah! Hurray!
For Southern rights, hurrah!
Hurray for the Bonnie Blue Flag that bears a single star.

The movement against Confederate songs continued into the next century. The September 1917 issue of *Confederate Veteran* reprinted a *Minneapolis Tribune* article that condemned "Marching through Georgia." J. H. McNeill, wrote:

The "hymn of hate" ought not to be played or sung now, when the stirring up of the spirit of sectionalism is a sin, a shame, a crime against the nation. There is no North, no South, simply the United States, one and inseparable. Instead of a "hymn of hate," we should sing "Blest Be the Tie That Binds." If I were President, I would suggest a censorship of patriotic music and ask that every copy of "Marching through Georgia" be put in pigeonholes and left there until the angel Gabriel sees fit to call them forth.

The same issue of *Confederate Veteran* reported that a resolution had been presented at the convention of the Children of the Confederacy in July 1917, in Macon, Georgia, that stated:

Resolved, That the Children of the Confederacy of Georgia, in convention here assembled, do protest against the use of the so-called "hate song," "Marching through Georgia," and urge its suppression and elimination in all schools and on all public occasions.

"CRAZY BLUES" INJUNCTION (1920)

In 1920, Mamie Smith and Her Jazz Hounds released a gramophone recording of "Crazy Blues." The record is memorable not only because it was the first blues record ever issued but also because it became the center of a lawsuit designed to stop its further release. The song's composer, Perry Bradford, had written a number of songs for the earliest blues singers, and, as a result, had generated quite a following. The plaintiff in the case, Max Kortlander, filed suit against Bradford, along with several associated parties, claiming he had purchased all future rights to the song before Bradford recording it under the new title "Crazy Blues."

Kortlander's actions weren't based on allegations of copyright infringement, but were inspired by the song's popularity. A lot of money was at stake, as approximately 75,000 copies of "Crazy Blues" had been sold within a month of its release, and Bradford's first royalty check was allegedly around $100,000. Kortlander argued that he, rather than Bradford, should receive all profits generated from the record's sales or from any future recordings or publication of the song in sheet music form.

In 1921, the New York Supreme Court, in *Kortlander v. Bradford* (190 N.Y.S. 311), ruled that there was sufficient evidence for the plaintiff's claim. Subsequently, Bradford settled Kortlander's claim out of court.

AMERICA'S ANTI-JAZZ MOVEMENT (1910s–1930s)

Jazz, which some historians claim is America's first true musical genre, originated in the late 19th and early 20th centuries. The city of New Orleans has been called the birthplace of jazz, although its history is difficult to trace. Early jazz was an amalgam of ragtime, blues, brass band music, hymns and spirituals, minstrel music and work songs, and even had European influences. In "The Origins of Jazz," Len Weinstock wrote that the genre's connection to New Orleans comes from the involvement of Creole musicians, some of whom were conservatory trained in Paris. The city's Creole people were privileged members of the community and lived with the French on the east side of Canal Street. In 1894, New Orleans enacted an ordinance that forced the Creole people to move out of the French section of the city into the poorer African American neighborhoods west of Canal Street. Out of this came jazz, a musical novelty that expressed the clash that resulted from these changes.

But as jazz grew in popularity, it also faced resistance. In 1918, the first documented jazz performance by a local band in the State of Washington took place in Seattle. A backlash against the concert is evident in its news coverage. On June 13, the *Seattle Daily Times* published a front-page story with the headline "Is Jazz Menace to Civilization? Worse Than Booze, Say Club Women."

In 1924, bandleader Paul Whiteman premiered George Gershwin's revered "Rhapsody in Blue" as an example of symphonic jazz, and by the 1930s, jazz was the dominant form of popular dance music in the United States. At the same time, a full-blown anti-jazz movement had developed. Jazz's association with African Americans made it odious to white racists, a fact demonstrated by widespread efforts to suppress it. On December 22, 1933, Washington State Representative William A. Allen introduced a bill to establish a commission to study jazz's dangerous effects. It was titled the "jazz intoxication" bill, and although it was never enacted, it serves as a cogent example of the determination of anti-jazz zealots. As the popularity of jazz giants such as Louis "Satchmo" Armstrong and Duke Ellington grew, though, objections to the musical genre waned, and the genre gained widespread mainstream acceptance. Music historians now call the period from 1930–1950 the golden age of jazz.

THE CHITLIN CIRCUIT (1930s–1960s)

Owners of music clubs, theaters, and concert halls who refuse to allow entertainers to perform in their venues are imposing what experts call "extralegal" censorship. African American musical performers were subjected to this brand of censorship in the decades leading up to the 1960s Civil Rights movement, especially in the South. In response, those willing to book African American acts created an informal network that spread through the southern, eastern, and mid-western areas of the United States. Called the Chitlin' Circuit, the system offered safe and acceptable places for African American musicians, vocalists, comedians, and other entertainers to perform.

Some of America's most esteemed African American performers started their careers in the clubs and theaters that were part of the Circuit, including Count Basie, Sam Cooke, Duke Ellington, Ella Fitzgerald, Jimi Hendrix, The Supremes, Aretha Franklin, and a host of others. In an interview included in the 2013 video "Why We Should Build the R&B Music Hall of Fame Museum," Ruth Brown, considered by many to be the "Queen of R&B," recalled that before new artists could claim they had made it, they had to prove themselves at four of the Circuit's most revered theaters: the Apollo, in New York; the Regal Theater, in Chicago; the Howard, in Washington, D.C.; and Uptown, in Philadelphia.

The Chitlin Circuit has been memorialized by the Mississippi State Blues Commission, which erected a historic marker in its honor on its Mississippi Blues Trail. The marker stands in front of one of the Circuit's venues, the Southern Whispers Restaurant, in Greenville, Mississippi. The café drew crowds eager to enjoy the Delta blues, big band jump blues, and jazz its performers specialized in.

BILLIE HOLIDAY'S "STRANGE FRUIT" (1939)

The lyrics of "Strange Fruit" were so controversial for that era that some U.S. radio stations refused to allow their disc jockeys to play Billie Holiday's 1939 recording of it. The song's composer, Abel Meeropol, wrote "Strange Fruit" after he saw a photograph of a lynched African American man hanging from a tree. A teacher, poet, social activist, and amateur composer, Meeropol hoped his song's message would force people to confront the ugly reality of one of racism's most evil acts. The images its lyrics conjure up, such as "Pastoral scene of the gallant South, The bulging eyes and the twisted mouth," are powerful.

Billie Holiday first sang the song during the late 1930s at

Jazz vocalist Billie Holiday in 1949. Her 1939 recording of "Strange Fruit," a song about lynching, was a cause célèbre. The Record Industry Association of America has included it in its list of "Songs of the Century." (Library of Congress, Carl Van Vechten Collection)

New York City's only racially integrated nightclub, Café Society. At the time, few songs tackled the day's social issues, and she recalled in her autobiography how nervous she was about how the audience would react. She wrote, "There wasn't even a patter of applause when I finished. Then a lone person began to clap nervously. Then suddenly everybody was clapping." Eventually, Holiday sang "Strange Fruit" at the conclusion of all of her shows.

Columbia Records told Holiday they would not release a recording of the song, although they eventually allowed Commodore Records to do so in 1939. Initially, the record sold well in Northern urban markets, but not in the South, where radio stations refused to play it. *Time* magazine denounced the recording as a "prime piece of musical propaganda."

After Holiday's 1959 death, "Strange Fruit" fell into relative obscurity, although new recordings by Nina Simone and Josh White covering the song were released. In 1999, *Time* magazine reversed its earlier position on the song and named it the "Song of the Century." A British music publication, *Q*, named "Strange Fruit" one of "ten songs that actually changed the world."

BLACKLISTING THE WEAVERS

During the Cold War era, one of America's most popular musical groups, The Weavers, was swept up in the anti-communism hysteria that swept the nation. Formed in 1948, the group included Ronnie Gilbert, Lee Hays, Fred Hellerman, and Pete Seeger. In 1950, the popularity of their songs helped bring folk music into the American mainstream. "Good Night Irene" was a number one hit for 13 weeks in 1950, and "Midnight Special" and "On Top of Old Smokey" also put the group in the limelight.

The Weaver's popularity reminded America's anti-communists of Seeger and Hays' earlier activism. In the early 1940s, two members of The Weavers, Seeger and Hays, were part of the Almanac Singers, a musical group that not only sang about everyday life but about the era's social and economic problems. In doing so, they promoted pacifism, isolationism, and the interests of labor organizations in songs with titles such as "Talking Union" and "Which Side Are You On?" Seeger and Hays were strong supporters of the United States during World War II, but after its conclusion, they returned to their earlier causes.

After The Weavers formed, they struggled for the first year. In June of 1950, however, a pair of their recordings, "Tzena Tzena Tzena" and "Goodnight Irene," hit number one and stayed there for months. Until late 1951, the group's popularity helped them secure bookings, even as the Federal Bureau of Investigation (FBI) carried out secret surveillance and investigation activities against the band's membership. But after the House Un-American Activities Committee declared in early 1952 that three of the group's members were thought to be Communists, the Weavers' fortunes plummeted. Decca Records dropped their recordings from its catalog; radio stations refused to play their songs; and entertainment venues refused to book their concerts.

In 1955, Seeger and Hays were subpoenaed to testify before the U.S. House Un-American Activities Committee. Hays refused to testify under the protection of the Fifth Amendment, and Seeger claimed such punishment was a violation of his First Amendment rights. Despite these developments, in 1955, The Weavers were asked to perform at Carnegie Hall in New York City. The concert was sold out, and in 1957, Vanguard Records released an LP titled "The Weavers at Carnegie Hill." This led to several tours and another album. In 1982, a documentary film titled "The Weavers: Wasn't That a Time!" was released. The group received a Grammy for lifetime achievement in 2006.

ELVIS THE PELVIS

In 1956 and 1957, American church leaders derided the music and on-stage antics of a young singing sensation named Elvis Presley as the "work of the devil." Expressing great concern that young people attracted to Presley's music would be led into sin, religious leaders made Presley the subject of many Sunday morning sermons and written warnings. Presley historian and fan Alan Hanson noted, for example, that on Sunday, December 2, 1956, Reverend Carl Elgena of Des Moines, Iowa, warned the members of his congregation that "Elvis is morally insane" and that "by his actions he's leading other young people to the same end."

Hanson notes that Presley, who grew up in the Assembly of God church and was deeply influenced by gospel music, took strong exception to the idea that his music would lead others into sin. In June 1956, he told a *Charlotte* [North Carolina] *Observer* newspaper reporter, "When I sing this rock and roll, my eyes won't stay open and my legs won't stand still. I don't care what they say, it ain't nasty." After *Life* magazine published an image of a minister denouncing him, Presley responded, "That hurt me bitter. God gave me my voice. I never danced vulgar in my life."

Rock and roll singer Elvis Presley performs on stage in 1956. Presley's suggestive hip movements stirred up a storm of instant popularity and controversy. (Michael Ochs Archives/Getty Images)

But Presley's objections failed to quell his critics, and those who criticized rock 'n' roll more generally. Before Presley arrived in Chicago as part of his 1957 tour of the Midwest and Canada, Samuel Cardinal Stritch, the Archbishop of Chicago's Roman Catholic Church, publicly condemned rock 'n' roll. He wrote:

Some new manner of dancing and a throwback to tribalism in recreation cannot be tolerated for Catholic youths. When our schools and centers stoop to such things as "rock and roll" tribal rhythms, they are failing seriously in their duty. God grant that this word will have the effect of banning such things in Catholic recreation.

Hanson observed, however, that not all ministers condemned Elvis, and some even came to his defense. The Reverend James H. Elder, of Memphis, for example, told the *Toronto Star*:

These diehards, who haven't had a youthful thought since the Civil War, say that rock and roll music is the theme song of juvenile delinquency and that Elvis Presley is making "dead end kids" out of the whole generation. Nothing could be more idiotic. It is supposed to be perfectly all right for every bald-headed man in America to drool as Marilyn Monroe goes slithering across the pages of our time on the arm of husband number three. But the very moment that youth dance and Elvis shakes his left leg a bit, it's supposed to be juvenile delinquency of the worst sort.

"LEER-ICS" AND THE MUSIC INDUSTRY (1950s)

In the 1950s, the growing popularity of rock 'n' roll and rhythm and blues led to calls for self-censorship from within the music industry. Rock historian Theo Cateforis noted that on February 23, 1955, *Variety* editor-in-chief Abel Green launched a series of editorials complaining about the dangers of rock 'n' roll and the industry's unwillingness to censor itself. Songwriters, he argued, should not pander to human's basest instincts through their creation of "leer-ics."

Music "leer-ics" are touching new lows and if the fast-buck songsmiths and music makers are incapable of social responsibility and self-restraint then regulation—policing, if you will—will have to come from more responsible sources. . . .

What are we talking about? We're talking about "rock and roll," about "hug," and "squeeze" and kindred euphemisms which are attempting a total breakdown of all reticence about sex. . . .

The time is now for some serious soul-searching by the popular music industry.

Broadcast Music, Inc. (BMI), along with other trade organizations that served the interests of songwriters, composers, and music publishers, likewise approved of music censorship. BMI, which was founded in 1939, in New York City, collected license fees from those who wished to record or play the music of its members, and redistributed such fees in the form of royalties.

In the mid-1950s, BMI began to assume a censorship role as it "cleared" the songs it was thinking of licensing. It did so both to protect its clients and its own interests. Gradually, however, such "clearings" involved looking not only for copyright problems but also for lyrics that might be considered profane or otherwise indecent. BMI considered this in everyone's best interests, as they knew that censors at the four television networks would refuse to license music deemed inappropriate for their audiences. As they screened various songs' lyrics, BMI's reviewers changed them and warned its licensees about certain songs deemed potentially troublesome. Frank Sinatra's recording of "From the Bottom to the Top" was put on BMI's "Play With Caution" list, and changed the lyrics of Bill Haley's "Shake, Rattle and Roll" from "You wear low dresses, the sun comes shinin' through. I can't believe my eyes, all of this belongs to you," to "You wear your dresses, your hair done up so nice. You look so warm, but your heart is cold as ice" (Sanjek, 1988).

MUSIC STORE CENSORSHIP AND SELF-CENSORSHIP

Before the emergence of iTunes and other online music distributors, record stores were among every community's most popular commercial establishments. Simultaneously, at times they became the targets of those seeking to stop the sale of music considered unsuitable for public consumption, particularly for young people.

In the 1950s and 1960s, as rock 'n' roll music entered the mainstream, some local community leaders came to see themselves as vigilant guardians of community values that were under siege from this "immoral" brand of music. One way they carried out this agenda was to police record stores to see what records they carried, and to issue warnings to store owners to refrain from selling such records. On several occasions, police were sent to confiscate records and arrest storeowners and employees. In Houston, Texas, for example, the Juvenile Delinquency and Crime Commission regularly compiled a list of records it warned city storeowners not to sell (Martin and Segrave, 1993).

Additional waves of censorship have spread across the country from time to time. In the early 1990s, a number of popular musical groups willing to skirt propriety in their lyrics, music videos, and album covers prodded community leaders to action. Sales of 2 Live Crew albums resulted in the arrest of record storeowners on obscenity charges, and those who sold certain Red Hot Chili Peppers and Jane's Addiction recordings also got into trouble. In Los Angeles in 1990, after hanging the cover poster for Jane's Addiction's "Ritual de lo Habitual" album in the window of his shop Off the Record, Rick Berry was charged with "distributing obscene material." The cover of the album included images of naked women with their heads on fire. His potential penalty was $100 and 30 days in jail.

Some music stores, department stores, and chains have sought to avoid the negative publicity associated with such police actions by refusing to sell certain records. In 1969, after Detroit's Hudson's department stores refused to carry MC5's "Kick Out the Jams," the group responded by paying for an ad in two underground magazines that said, "F**k Hudson's." More widely known is Walmart's ban on the sale of certain recordings, including Eminem's recordings of "Mosh," an anti–Iraq war song and video released late in 2003. After Walmart refused to sell "Mosh," Eminem altered its lyrics.

Today's music fans predominantly stream the music they listen to or purchase digital albums or tracks from the comfort of their own homes. They no longer rely on brick-and-mortar stores for their music purchases. That said, censorship of streamed music does exist. For example, iTunes maintains a policy of censoring profanity in song titles by labeling such songs as "explicit." If iTunes labels a song as "clean," it typically offers a more explicit version as well.

JUKEBOX CENSORSHIP

In 1890, Louis Glass and William S. Arnold invented the forerunner of today's coin-operated jukeboxes. The term "jukebox" came into use in 1940, just as they were entering their golden days, which lasted until the mid-1960s. Writer Tyler Cowen wrote, in his book *In Praise of Commercial Culture*, that by the mid-1940s, approximately 75 percent of the records distributed in the United States were available on jukeboxes. Clearly pop music artists had a lot to lose if jukebox companies refused to put their recordings on their machines.

Those who objected to certain kinds of music, musicians, and vocal artists sometimes targeted the jukebox in their efforts to protect their communities. Laws banning jukeboxes were enacted, and the operators of jukeboxes were at times told to remove certain records. The following events serve as examples of the kinds of legal and extralegal remedies used by various authorities.

- In 1948, Memphis Vice-Mayor Joe Boyle ordered police to smash 400 copies of three blues records they had declared to be "obscene" and banned their distribution through record sales or on the jukebox.
- In 1953, six South Carolina counties enacted laws forbidding jukeboxes within hearing distance of churches.
- In September 24, 1954, *Billboard* magazine published an editorial titled "Control the Dimwits" that condemned R&B songs with lyrics featuring double entendre references to sex. In response, police in Long Beach, California; Memphis, Tennessee; and other cities confiscated jukeboxes containing such songs, and fined their owners.
- Also, in 1954, the Houston, Texas, Juvenile Delinquency Commission removed Elvis Presley's recording of "Good Rockin' Tonight" from the community's jukeboxes and record stores.

- In 1956, the leader of the North Alabama Citizens' Council (NACC), located in Birmingham, Alabama, Asa "Ace" Carter, warned the community that they were "setting up a twenty-man committee to do away with this vulgar animal-istic nigger rock and roll bop. Our committee will check with restaurant owners and cafes to see what bebop records is on their machines and then ask 'em to do away with 'em" (Bertrand, 2000).
 - In response, some of Birmingham's white youth responded, "rock 'n' roll is here to stay, regardless whether the voice coming from the jukebox is black or white."
- In 1956, the San Antonio, Texas, Parks Department went to local swimming pools and removed all rock and roll records from their jukeboxes.

BOB DYLAN'S "TALKIN' JOHN BIRCH PARANOID BLUES" (1963)

In 1963, just as musician and singer Bob Dylan was starting to gain celebrity status, he was asked to appear on CBS's *Ed Sullivan Show*. During rehearsals, Dylan sang the song he planned to perform on Sullivan's March 12 show, "Talkin' John Birch Paranoid Blues," which was from his second album, *Freewheelin' Bob Dylan*. No one objected until, just before the show aired, Dylan was informed that CBS wanted him to choose a different song to perform. Dylan refused to cater to CBS's censors and walked off the show's set in protest.

In a humorous way, Dylan's "Talkin' Blues" lambasted the John Birch Society's ultra-conservative paranoid stance on the spread of international communism. The political and economic prominence of some members of the society, however, worried network officials, who were concerned that the song's lyrics unfairly associated the society with the views of Adolf Hitler and that this could trigger a libel suit.

After Ed Sullivan and the show's producer issued a statement criticizing CBS's refusal to allow Dylan to perform "Talkin' Blues," the network refused to comment. Decades later, Dylan returned to CBS, for the first time since 1963, when he appeared on two of David Letterman's shows, including one of Letterman's final May 2015 broadcasts.

KEEPING "UNDESIRABLE" PERFORMERS OFF THE STAGE

On numerous occasions in American history, musical artists have been prevented from performing in public because of objections to their political beliefs, their skin color, or musical content deemed to be a threat to public safety. Some have been deported or not allowed to enter the United States; others have been prevented from booking performances and/or getting recording contracts or have been physically attacked while performing.

In July of 1949, a witness at a House Un-American Activities Committee (HUAC) declared that African American actor and musical performer Paul Robeson, an outspoken supporter of liberal political causes, was "the Kremlin's voice of

America." After he was blacklisted and had his passport revoked, he was unable to work or travel. His yearly income dropped to nearly nothing.

Marian Anderson was widely considered to be one of the 20th century's most celebrated singers. She was renowned for her performances at major concert halls throughout the United States and Europe between 1925 and 1965. As an African American, however, she was at times subjected to discrimination. One of the most famous incidents occurred in 1939, when the Daughters of the American Revolution refused to allow her to perform in Washington, D.C. In response, First Lady Eleanor Roosevelt came to Anderson's aid and arranged for her to perform before a giant crowd in an open-air concert on the steps of the Lincoln Memorial.

Those seeking to quell the 1960s British Invasion, including the powerful American Federation of Musicians (AFM), discouraged the scheduling of a number of UK bands in the United States. After their successful 1965 tour, the Kinks were unable to book a tour in America until 1969. Another case involved The Beatles. After the band's successful 1964 tour, the AFM launched an unsuccessful bid to keep the band from touring in the United States again. Also in 1964, the Rolling Stones were banned from performing in Cleveland after a concertgoer fell from a balcony. Music historians claim AMI was seeking to quell the rising popularity of these bands to protect their financial interests.

On April 10, 1956, African American pop vocalist Nat King Cole was physically assaulted by three men during a performance at the Birmingham, Alabama, Municipal Auditorium. Afterward, Cole said to the audience:

> I just came here to entertain you. I thought that was what you wanted. I was born here. Those folks have hurt my back. I cannot continue, because I have to go to a doctor.

Cole's bewilderment was sorely felt not only by his fans but by the broader African American community. His attackers, brothers E. R. and Willis Vinson and Kenneth Adams, were members of the North Alabama Citizens' Council (NACC), a segregationist organization led by Ku Klux Klan member Asa "Ace" Carter and known for its extreme anti–African American and anti-Semitic activities. The group was eager to nip the burgeoning civil rights movement in the bud, and one of its chief strategies was to wipe out rock and roll music, which it argued was linked to communism. Although Nat King Cole was not a rock-and-roll artist, because of his race, the three NCAA members were inclined to overlook that detail.

The attack on Cole is but one of a number of similar actions taken against musical artists for one reason or another. In 2013, for example, Lester Chambers, a well-known soul singer who was once part of the Chambers Brothers, was attacked while performing in San Francisco. At a July 13 concert, a woman assaulted him after he dedicated a song to Trayvon Martin, an unarmed 17-year-old African American high school student in Miami Gardens, Florida, who had been shot to death by George Zimmerman, the watch coordinator of a Neighborhood Watch

Program, in Sanford, Florida. Martin was a junior at Michael M. Krop High School and lived with his mother and older brother. The day he was shot, he and his father were visiting his father's fiancé, in Sanford. The attack on Chambers took place on the day it was announced that Zimmerman had been acquitted.

THE FBI INVESTIGATES THE LYRICS OF "LOUIE LOUIE" (1965)

The belief that certain pieces of music are somehow linked to illicit sex has generated angst among parents and community leaders. A notorious example of such concern began when an FBI investigation was launched to determine whether the lyrics of the rhythm and blues song titled "Louie Louie" were obscene. There was some doubt as to the validity of such concerns, as it was difficult to understand the words of the song because of the way The Kingsmen recorded it in 1957. Indeed, the way Jack Ely, The Kingsmen's lead singer, sang "Louie Louie" turned the record into a pop culture phenomenon. In his 1989 book, *The Heart of Rock and Soul*, music critic Dave Marsh wrote:

> [Ely] went for it so avidly you'd have thought he'd spotted the jugular of a lifelong enemy, so crudely that, at that instant, Ely sounds like Donald Duck on helium. And it's that faintly ridiculous air that makes The Kingsmen's record the classic that it is, especially since it's followed by a guitar solo that's just as wacky.

The FBI's inquiry into the dangerousness of "Louie Louie" was sparked when an outraged parent wrote to then–U.S. Attorney General Robert F. Kennedy. In June 1965, under the new attorney general, Nicholas Katzenbach, the agency began a research project designed to decipher the song's words. After four months, its investigators announced that the song's words were "unintelligible at any speed." An FBI agent interviewed a member of the band, who denied that it included any unsavory lyrics.

Since that time, the song has not only ceased to be controversial, but it has become one of the nation's most popular and enduring songs. More than a thousand renditions of the song have been recorded, according to LouieLouie.net, and the song has found its way into the hit films *National Lampoon's Animal House* (1978) and *The Naked Gun* (1988). From 2003 to 2012, the City of Tacoma, Washington, held LouieFest, a summer music and arts festival. And in Portland, Oregon, a sculpture titled "Louie Louie, 2013," is displayed on the lobby wall of the city's federal building.

DEBATING MUSIC LYRIC WARNING STICKERS (1985)

After Tipper Gore, wife of U.S. senator and future Vice President Al Gore, purchased a Prince album for her daughter, she decided to listen to its songs' lyrics.

Gore became so upset that she was inspired to help build a national campaign against explicit music lyrics. She later wrote about her reaction to the lyrics in her book *Raising PG Kids in an X-Rated Society*. She recalled:

> In December 1984, I purchased Prince's best-selling album *Purple Rain* for my 11-year-old daughter. . . . When we brought the album home, put it on our stereo, and listened to it together, we heard the words to . . . "Darling Nikki" . . . I couldn't believe my ears! The vulgar lyrics embarrassed both of us. At first, I was stunned—then I got mad.

The nation's mood in the mid-1980s was ripe for such an organization, as it was in the midst of a backlash against the music industry, which had increasingly been pushing the limits of what was deemed acceptable by many Americans, including influential conservative organizations like the Moral Majority.

Gore worked with three prominent women with ties to Washington, D.C.: Susan Baker, wife of then–Treasury Secretary James Baker; Pam Howar, wife of realtor Raymond Howar; and Sally Nevius, wife of Washington City Council Chair John Nevins. In 1984, they collaborated in the formation of the Parents Music Resource Center (PMRC), which was successful in prodding the U.S. Senate to hold a "porn rock" hearing and in talking the Record Industry Association of America (RIAA) into implementing a parental advisory label system for musical recordings.

The U.S. Senate hearing, which took place on September 19, 1985, attracted considerable publicity because of the testimony of pop stars Frank Zappa, John Denver, and Twisted Sister's Dee Snider, among others, who spoke out against the establishment of a music rating system and music censorship in general. *Washington Post* reporter Richard Harrington wrote that a "circus atmosphere pervaded the Russell Senate Office Building, with rock fans and foes angling for the few available seats."

Two months after the Senate hearings, the PMRC and RIAA came to an agreement on the words the stickers would include. By 1992, approximately 225 records had carried them. What the stickers say, and where they are located, has changed over the years, but in general, they warn consumers that the material they are considering for purchase contains profanities and/or references to sex, violence, and substance abuse. The RIAA also urges companies to use stickers to warn consumers about music that is racist, homophobic, or misogynistic. Recordings with stickers are often sold alongside unlabeled "clean" versions of the albums in which the offensive material has been deleted. Online music stores include stickers next to the albums and songs they market.

Many have criticized the effectiveness of the RIAA's parental advisory warning system. One complaint is that the labels make it easier for young people to find the offensive songs and albums their parents don't want them to listen to. The fact that use of the stickers is entirely voluntary rankles those who believe they should be required. In addition, the program's critics argue that the stickers offer retailers opportunities to brand themselves as "family friendly."

Another of PMRC's initiatives was the publication of a list of songs it considered especially dangerous. The list's "Twisted Fifteen" includes songs by Madonna, Prince, Cyndi Lauper, Twisted Sister, W.A.S.P., Mary Jane Girls, Venom, and Mercyful Fate, among others. PMRC argued that these songs were so offensive that they should be banned from the airwaves.

THE BACKLASH AGAINST HEAVY METAL

Heavy metal is a rock 'n' roll genre noted for its strong beat, loudness, discordant sounds, and rebelliousness. Rock historians find the roots of the genre in the recordings of the English bands Deep Purple, Black Sabbath, and Led Zeppelin, who formed in the late 1960s. Their music inspired American musicians and groups like Alice Cooper and Judas Priest. Since then, heavy metal has spun off into a number of subgenres, including thrash, death, black, power, and doom metal. The many critics of the genre and its variations have complained that these performers often drench their music in violent, drug-oriented, hedonistic, misogynistic, and satanic overtones that pose a threat to young people and society as a whole.

Parents, religious leaders and social conservatives have attacked heavy metal music since it began to gain popularity. One of the motivations of the founders of the Parental Music Resource Center (PMRC) was to warn people about heavy metal music. The organization urged record companies to put warning labels on their heavy metal albums, and published it's famous "Filthy Fifteen" list, which included songs by metal groups Judas Priest, Mötley Crüe, AC/DC, Twisted Sister, Def Leppard, Mercyful Fate, Black Sabbath, and Venom.

In addition, seeking to establish a link between heavy metal and crime, a number of lawsuits have attacked heavy metal bands and their record companies. One was filed by the parents of 19-year-old John Daniel McCollum, who shot and killed himself as he listened to Ozzy Osbourne's recording "Suicide Solution." The McCollums sued Osbourne and CBS Records in 1986, claiming the song's lyrics—"Made your bed, rest your head. But you lie there and moan. Where to hide? Suicide is the only way out"—drove their son to his death. In 1988, a California court dismissed the lawsuit, claiming that Osborne's song could not be blamed for McCullum's suicide.

Another lawsuit followed a 1985 incident in Nevada involving two young men who shot themselves in the head after forming a pact to kill themselves. One of the men died immediately, and the other was severely disfigured and died three years later. In a lawsuit filed against Judas Priest, the parents of both of the men claimed their sons had killed themselves because of the subliminal messages in some of Priest's lyrics. The case didn't go to trial until 1990, but when it did, it generated national attention. The plaintiff's attorney wrote a *Los Angeles Times* op-ed piece that claimed that the lyrics of "Better By You, Better Than Me," for example, "let's be dead" and "do it," were provocative enough to enter the psyches of its listeners. Although Judge Whitehead dismissed the case after six week, he stated that he agreed that there were "subliminals" in the album, although they could only be

detected if the sounds were isolated and amplified. The trial is the subject of a 1991 documentary titled *Dream Deceivers: The Story behind James Vance vs. Judas Priest*.

In addition to anti-heavy metal publicity, record album warning labels, and lawsuits, those seeking to stamp out heavy metal bands have discouraged owners of theaters and other music venues from booking them. In 1994, the owners of Salt Lake City's Delta Center refused to allow Marilyn Manson to open a concert for Nine Inch Nails because they claimed his act would violate a clause in their booking contract that prohibited indecent, obscene, immoral conduct. Delta Center officials insisted that Manson alter some of his lyrics, not speak between musical numbers, and not sell any of the tour merchandise that they found objectionable. Manson decided he couldn't agree to such conditions and didn't book his performance. At the concert, Trent Reznor, a member of Nine Inch Nails, invited Manson on stage and read a letter to the audience explaining why he wasn't performing. Reznor ended the concert with an obscenity-laden diatribe against Salt Lake City's mayor and the Church of Jesus Christ of Latter-day Saints.

CONTROVERSY OVER MUSIC VIDEOS (1980s–PRESENT)

Although music has been combined with filmed imagery since at least the 1920s, music videos as we currently understand them came into their own in 1981, when MTV made them the basis of all of its programming. MTV's popularity has attracted many others hoping to capitalize on the success of the music video. Music video stations have proliferated across the world, and music videos appear on digital cable TV, satellite television networks, and the Internet. In the United States, MTV and MTV-affiliated channels remain a leader in the field, but other well-known carriers of music videos include Black Entertainment Television, VH1, and YouTube.

Since its 1981 debut, MTV pushed the boundaries of what's acceptable in the music world. From time to time, however, MTV refused to include especially provocative music videos in its programming. Music videos were rejected by MTV because of their taboo subjects, glorification of violence, references to suicide, religious overtones, explicit erotica, ill treatment of women, political messages, and ethnic or racial references, among other things.

MTV restricted music videos in a variety of ways. Some were banned entirely; some moved to times when fewer kids are watching; and some were broadcast after the artists removed or changed the most offensive material in the video. The sexually suggestive content of several of Madonna's music videos—"Erotica," "Justify My Love," and "What It Feels Like for a Girl"—led MTV to ban them. In another case, MTV agreed to air Madonna's original "American Life" music video with a less sexy version.

Other musical performers whose videos were banned or otherwise censored by MTV included Sean Kingston, Michael Jackson, Maroon 5, Foster the People, Magadeth, Twisted Sister, Sepultura, Suicide Silence, M.I.A., Mistah F.A.B, Queen, The Prodigy, Public Enemy, and Primus.

Black Entertainment Television (BET) has also shied away from embracing sexually explicit music. For example, the channel refused to allow the video versions of Ciara's song "Ride" and Nicki Minaj's "Stupid Hoe" to air.

Country music has not been immune from music video censorship, and one of the best known of these incidents relates to a Garth Brooks music video. When Brooks recorded the audio edition of "The Thunder Rolls," he left out its third verse because of its references to domestic violence. The song is about a married man driving home in a rainstorm from an assignation with another woman. Once home, his wife runs to meet him, smells his lover's perfume, and becomes angry. At this point, the third verse describes her reaching for a pistol so that she never again has to worry about his whereabouts.

Brooks included the third verse in his music video, and shortly after its release on May 1, 1991, The Nashville Network (TNN) and Country Music Television (CMT) pulled it from their programming. The music channels said they would resume airing the video if Brooks included a disclaimer. Brooks refused to do so, and eventually the news had spread around the country. Brooks was subsequently honored with various awards for the video, including the Country Music Association's Video of the Year.

Music video censorship not only takes place on television but on the Internet, as is demonstrated by the difficulties YouTube has experienced in its efforts to deal with material many feel is unsuitable for general audiences. In some cases, it requires users to verify their age before watching. For example, Rihanna's "S&M" video is labeled "inappropriate for some users," and viewers must verify that they are at least 18 years of age.

2 LIVE CREW AND "AS NASTY AS THEY WANNA BE," 1989–1992

The first music album ruled by a U.S. court as legally obscene was 2 Live Crew's recording "As Nasty As They Wanna Be." The 18-track recording features "Me So Horny" and "Dick Almighty" as well as a number of other songs many people found offensive. The album was released on February 7, 1989, and eventually earned the RIAA's double platinum award. They simultaneously released a cleaner version of the album titled "As Clean As They Wanna Be."

In mid-February 1990, after receiving complaints from members of the public, the Broward County, Florida, sheriff's office investigated whether local record stores were selling the "Nasty" version of the album. After transcribing its lyrics, police went to the Broward County Circuit Court to ask a judge to declare whether the album contained obscene content in violation of section 847.011 of Florida statutes and under applicable case law. On March 9, 1990, Judge Mel Grossman ruled that it did, and area record stores received an order that forbade them to sell it.

On March 16, Skyywalker Records and 2 Live Crew filed suit against Broward County Sheriff Nicholas Navarro, challenging the legality of the judge's order under the First and Fourteenth Amendments. On June 6, Judge Jose Gonzalez read his opinion, which ruled against the band, to a packed courtroom. Gonzalez reminded

participants that the First Amendment's protection of speech does not extend to obscene material. In response, 2 Live Crew argued that the public should decide what is or isn't obscene, and that the album cover contained a warning label. After evaluating the album's lyrics, using the standards of the Miller obscenity test, Gonzales ruled that the album was legally obscene and that the owner of any record store that sold it would face charges.

A few days later, Charles Freeman, the owner of a Florida record store, was arrested and charged with violating the state's obscenity law for selling the band's album. At his record shop, E.C. Records, Freeman had sold nearly 1000 copies of the "Nasty" album. Freeman was convicted on October 3, but his conviction was later overturned.

On June 10, three members of 2 Live Crew were arrested on obscenity charges during a performance at a Fort Lauderdale nightclub. Their trial, which began October 16, attacked national attention. The *New York Times* reported that, in opening statements, Assistant Florida State Attorney Leslie Robson told the jury, "The evidence is irrefutable. You're going to hear graphic descriptions of sexual intercourse, anal intercourse, oral intercourse."

The attorney for 2 Live Crew called on expert witnesses John Leland and Dr. Henry Louis Gates Jr. A well-known authority on hip-hop, Leland was a senior editor at *Newsweek* magazine. Gates, a professor of American literature at Duke University, has written about rap as a part of African American culture. Gates testified that he considered the members of the group to be "musical geniuses" and that the album's lyrics satirize the stereotype of the oversexed African American male.

The jury refused to convict the three members of the group who had been arrested. In an October 21 *Los Angeles Times* article, one of the jurors was quoted as saying, "Our first and strongest impression was that this is political. They were thumbing their noses back [at Broward County and Navarro]." Asked if she found the songs' words offensive, another juror said, "We found many things humorous. We looked at this as a comedy."

Nearly two years later, Federal Judge Jose Gonzales's order banning the sale of "Nasty As They Wanna Be" was revisited after an appeal by 2 Live Crew and its record company. After the 11th U.S. Circuit Court of Appeals reviewed the case on May 7, 1992, it announced: "We reject the argument that simply by listening to this musical work, the judge could determine that it had no serious artistic value. REVERSED."

MUSIC, COMMERCIAL PARODY, AND THE LAW

The well-known saying "imitation is the sincerest form of flattery" doesn't hold true when it comes to copying music or other forms of intellectual property. But what about the parodies that are so often featured in popular media, such as those seen on "Family Guy," "South Park," "Saturday Night Live," the Haute Diggity Dog's Louis Vuitton–like dog toys, and rapper Ghostface Killah's song "The Forest"? Merriam-Webster defines parody as "a piece of writing, music, etc., that imitates

the style of someone or something else in an amusing way," and producers of commercial parody seek to use such work for entertainment purposes and to reap financial rewards.

For most of America's legal history, commercial parodies have not been protected under the guidelines of "fair use" doctrine, a legal framework that allows for the limited use of others' intellectual property as long as certain requirements are adhered to. But in the past several decades, the federal courts have broadened the definition of "fair use," both in copyright and trademark law, to include commercial parodies that use, but change, protected works in ways that offer political, economic, social, and/or social commentary.

The legal dispute that led to this change in copyright law was the U.S. Supreme Court's *Campbell v. Acuff-Rose, Inc.*, decision in 1994. This copyright infringement case began after the band 2 Live Crew recorded a parody version of "Oh, Pretty Woman," Roy Orbison's 1964 classic hit. The owner of the Orbison song, Acuff-Rose Music, had refused to give the band permission to record its new version, titled "Pretty Woman," because of its sexually offensive, anti-female lyrics. 2 Live Crew recorded the song without permission and was quickly served with papers ordering them to take the recording off the market. The band prevailed in its claim that its use of the song was protected by the fair use doctrine of the Copyright Act of 1976 (17 U.S.C. 107), but lost at the Circuit Court level. In 1994, the U.S. Supreme Court unanimously ruled that commercial parody is legal when it is "transformative," that is, it changes the meaning of the original work in ways that comment on or criticize it in a humorous way. Such uses do not require that the parodist ask permission from the copyright owner.

For parodies to be free from constraint in trademark law, courts have ruled that there must be little likelihood that the public will confuse the two. This rule applies to many kinds of trademarks, including those that are musical in nature. A legal decision that reinforces this rule is the U.S. Court of Appeals Second Circuit's 2007 decision in *Louis Vuitton Malletier S.A. v. Hot Diggity Dog, LLC*. Louis Vuitton markets luxury luggage, leather goods, handbags and accessories across the world, including a line of expensive pet accessories. Hot Diggity Dog sells dog toys and dog beds that parody Vuitton's line of pet collars, leashes, and dog carriers. In defense of its pet accessories, Hot Diggity claimed their products did not violate trademark law because the public would not confuse them with those marketed by Vuitton. The district court agreed, and so did the U.S. Court of Appeals for the Fourth Circuit.

In fact, creative people are restricted from unauthorized uses of unaltered and unattributed aspects of others' works because to do so violates copyright or trademark law unless such uses fall within the boundaries of the fair use doctrine. The rules are complicated, and cases are evaluated individually in light of their facts and court decisions in the copyright or trademark law areas.

Examples of other lawsuits filed to stop the creators of pop culture–related commercial parodies from distributing their work abound. Another example of an influential court decision involved the use by Paramount Pictures of a famous

Annie Leibovitz photograph of actress Demi Moore in its creation of a similar image with the head of actor Leslie Nielsen superimposed over that of a naked pregnant woman. In 1998, the U.S. Court of Appeals for the Second Circuit decided in favor of the movie company in *Leibovitz v. Paramount Pictures Corp* because of its use of humor to transform the photo's original meaning.

BANNED FROM *SATURDAY NIGHT LIVE* (1992)

Although *Saturday Night Live (SNL)* is known for its willingness to flaunt convention and embrace edgy material, its producers are not happy when the acts they book deviate from their expected performances in ways that threaten the bottom line. Occasionally, such deviations have led *SNL* to ban their guests from future appearances. One of the most famous of these incidents took place on October 3, 1992, when Irish singer Sinèad O'Connor used her time onstage to accuse the Roman Catholic Church of covering up cases of the sexual abuse of children. O'Connor started her act by singing an a cappella version of Bob Marley's "War," changing the lyric "racism" to "child abuse." After finishing the song, she held up a photo of Pope John Paul II; sang the word "evil"; tore the photo up, saying, "Fight the real enemy"; and threw the photo's pieces at the TV camera. After O'Connor's statement attracted international attention, including outrage expressed by many Roman Catholics, she was informed by *SNL* that she would never be allowed to appear on the show again.

O'Connor is not the only musician was has been censored by *SNL*. In 1978, musician and singer Elvis Costello stopped in the midst of his agreed-upon song "Less Than Zero" and said, "I'm sorry, ladies and gentlemen, but there's no reason to do this song here," before switching to his song "Radio, Radio." This led SNL to ban him from future appearances, although he was invited back in 1989.

In 1996, the band Rage Against the Machine was cut from two songs to one because of their plans to hang the U.S. flag upside down from their amplifiers to protest the appearance of Republican presidential candidate Steve Forbes. Other musicians and bands banned or otherwise censored by *SNL* have included Frank Zappa, The Replacements, Cypress Hill, and Fear.

THE DIXIE CHICKS AND COUNTRY MUSIC FANS (2003–PRESENT)

In early 2003, the Dixie Chicks, an immensely popular country music group from West Texas, became caught up in a series of events that provided stark evidence that celebrities who voice their opinions on controversial matters of public policy risk losing some of their popularity if they go public with their views. On March 10 of that year, during a concert in the United Kingdom, lead singer Natalie Maines made strong comments about President George W. Bush, who was on the verge of launching a military invasion of Iraq. Maines told her audience, "Just so you know, we're on the good side with y'all. We do not want this war, this violence, and we're ashamed the president of the United States is from Texas."

After the remarks went viral, many country music fans expressed deep anger. In response to this backlash, radio stations refused to play the group's recordings, and protests were organized to publicly destroy Dixie Chicks CDs.

On March 12, Maines released a statement on the group's website that put her comments in a broader context. She wrote:

> We've been overseas for several weeks and have been reading and following the news accounts of our government's position. The anti-American sentiment that has unfolded here is astounding.
>
> I feel the president is ignoring the opinions of many in the U.S. and alienating the rest of the world. . . . My comments were made in frustration and one of the privileges of being an American is you are free to voice your own point of view. . . . While we support our troops, there is nothing more frightening than the notion of going to war with Iraq and the prospect of all the innocent lives that will be lost.

This was followed on March 14 by the following statement:

> As a concerned American citizen, I apologize to President Bush because my remark was disrespectful. I feel that whoever holds that office should be treated with the utmost respect.
>
> We are currently in Europe and witnessing a huge anti-American sentiment as a result of the perceived rush to war. While war may remain a viable option, as a mother, I just want to see every possible alternative exhausted before children and American soldiers' lives are lost. I love my country. I am a proud American.

When the group returned home for the U.S. portion of its tour, concert attendance was down, and metal detectors were used at venue entrances because of threats that had been issued against the band.

> In May of 2006, Maines backtracked on her 2003 apology to Bush. She said, I don't feel that way anymore. I don't feel he is owed any respect whatsoever . . . If people are going to ask me to apologize based on who I am . . . I don't know what to do about that. I can't change who I am.

The band eventually found its way back to success as a chart-topping, award-winning musical group. In 2007, when the Chicks received a Grammy for the album of the year, Maines said, "I think people are using their freedom of speech with all these awards. We get the message." The album they received the Grammy for, *Taking the Long Way*, is considered the band's response to the 2003 controversy. One song in particular, "Not Ready to Make Nice," according to Maines, speaks to their experiences after the controversy erupted.

"AMAZING GRACE" AND FOOTBALL (2016)

The performance of popular music with religious overtones at public school events has occasionally resulted in disagreements over whether the performance of such music constitutes a violation of the First Amendment's religious establishment clause. In July 2016, for example, a dispute erupted in Holton, Alabama, after County Education Board officials announced they would not allow its high school band to perform the hymn "Amazing Grace" at its football games. The Board's announcement stated:

> Our Constitution prohibits us from promoting religion in our educational programs and activities. . . . While we understand the feelings of the parents who are unhappy about the decision, we have an obligation to comply with the law.

The Board decided to ban the hymn after receiving a complaint about the song's association with Christianity. The First Amendment's establishment clause prohibits the government from establishing an official religion and from favoring one religion over another.

Public reactions to the school's banning of the song resulted in a fierce public debate. Kayla Moore, president of the Alabama-based Foundation for Moral Law, issued a statement that was published by the Christian Newswire, in which she wrote, "Singling out religious music for censorship is not religious neutrality, it is religious hostility."

Thousands of others weighed in on the matter in the comments sections of various newspapers' websites. On AL.com, for example, one reader wrote:

> "Amazing Grace" is a beautiful song for funerals and church services, but you all are angry that it's not played at a half-time show? It's called a half-time show because it's entertainment, not a revival.

In contrast, another reader wrote, "Why do the atheists want to shove their religion down our throats? I don't wish to live in their theocracy."

Two days after the county school board announced that the high school band could not perform the hymn, it reversed its stance. The School District Superintendent André Harrison said he changed his mind after hearing from concerned parents and talking to attorneys. He was later quoted by Moody of the Sarasota Herald-Tribune:

> After word of my decision circulated, I heard from many concerned parents, and frankly I still had reservations about my initial decision. I asked counsel to do further research on the issue and present me with options that would keep the district in legal compliance, but permit performance of one of the most iconic songs in the history of our nation.

FURTHER READING

Bertrand, Michael (2000). *Race, Rock, and Elvis*. Urbana: University of Illinois Press.

Cateforis, Theo (2013). *The Rock History Reader*. New York: Routledge.

First Amendment Center (2001). *Free Speech and Music: A Teacher's Guide to Freedom Sings*. Nashville, TN: Author.

Gore, Tipper (1987). *Raising PG Kids in an X-Rated Society*. Nashville, TN: Abington Press.

Hanson, Alan (2011). "Elvis Presley Endured Criticism from Religious Leaders in 1950s," Elvis History Blog, February, http://www.elvis-history-blog.com/elvis-religious-criticism.html.

Hrynkiw, Ivana (2016). "Superintendent Reverses Decision" AL.com, July 24, http://www.al.com/news/montgomery/index.ssf/2016/07/superintendent_reverses_decisi.html.

"Marching Through Georgia," and "Resolution Against Hate Song" (1917). *Confederate Veteran*, September.

Marsh, Dave (1989). *The Heart of Rock and Soul*. Boston: Da Capxo Press.

Martin, Linda, and Kerry Segrave (1993). *Anti-Rock: The Opposition to Rock 'n' Roll*. Hamden, CT: Da Capo Press.

Moody, Nekesa Mumbi (2007). "Dixie Chicks lead Grammys with 5 awards." *Sarasota Herald-Tribune*, February 12.

Nuzum, Eric (2001). *Parental Advisory: Music Censorship in America*. New York: Perennial.

Roberts, Michael (2010). "A Working-Class Hero Is Something to Be: The American Musicians' Unions' Attempt to Ban the Beatles." *Popular Music*, 29(1): 1–16.

Sanjek, Russell (1988). *American Popular Music and Its Business: The First Four Hundred Years, Volume III: From 1900 to 1984*. New York: Oxford University Press.

Street, John (2012). *Music and Politics*. Cambridge: Polity Press.

Vaillancourt, Eric (2011). "Rock 'n' Roll in the 1950s: Rockin' for Civil Rights," master's thesis, The College at Brockport: State University of New York, http://digitalcommons.brockport.edu/cgi/viewcontent.cgi?article=1118&context=ehd_theses.

FIVE

The Visual Arts

INTRODUCTION

When exploring the history of freedom of expression in the world of the arts, one should begin by addressing the question: What is art? The *Oxford English Dictionary* defines it as "the expression or application of human creative skill and imagination, typically in a visual form such as painting or sculpture, producing works to be appreciated primarily for their beauty or emotional power." But art is so subjective. Must all works of art be beautiful? Uplifting? Understandable? Because our purpose is to explore the relationship between art and freedom, Andy Warhol's perspective—that art is "anything you can get away with"—is apropos. Indeed, throughout history, art has generated controversy.

The First Amendment refers specifically to the freedoms of speech and the press, but in fact has always been understood to encompass a wide range of artistic expression. Today, the visual arts enjoy considerable protection from censorship, although the line between protected and censurable art has always been difficult to discern. Differences in personal values complicate discussions of art, as do the social, political, and cultural environments that surround it. In only a second, unexpected events can transform once tolerable works of art into unacceptable ones, and artists into pariahs. After the terrorist attacks of September 11, 2001, on U.S. soil, for example, the perspectives of Americans on art that deals with terrorism, national security, and other related topics were transformed.

The U.S. Supreme Court has ruled that the First Amendment protects all art from government censorship except that which is obscene, libelous, poses an immediate threat of violence, or endangers the nation's security in times of war. In addition, government officials may impose "time, place, and manner" restrictions on the exhibition of art, although such strictures must adhere to certain rules. One of the most important things government officials and legislators must remember

is that such rules must be content neutral. Thus, staff and board members of publicly funded federal, state, or local art museums or other government facilities must be careful not to attempt to censor works of art simply because they don't like their subject matter or themes. In contrast, owners of private art collections, galleries, or museums are not bound by such rules.

As the events discussed below demonstrate, history has transformed art from a relatively exclusive field into a more diverse and essential component of popular culture. Along the way, clashes over art's themes and topics, aesthetic qualities, and suitability for all audiences have increased in number and intensity. Today's assaults on the arts include challenges to public art programs that sometimes lead to funding cuts, calls for removal of individual works of art from galleries or other spaces, boycott campaigns, efforts to block access to artworks, attempts to remove art from public schools, and legislative efforts to restrict artistic expression, among other things.

Some contemporary artists respond to the imposition of censorship by agreeing to change their work of art in ways that render them acceptable. Some respond by creating new works of art that embody messages of protest against assaults on their artistic freedom. Still others challenge censors' actions against their work by seeking a redress of their grievances through constitutionally based lawsuits. At times, artists and the other plaintiffs involved in art-related lawsuits gain the support of organizations devoted to protecting the arts from censors. The National Coalition Against Censorship and the American Civil Liberties Union, among others, are known for their support of Americans' artistic freedom.

THE GREEK SLAVE CONTROVERSY (1840s–1850s)

Victorian values stressing a strict brand of straight-laced morality dominated American social life during much of the 19th century. The advocates of such standards were loud in their opposition to prostitution, gambling, promiscuity, alcohol, and any art or literature that portrayed nudity or contained references to sex. Many others, in contrast, appreciated the artistic and literary depictions considered so dangerous by these critics.

A demonstration of the clash of such cultural values is seen in Americans' reactions to a series of exhibitions from 1847 to the mid-1850s featuring Hiram Power's famous sculpture *The Greek Slave*. This showing of Power's work was a landmark event in the history of art because it was the first exhibit of an American-made nude sculpture in the country. Thousands flocked to view Power's full-scale marble rendering of a voluptuous nude young woman, bound in chains, for sale in a Levantine slave market. She is portrayed holding a small cross on a chain, with a robe draped along her right side. Some visitors drew parallels between *The Greek Slave* and the slaves currently working on plantations in the American south, and advocates of women's rights considered the statue a symbol of man's oppression of women.

Many considered the statue a masterpiece. Reflecting on its exhibition in Milwaukee, the author of a November 7, 1850, comment in the *Daily Sentinel* stated:

> This beautiful statue was visited, yesterday, by many of our citizens, and seen by none with other feelings than those of unmixed admiration. It is a noble production of a noble art; the work, too, be it remembered, of a Native Artist. Let it be borne in mind that the Statue will remain here but two days longer. We would not have it leave Milwaukee without being seen by every one of our citizens who can appreciate what is beautiful in Art, or who take a just pride in the achievements of an American Sculptor.

The statue's nudity led some to raise their voices in the press and pulpit. However, in the April 1976 issue of *Art Journal*, art scholar Linda Hyman argued that the public overlooked such scruples by imbuing the young woman with "a lofty purity, a saintly spirituality, and a heart of gold." In doing so, people were supposedly able to overlook her nakedness. Steps were taken, however, to offer special viewing hours for both sexes, and other times were reserved for men only.

DIEGO RIVERA'S *MAN AT THE CROSSROADS* MURAL (1933)

On numerous occasions, tensions over international politics and fears concerning the spread of political ideologies have led to censorship of the visual arts. In 1933, in the midst of America's strong backlash against Communism and the Soviet Union, the famous Mexican painter Diego Rivera was commissioned by Nelson Rockefeller to paint a set of three murals for installation in New York City's Rockefeller Center. Titled *Man at the Crossroads Looking with Hope and High Vision to the Choosing of a New and Better Future*, Rockefeller hoped the paintings would make people ponder the current state of their lives and the world around them. But Rivera, who, despite being formally expelled from the Communist Party in 1929, still held strong beliefs about capitalist oppression of the working class and ethnic minorities, decided to add politically explosive elements to the project. The center mural would be named *Man at the Cross Roads*, and was intended to contrast capitalism and socialism. The two flanking murals were named *The Frontier of Material Development* and *The Frontier of Ethical Evolution*, respectively.

When Rockefeller learned that Diego's murals were to include a portrait of Vladimir Lenin and a rendition of a Soviet Russian May Day parade, he ordered them destroyed even before they were completed. Protests were heard from artists and others who condemned Rockefeller's decision as censorship, but they were ignored. Only black and white photographs exist of the original incomplete murals. Using the photographs, Rivera repainted the composition in Mexico under the name *Man, Controller of the Universe*.

The destruction of the Rivera murals inspired other artists and writers to create works about the event. In 1933, American poets Archibald MacLeish and

Mexican painter Diego Rivera seated in front of his mural-in-progress depicting American "class struggle," 1933. The mural, "Man at the Crossroads," created in New York's Rockefeller Center, was eventually destroyed because Rivera refused to remove the portrait of Vladimir Lenin he had included in the painting. (Library of Congress)

E .B. White published poems about the incident. MacLeish's poem is titled "Frescoes for Mr. Rockefeller's City," and White composed "I Paint What I See: A Ballad of Artistic Integrity." American filmmakers have also been inspired by Rockefeller's destruction of the murals. Among the films that tell the story behind the removal of River's paintings are *Cradle Will Rock* and *Frida*.

ARSHILE GORKY'S LOST NEWARK AIRPORT MURALS (1936–1937)

Art financed by government funds, widely known as public art, is often subject to special scrutiny because of its reliance on taxpayer monies. Defenders of such scrutiny say that art that does not reflect the values of the majority of taxpayers should not receive such financial support. But many artists and their allies assert that imposing such conditions hinders artistic freedom of expression and amounts to a kind of invisible censorship.

During the Great Depression, some of the nearly 10,000 works of art created by out-of-work artists under the auspices of the government-sponsored Federal Art

Project became the subject of fierce criticism. Not only is public art often considered an expensive luxury that the government can ill afford to spend money on during times of economic duress, but the topics and themes of public art have stirred adverse reactions for being too radical or otherwise objectionable.

One artist whose work was censored in the 1930s was Arshile Gorky, a painter who today is considered one of the 20th century's leading masters of modernism. In 1936, Gorky was commissioned by the Federal Art Project to create a group of 10 painted murals to be installed at the Newark (New Jersey) Airport. Gorky named the group of murals *Evolution of Forms under Aerodynamic Limitations*. Before he finished the exhibit, a single panel was put on display at the Newark Museum. Gorky used a photograph of an airplane to compose the mural, which portrayed an abstract portrayal of its elements. On December 13, 1936, a *New York Times* reporter wrote that Gorky was seeking to create the mood of flying, and "the use of this method has led to much diversity of opinion on the part of visitors to the museum." A month later, the *New York Times* once again turned its attention to Gorky's work and that of other artists funded by the government. According to Edward Alden Jewell, "From the taxpayer's point of view, these projects have been alike championed and condemned. They have been thought constructive and ill-advised."

A short time later, the murals disappeared. Although there is little evidence of what happened to the murals, it was suspected that U.S. Army Air Corps officials authorized workers to cover the paintings up with approximately 14 coats of paint. The whereabouts of the paintings remained a mystery until two of them were discovered and restored in the early 1970s. The Newark Museum, which stores the paintings, displayed them in an extensive Gorky exhibition that opened in 1978.

DEBATING FEDERAL FUNDING FOR THE ARTS (1980s–1990s)

In the late 1980s and 1990s, a number of artists who had received federal funds to support their art were notified that their awards had been revoked because of the offensive nature of their work. The first was Karen Finley, a feminist performance artist whose 1990 performance art production, titled *The Chocolate Smearing Incident*, was belittled by journalists Robert Novak and Rowland Evans. As Finley performed the series of monologues that made up the show, she smeared chocolate on her body to raise awareness about male violence against women. After the National Endowment for the Arts (NEA) responded by revoking Finley's grant, she challenged the government's "decency in art" standard as a violation of the First Amendment. In 1998, the U.S. Supreme Court ruled against Finley in a case titled *National Endowment for the Arts v. Finley*. Finley argued that the government's standard was so vague that it was facially invalid and therefore should be struck down. The court disagreed, contending that the rule was not an unconstitutional content-based rule. In response to her defeat, Finley performed a work she titled *Return of the Chocolate Smeared Woman*.

Artists and photographers Robert Mapplethorpe and Andrew Serrano also lost their NEA funding in this era of heightened sensitivity to art of a controversial

nature. Mapplethorpe's black and white photographs embody homoerotic and sadomasochistic themes that members of Congress and conservative and religious organizations found unacceptable. When a collection of his work titled *The Perfect Moment* was scheduled for exhibition in 1989 at the Corcoran Gallery of Art in Washington, D.C., Mapplethorpe's critics challenged the government's support for art they considered obscene. The Corcoran eventually cancelled the show, and this triggered a national debate over whether federal funds should be used to support the arts.

Andrew Serrano's NEA funding was also threatened by members of Congress and other offended Americans. The work that prompted the loudest objections was a photograph titled *Piss Christ*, which portrays a plastic crucifix of Christ submerged in what the artist said was a glass of his own urine.

RICHARD SERRA'S *TILTED ARC* (1980s)

In the early 1980s, a public dispute, culminating in a series of legal clashes, arose in New York City over the installation of a publically funded sculpture erected in the middle of Federal Plaza by artist Richard Serra, one of the period's leading minimalist sculptors. Named *Tilted Arc*, the piece was commissioned in 1979 by the federal government under the auspices of the General Services Administration's (GSA) Art in Architecture program. Serra was paid $175,000 to create the work, which was erected on a plaza in front of a new addition to the Javits Federal Building in lower Manhattan. Criticism of the sculpture quickly developed among nearby office workers, who claimed that the 120-by-12-foot piece of curved steel was an eyesore that severely disrupted local foot traffic. Within a few months of its installation, more than a thousand people had signed a petition demanding its removal.

Over the next few years, as pressure to remove the *Tilted Arc* grew, public hearings were held, and well-known artists and public officials joined the ranks of groups on both sides of the issue. Serra argued that the sculpture was a site-specific work, and to relocate it would destroy its integrity. The artist had the support of many artists, art historians, and other influential people. On the other side were thousands of local office workers, politicians, and judges, among others.

Complicating the situation was the fact that public money was used to finance the *Tilted Arc*. The GSA's Art in Architecture Program mandated that when government funds were used to erect new buildings, a portion of the funds allocated for their construction would be used to commission the installation of new works of art nearby. Addressing this issue, *New Yorker* art critic Calvin Tomkins claimed, "I think it perfectly legitimate to question whether public spaces and public funds are the right context for work that appeals to so few people—no matter how far it advances the concept of sculpture."

In 1985, a federal court ruled against Serra, arguing that because the GSA owned the work, no one could prevent them from changing or dismantling it. In addition, the court recognized that nothing in Serra's contract guaranteed that the sculpture could not be removed and that the public's demands for such had more power than

his free speech rights. In response, Serra filed an appeal and a $30 million lawsuit. He claimed that by removing the work, the GSA had breached their contract, violated trademark and copyright laws, and violated his First Amendment rights. None of Serra's arguments prevailed, and in 1989, *Tilted Arc* was dismantled and put into storage. After the decision, Serra commented that the case's outcome demonstrates the court system's preference toward capitalistic property rights over democratic freedom of expression.

SCOTT TYLER'S *WHAT IS THE PROPER WAY TO DISPLAY AN AMERICAN FLAG?* (1989)

The desecration of the American flag has long been a sensitive topic in the United States, especially among military veterans who have risked their lives to defend it, along with many people in the community at large. By the late 1800s, state legislatures across the nation had begun to enact state flag desecration statutes to punish actions their members perceived as intolerable insults to the nation's flag, and in 1942, the U.S. Congress adopted the nation's first federal flag desecration law. Since then, many disputes over flag desecration have arisen, and another chapter in this saga was opened in March of 1989, when a work of art created by Scott Tyler, a 24-year-old Chicago Institute of Arts student, was included in one of the school's shows. *What is the Proper Way to Display a Flag?* involved the placement of an American flag on the gallery floor beneath photographs that showed flag-draped coffins and flag burnings. Critics argued that the flag was placed on the floor in such a way that it invited visitors to walk on it, and thousands of protesters arrived at the Institute to express their outrage.

News of the exhibit quickly reached Washington, D.C., where many leaders expressed shock at the impropriety of Tyler's work of art. President George H.W. Bush called Tyler's art "disgraceful." U.S. Senator Bob Dole of Kansas, himself a veteran, introduced legislation that passed 97–0 that amended federal law so that it would become a crime to display an American flag on the floor or on the ground. The Indiana and Illinois legislatures condemned the work, the Chicago City Council adopted an ordinance forbidding flag mutilation or defacement, and there were demands for the resignations of Art Institute board members.

Some of the visitors who viewed the exhibit commented on Tyler's work in notebooks he provided for them to record their thoughts. In March 1989, William A. Schmidt offered a sampling of these comments in the *New York Times*. "Shame!" wrote one visitor, and another said, "I protested the war in the late 60s. I never thought I'd side with the veterans."

Institute leaders defended Tyler's work, however, and expressed concern about the fierce reactions of officials, veterans, and the others who were so quick to condemn it. As Schmidt noted, Tony Jones, the Institute's president, asserted that it was "the responsibility of institutions like ours to protect art, no matter how controversial, charming or soporific."

Huge groups of angry military veterans opposed to Tyler's installation began a series of on-site protests that lasted until the show was officially closed. When some of the veterans sought through legal means to remove Tyler's piece from the exhibit, a Cook County Circuit Court refused, arguing that it was as much "an invitation to think as to act."

Ironically, a work similar to Tyler's was included in a student exhibition at the California Institute of the Arts, in Valencia, early in March 1989. The *Los Angeles Times* reported on March 7, 1989, that veterans arrived at the exhibit to protest shortly after two unidentified men walked into the facility and removed the flag. The artist, Adam Green, said, "It's a sad state of affairs. It is, at its best, inane."

On June 21, 1989, a few months after these incidents, the U.S. Supreme Court struck down a State of Texas statute that made it a crime to "desecrate" or otherwise "mistreat" the flag in a way the "actors knows will seriously offend one or more persons." According to the 5–4 majority decision in *Texas v. Johnson*, flag burning constituted an act of "symbolic speech" protected by the First Amendment.

GUERILLA GIRL CLAIMS OF DE FACTO CENSORSHIP (1980s–PRESENT)

Individuals and groups occasionally challenge the curators of America's art museums to be more open to collecting and exhibiting the work of artists they believe have been overlooked. Since the 1980s, this has been the agenda of a group of female artists who call themselves the Guerilla Girls. Choosing to remain anonymous, they captured the attention of museum officials and the public at large through protest gatherings and the distribution of "in-your-face" billboards, stickers, and posters. One of their most successful strategies is to appear at protest gatherings wearing gorilla masks. The group has also published a book titled *The Guerilla Girls' Bedside Companion to the History of Art*, which reiterates members' belief that the mainstream art community is both sexist and racist.

One of the group's best-known protests took place in the late 1980s in New York City. Through posters and billboards, they waged battle against the Metropolitan Museum of Art, which they complained has been neglectful of the work of female artists. Their posters asked, "Do women have to be naked to get into the Met. Museum?"

The Guerilla Girls have launched protests all over the country since then. In 2016, for example, they started a "Twin Cities Takeover" campaign in Minneapolis-St. Paul. The group's website described their plans for the Minnesota communities.

The Guerilla Girls—infamous for exposing sexism, racism and corruption in the art world, are taking over the Twin Cities. In 2016, watch public art by and inspired by the Guerilla Girls pop up across the Minneapolis/St. Paul metro area and beyond, and get wild with these masked avengers at community events. Raise your voice (and a furry fist) for equality!

GRAN FURY'S "KISSING DOESN'T KILL" CAMPAIGN (1989)

The average person in Western society is bombarded with hundreds of adver-
tisements each day, in newspapers, magazines, commercials, billboards, film trailers,
product placements, and more. Although their primary purpose is to sell prod-
ucts and services, they also teach us about popular culture, and in some cases they
themselves become pop icons. America's annual NFL Super Bowl commercials are
an institution with impact that goes far beyond the products they promote, and it
would be difficult to find Americans unfamiliar with the ad slogans "Can You Hear
Me Now?" or "Where's the Beef?"

Advertising's impact at times leads to controversy, particularly when ads promote
ideas that a large number of people aren't comfortable with. This is what happened
in 1989, when Gran Fury, a collective of graphic designers and other communica-
tion professionals with a self-described mission to change the way people think
about AIDS, launched an ad campaign titled "Kissing Doesn't Tell: Greed and
Indifference Do." Gran Fury was the propaganda branch of ACT UP (the AIDS
Coalition to Upset Power). Its goal was to create ads that would shock people into
coming to grips with the AIDS crisis, which they believed was spreading faster than
it would if people were more knowledgeable about it.

The campaign included posters and billboards with images of same-sex couples
kissing, along with the statements "Kissing Doesn't Tell: Greed and Indifference Do"
and "Corporate Greed, Government Inaction, and Public Indifference Made AIDS a
Political Crisis." Because Gran Fury didn't want to offend one of its funders, it pulled
the taglines out of any images that ran outside of New York City. The publicity gener-
ated by the campaign, the debate it triggered, and the group's response to the criti-
cism it was confronted with likely helped Gran Fury and ACT UP reach more people.

SENSATION EXHIBIT RAISES QUESTIONS CONCERNING MUSEUM FUNDING (1999)

Museums funded by taxpayer dollars have at times sponsored public programs
so offensive to some community members that calls for cutting their operating
budgets have been heard. This happened to the Brooklyn Museum of Art in 1999,
when the city threatened to cut its budget and evict it from its facility after it opened
the exhibit *Sensation*. One of the exhibit's most shocking works of art was Chris
Ofili's *The Holy Virgin Mary*. The piece portrayed an image of the Virgin Mary
smeared with elephant dung amidst images of female genitalia clipped from
pornographic magazines. Another controversial work of art in the show was a
13-foot-high image of a vicious British child killer, created with the shapes of
children's handprints. The museum warned visitors about the exhibit in advance,
issuing a yellow warning stamp that spoke of its contents. It said the display "may
cause shock, vomiting, confusion, panic, euphoria and anxiety."

When New York City Mayor Rudy Giuliani learned of the exhibit, he called it
"sick stuff" and threatened to withdraw $7 million of the museum's annual funds.

This led to a confrontation between the mayor, museum officials, and citizens who demanded that the city not be allowed to cut the museum's funds. At a rally in support of the museum, hundreds of demonstrators carried signs complaining about Giuliani's lack of respect for the First Amendment. Lawsuits were filed on both sides, and on November 1, 1999, a federal court ordered the City to restore the funding and terminate its eviction action.

In December, a visitor to the exhibit defaced Ofili's piece by smearing it with white paint. In response, the museum took steps to protect Ofili's painting by showing it behind a Plexiglas screen.

The Holy Virgin Mary was scheduled to travel to Australia for an exhibition in 2000, but it was cancelled after the U.S. controversy erupted. In 2015, it sold at auction for $4.6 million.

CONTROVERSY ERUPTS OVER PHOTOGRAPHY OF NUDE CHILDREN (1990s)

Debates over whether photography is art have been raging for generations. But one thing that has never been in doubt is the communication medium's popularity. What fascinates people about photography is how it allows them to view the world through a variety of lenses. At times, however, the contents of photographs have been so troubling that demands for their censorship have been raised. Public outrage over child pornography has led most of America's state legislatures to pass laws that have made the activity one of the most heavily punished offenses in the realm of criminal law.

But what about photographs of scantily attired or nude children created by photographers who claim such images are art rather than pornography? In 1997, a dispute arose in the United States over a decision by Barnes & Noble to stock several books that include photos of nude children. One of the books, *The Age of Innocence*, includes photos of nude children taken by French photographer David Hamilton. But the most controversial books stocked by the bookstore chain included the photographs of Jock Sturges, a San Francisco native notorious for his images of nudist families. When word spread that Barnes & Noble was carrying Sturges's book, calls for removal of the title from the chain's bookshelves were heard across the country. Particularly scrutinized were *Radiant Identities* (1994) and *The Last Day of Summer* (1991), books that include images of nude adolescents. Conservative Christians and many other Americans, including broadcasters sympathetic to conservative causes, urged concerned citizens to pressure Barnes & Noble to take such books off their shelves, and encouraged them to go to stores to rip them up.

In response to the Barnes & Noble controversy, an Alabama grand jury indicted the company in February 1998 on felony obscenity charges. Under the mantle of the First Amendment, its owners refused to remove Sturges's books. That spring, charges were dropped when the chain's owners agreed to keep books with nude photographs of children out of the reach of kids. A similar unsuccessful attempt to

outlaw Sturges's books was initiated by the State of Tennessee. Sturges was used to such treatment, for in 1990, Federal Bureau of Investigation agents had raided his San Francisco studio and confiscated his equipment.

Sturges and Hamilton are not the only photographers whose images of children have led to public concern. American photographer Sally Mann's 1992 book *Immediate Family* upset many because it includes naked photographs of her children. Mann's critics question her decision to photograph everyday moments of her children when they were naked or injured. On March 29, 1989, the *San Diego Tribune* published a review of her work under the title, "It May Be Art, but What About the *Kids*?" In a discussion of her photos, in *Hold Still: A Memoir with Photographs*, Mann wrote, "I never thought of them as being sexual; I thought of them as being simply, miraculously and sensuously beautiful."

UPROAR OVER RODIN SCULPTURES AT BRIGHAM YOUNG UNIVERSITY (1997)

In 1997, administrators at Brigham Young University (BYU), in Provo, Utah, scheduled the exhibition of a collection of sculptures by famous French sculptor Auguste Rodin at its art museum. For several months before *The Hands of Rodin* was set to arrive, university and museum leaders wondered whether all of its contents were suitable for exhibition at BYU, which is owned and operated by The Church of Jesus Christ of Latter-day Saints. Approximately 99 percent of BYU's students are members of the LDS Church. Troubling administrators and art curators were four sculptures that portrayed nudity. Among them is one of the artist's most widely known and revered pieces, *The Kiss*. After lengthy discussions, the university announced that the four works would not be included in the show because officials believed they would disrupt the exhibit and offend some viewers.

To protest the museum's decision, groups of BYU students gathered in front of the university's administration building with signs that read "We Can Protect Ourselves" and "Would We Have to Put Shorts on (Michelangelo's) David?" They marched around the area chanting, "Don't ban Rodin." As the *Deseret News* reported, one student said, "I think the administrators should allow us to see the classics of art. Nobody has ever been offended by a piece by Rodin, that I know of."

Art experts across the nation weighed in on the university's exclusion of the four sculptures. Clare Vincent, associate curator for European Sculpture at the New York Metropolitan Museum of Art, expressed surprise at the decision, according to journalist Dan Egan. "I wouldn't have thought . . . [*The Kiss*] was still very controversial. There are a great many things that are more shocking on television."

CENSORSHIP AT FOLEY'S DEPARTMENT STORE (2000)

In March 2000, Foley's Department Store, in Houston, Texas, invited photographic artist Bill Thomas to display a collection of his images in the window of its

downtown store. The installation, which Thomas named *Today's Special*, commemorated the 1960s African American sit-in protests that led to the integration of the city's lunch counters. One of the photos, *Racial Tensions*, features two men, one black and the other white, wearing nooses around their necks that are attached to a beam above them and standing on the ends of a see-saw.

After a group of Foley's African American employees complained about the image that included the noose, store CEO Tom Hogan ordered its removal. This led to a discussion between Hogan and a group of African American community members who hoped the photo would remain on exhibit. After Hogan announced that he would not change his mind about its removal, according to the National Coalition Against Censorship's newsletter, Thomas commented, "I'm beginning to think that the notion is growing that the right of objections transcends the right of expression."

Although Foley's was under no obligation to display the photos or leave the one that was most offensive to its employees in place, Foley's critics see the removal of the image as a lack of willingness to confront the painful realities of the city's troubled racial history. Thomas later reinstalled the exhibit at Houston's Vine Street Galleries.

THE BOONDOCKS: COMIC ART UNDER SCRUTINY (2000s)

The American comic strip *The Boondocks*, which first appeared in 1996, made its national debut in April of 1999. The strip drew a lot of attention, and not all of it was positive. Its fans appreciated its scathing brand of political and racial satire, while its critics thought its creator, Aaron McGruder, sometimes went too far. The 9/11 attack inspired him, for example, to create strips that referenced people and the event in ways that some found troublesome. On September 25, McGruder referred to New York City's mayor as "President Giuliani." Admirers of Giuliani's conduct in the attack's aftermath did not appreciate McGruder's implied criticism of the leader as paranoid.

This episode in the history of American comic strips reminds us that comic strips are one of the most popular, but potentially controversial, forms of visual art in today's world. Not only are they meant to be funny, but provocative. As Charles M. Schulz, the creator of *Peanuts*, said, "Cartooning is preaching. And I think we have a right to do some preaching. I hate shallow humor. I hate shallow religious humor, I hate shallow sports humor, I hate shallowness of any kind."

The Boondocks, which ran until 2006, tells the story of young, black radical Huey Freeman and his brother Riley. The strip opens just after the brothers had moved from the South Side of Chicago to a fictional white east coast suburb. Huey, named after radical Black Panther leader Huey Newton, is critical of many aspects of African American culture as well as of the Bush Administration and other political entities. His grandfather, Robert, is a World War II veteran and civil rights activist with little tolerance for Huey's views. The strip's outspoken perspective subjected it to such harsh criticism that the publishers of some newspapers refused to include it on several occasions. In addition, some newspaper publishers decided to move

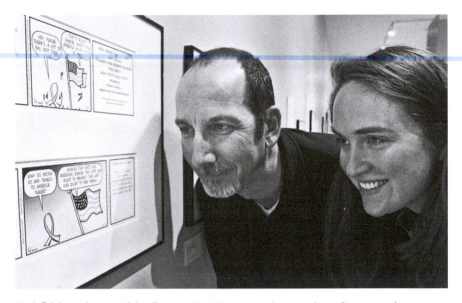

Rod Gilchrist, director of the Cartoon Art Museum, and curator Jenny Dietzen read a cartoon strip from *The Boondocks* by artist Aaron McGruder, in San Francisco, February 25, 2003. The strip was part of an exhibit at the museum called "Hate Mail: Comic Strip Controversies" that looked at how newspapers, artists, and readers have dealt with controversial subjects in the funny papers. (AP Photo/Ben Margot)

the strip to their papers' op-ed sections or pull any strips that would likely generate controversy.

The Boondocks is but one of a number of controversial comic strips. Comics were first published in the United States during the waning years of the 19th century. Because of the accessibility of comic strips to young people, most of their publishers warned their creators to refrain from including in them certain words and images considered unsuitable. In the late 1940s, as fears of the spread of communism grew, publishers of comic strips sought to avoid the attention of Congressional committees bent on eliminating threats to the country's security. In 1947, Scripps-Howard censored *Li'l Abner* because of the way it portrayed U.S. Senators in a negative light. In a September 29, 1947, *Time* magazine article, Scripps-Howard executive Edward Leech was quoted as saying, "We don't think it good editing or sound citizenship to picture the Senate as an assemblage of freaks and kooks . . . boobs and undesirables."

The Boondocks became an animated television sitcom that ran from 2005 to 2014. Its producers returned to the 9/11 controversy in the episode "The Garden Party" with the line, "Jesus is Black, Reagan was the devil, and the government is lying about 9/11."

GRAFFITI ART BLU CLASHES WITH A RENOWNED ART MUSEUM DIRECTOR (2011)

Street art is produced by artists who use the sides of buildings, fences, and other nontraditional art venues as canvases for their creations. Art historians have documented the roots of today's street art movement in the graffiti of mid-20th century New York City gang members and the work of others with a penchant for this form of expression. In the 1970s and 1980s, in reaction to the time's unsettling sociopolitical environment, young people across the nation started a new chapter in the movement. Eventually, examples of these illegal works of art found their ways into galleries and the broader art market. Although not everyone appreciates street art, many art enthusiasts and professionals believe it has earned a place in the contemporary art world.

Reactions to street art have varied from condemnation to acclaim. An example of street artist censorship took place in Los Angeles in 2010–2011. Blu, an internationally known Italian street artist, was invited by Jeffrey Deitch, the director of the Los Angeles Museum of Contemporary Art (MOCA) to paint a mural on the Geffen Contemporary building as part of the *Art in the Streets* exhibit about graffiti. Blu painted a scene of coffins draped in one-dollar bills to express his antiwar sentiments. Deitch, however, considered the mural inappropriate because it faced a Veterans Administration Hospital as well as a public monument honoring World War II Japanese-American soldiers. Within 24 hours, Deitch's order to whitewash Blu's mural had been carried out.

What happened reveals the power of anti-censorship activism within the street art community. On December 16, a group that named itself LA Anonymous displayed an anti-Deitch/MOCA poster a few blocks away from the original mural. The poster's image spread virally on the Internet when the *LA Times* published it the following day.

On January 3, 2011, a group of about 20 street and graffiti artists and war veterans gathered in the MOCA's parking lot to stage a guerrilla protest performance against Deitch. Their activities included projecting laser graffiti out of the back seat of a car with a laptop perched on its roof. The light show finished with the projection of Blu's mural, along with the word "censorship," back onto the wall of the Geffen building. Those involved in the activities formed the group LA RAW for the purpose of standing up for freedom of expression and voicing opposition to militarism and war. They also distributed "Deitch condoms" that included the phrase "Don't Be Blue, Practice Safe Art."

AIDS-RELATED ART EXHIBIT THREATENS STATE FUNDING FOR PUBLIC UNIVERSITIES (2016)

The first major art exhibit to examine the impact and ongoing influence of the AIDS crisis on American art and culture opened in early 2016 at the Zuckerman Museum of Art at Kennesaw State University. When word of the contents of *Art*

AIDS America reached state lawmakers, there was an immediate reaction. According to Georgia State Legislature members Earl Ehrhart, Lindsey Tippins, and Ed Setzler, the exhibit is so disgusting and blatantly political that its state funds should be cut. They are particularly offended by the painting *Bozo Fucks Death*, by Jerome Caja (1958–1995), and a work titled *Sweet Williams*, by Kennesaw professor Robert Sherer, that is made with HIV- and AIDS-tainted blood.

The three legislators recommend that state university staff seeking government funds for their art exhibits be forced to submit their exhibit plans for preapproval before any funds will be awarded. If this review system were put in place, it would likely be castigated as an illegal form of prior restraint that interferes with the First Amendment rights of state university students and personnel.

CENSORSHIP OF THE VISUAL ARTS
IN AMERICAN PUBLIC SCHOOLS

Although paintings, sculptures, prints, photographs, drawings, and all other kinds of visual arts are generally considered to be protected speech under the First Amendment, an exception to this rule involves American public schools. On many occasions, public school officials have imposed restrictions on the display of certain works of art and have expelled students and fired school personnel. Many who have protested such actions have based their arguments on a 1967 U.S. Supreme Court decision titled *Keyishian v. Board of Regents*. The author of the majority opinion in this case, Justice William Brennan, wrote:

> Our nation is deeply committed to safeguarding academic freedom, which is of transcendent value to all of us and not merely to the teachers concerned. That freedom is therefore a special concern of the First Amendment, which does not tolerate laws that cast a pall of orthodoxy over the classroom.

Despite such support for the academic freedom of public school students and personnel, a number of circumstances have led to their punishments for the creation and/or display of visual art. The rationale for such restrictions has come from concerns that the contents of certain works of art will corrupt or offend students, violate school polices, and/or trigger hostilities between groups of students. Both students and school personnel have been punished for the display of art officials consider problematic, and some of these disputes have led to First Amendment lawsuits. Such disputes also typically generate publicity that affects the reputations of everyone involved.

An example of the kind of cases that have arisen started in 1998, in Derby, Kansas, when a seventh-grade student was suspended from school for three days for drawing a 4-by-6-inch sketch of a Confederate flag during math class. The boy said he knew that the flag violated a "racial harassment and intimidation" policy the school district had adopted after incidents of racial tension a few years before. The

student and his father challenged the suspension, but a federal trial judge and the 10th Circuit Court of Appeals ruled for the school district.

Another case arose in 2003, in Albuquerque, New Mexico, when two teachers and a guidance counselor were suspended without pay for displaying posters, artwork, and other materials embodying opinions about the war in Iraq. One of the teachers, Allen Cooper, had refused to follow the administration's order to remove student-created posters about the war from his classroom. The American Civil Liberties Union defended the teachers, arguing that the schools had violated their rights to freedom of speech and equal protection under the law by censoring their antiwar expressions. The case was settled, with the teachers' rights and records restored. In addition, the schools amended their policies to ensure that their employees are not suspended for exercising their freedom of speech or for defending that of their students.

And in 2016, a photograph of the bare upper back of a female student was removed from an art exhibit displayed in the lobby of Susan Wagner High School in Staten Island, New York. The image was part of an art project designed to raise discussion about rape. Angry students protested the school's action in an online petition that displays the photo. Officials defended their action, arguing that the displayed photo violates the school's dress code and conduct policy, which prohibits girls from displaying thighs, shoulders, and bare backs. In addition, they worried that the photo might be offensive to students because of religious beliefs.

FURTHER READING

Carter, Edward L. (1997). "Students' Protest at BYU Is about more than Rodin," *Deseret News*, October 31.

Cherbo, Joni M., and Margaret J. Wyszomirski, eds. (2000). *The Public Life of Arts in America*. Rutger, NJ: Rutgers University Press.

Childs, Elizabeth C., ed. (1998). *Suspended License: Censorship and the Visual Arts*. Seattle: University of Washington Press.

Clapp, Jane (1972). *Art Censorship: A Chronology of Proscribed and Prescribed Art*. Lanham, MD: Scarecrow Press.

Egan, Dan. (1997). "BYU Won't Display Art of Touring Rodin Exhibit," *Spokesman-Review*, October 29, http://www.spokesman.com/stories/1997/oct/29/byu-wont -display-part-of-touring-rodin-exhibit.

"Events Here and There" (1936). *New York Times*, December 13.

"The Garden Party," *The Boondocks*, season 1, episode 1, directed by Anthony Bell (November 6, 2005; Honchō, Nakano, Tokyo: Madhouse Studio, DVD 2006).

Guerilla Girls. (n.d.). "Go Ape for Change with the Guerilla Girls," *Guerrilla Girls Twin Cities Takeover*, http://www.ggtakeover.com.

Hyman, Linda. (1991). "The Greek Slave by Hiram Powers: High Art as Popular Culture," *Art Journal: Special Issue, Censorship I*, 50 (Fall): 3.

Inge, M. Thomas (2000). *Charles M. Schulz: Conversations*. Jackson: University Press of Mississippi.

"In Texas—Positive Art Brings Negative Response." (2000). *National Coalition Against Censorship Newsletter: Censorship News*, 77 (spring, April 5), http://ncac .org/censorship-article/in-texas-positive-art-brings-negative-response.

Kammen, Michael (2006). *Visual Shock*. United States: First Vintage Book Editions, 241.

Mann, Sally (2015). *Hold Still: A Memoir with Photographs*. Boston: Little, Brown and Company. http://wiki.ncac.org/Today's_Special_(installation).

Schmidt, William E. (1989). "Disputed Exhibit of Flag Is Ended," *New York Times*, March 17.

"The Greek Slave" (1850). *Daily Sentinel*, November 7.

"The Press: Tain't Funny" (1947). *Time*, September 29.

Wallis, Brian, Marianne Weems, and Philip Yenawine, eds. (1999). *Art Matters: How the Culture Wars Changed America*. New York: New York University Press.

Wharton, David (1989). "Uproar 'Round the Flag: Exhibit at CalArts Sparks Dispute, Theft," *Los Angeles Times*, March 7.

SIX

Film

INTRODUCTION

Since it appeared on the scene in the 1890s, film has been one of the most contested forms of communication in the history of popular culture. Film came into being at the dawn of what historians have labeled the Progressive Era. In a speech before the Colorado Legislature, on August 29, 1920, Theodore Roosevelt lauded the liberal reforms that swept across American politics and society during that period, saying that "a great democracy has got to be progressive or it will soon cease to be great or a democracy." History has shown, however, that the era was riddled with strife over politics, immigration, race, ethnicity, economics, and a raft of other disruptive elements. In the midst of all this turbulence and controversy, the movies were especially rattling to those seeking to maintain the nation's stability and to protect its most vulnerable citizens. How could leaders be calm, knowing that audiences were arriving in droves to sit in dark theaters where they might be exposed to all manner of "dangerous" ideas?

The efforts undertaken by newspapers, review boards, lawmakers, religious leaders, and others seeking to have a voice in shaping the contents of movies resulted in protests, arrests, lawsuits, and even violence, among other things. As this set of case studies demonstrates, those seeking to censor film have often been successful in their efforts to "protect" society. Conversely, there have also been many times when advocates of free speech have prevailed. The political, social, and cultural climates in which films are released will continue to have a profound effect on how we perceive and react to them.

PEEP SHOWS AND EARLY PROJECTED FILMS (LATE 19TH CENTURY)

Late in the 19th century, penny arcades, parlors, saloons, and other business establishments featuring wide doors that opened to a city's or town's sidewalks were

considered to be hotbeds for the cultivation and growth of vice. Thomas Edison complicated the situation when, in 1891, he demonstrated his Kinetoscope. A few years later, Winsor McCay made matters worse when he announced he was ready to release a machine he called the Mutoscope. These coin-in-the-slot devices were essentially the same: Through their narrow openings, customers could view "peep shows" consisting of lighted images in motion.

As peep shows opened around the country, word reached police and other authorities that they featured "indecent" material. In August 1894, in San Francisco, Frank B. Gibson of the Society for the Suppression of Vice (a private citizens' group that was actually empowered by officials to arrest people deemed to be in violation of public morals) put Robert Klenck in jail after he didn't pay a $150 fine for displaying an "indecent public exhibition."

According to an article in the *Brooklyn Eagle*, on July 30, 1897, on New York's Coney Island, Reverend Frederick Bruce Russell, president of a local Law and Order Society, closed down several Mutoscope machines. The pictures that brought the action were titled *What the Girls Did with Willie's Hat*, and *Fun in a Boarding School*.

Newspaper writers eager for material to delight their readers often accompanied the police on their raids, and some papers took prominent roles in drumming up public support for shutting down these machines. In late 1899, for example, New York police went after the city's penny arcades in response to a crusade led by the Hearst newspaper syndicate that also involved religious leaders, school authorities, temperance officers, the Salvation Army, and the YMCA, which demanded police action and stronger city ordinances. Police responded by closing down arcades and confiscating their peep show machines and pictures.

These occasional raids failed to derail the public thirst for moving pictures, though, and proprietors of arcades began to add new, more sophisticated, moving picture machines to their array of amusements. The first documented exhibition of a projected motion picture on a wall in the United States took place in Richmond, Indiana, in June 1894. Charles Francis Jenkins organized the event for his family, friends, and a few newspaper reporters he thought might be interested in publicizing the demonstration of his new device. He used his machine, which he called the Phantoscope, to show a film of a vaudeville dancer. A year later, he arranged for several similar exhibitions at the Cotton States Exposition. Eventually, he sold his device to Thomas Edison, who changed its name to Edison's Vitascope. After Edison sold one of his Vitascopes to brothers Mitchel and Moe Mark, they opened what is considered the first permanently located motion picture theater in the world, in the Ellicott Square Building in Buffalo, New York.

Edison's Vitascope became a sensation as word spread that its pictures could be projected on a wall or screen. A writer for the July 6, 1896, *Los Angeles Times* called the machine "Edison's latest and most shining triumph. People turned out in droves to see the Vitascope and the pictures it exhibited. One of the features displayed on Edison's Vitascope, *The Kiss*, attracted as much attention as the machine itself. The 15-second scene showed the first kiss ever displayed on film. One of Edison's

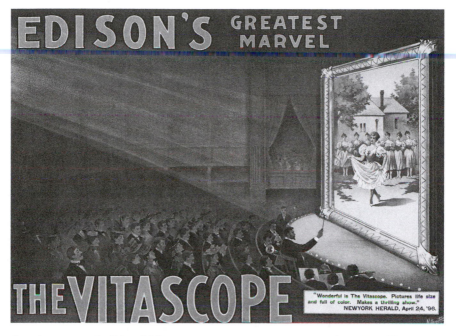

An advertisement for Edison's Vitascope motion picture projection machine, 1896. The Vitascope created quite a sensation among audiences and censors alike with a 15-second film called *The Kiss*, which showed the first on-screen kiss ever. (Library of Congress)

advertisements described the show in the following way: "They get ready to kiss, begin to kiss, and kiss and kiss and kiss in a way that brings down the house every time." Its actors, May Irwin and John Rice, had reenacted the final scene of the stage musical *The Widow Jones*.

As the *The Kiss* delighted audiences, it also prompted calls for censorship from those disturbed by its shocking display of affection. In New Orleans, the author of a letter published on July 28, 1896, in the *Daily Item* complained *The Kiss* should be dropped from the program because it was "too suggestive" and although it "may capture the fancy of the lascivious . . . it is actually repulsive to the clean mind."

MAINE'S ANTI-PRIZEFIGHTING FILM LAW (1897)

Contrary to many accounts about the history of American film censorship, the nation's earliest anti-moving picture law was not enacted to ban motion pictures that depicted sex and crime. Instead, the country's first anti-film statute was passed to stop the exhibition of prizefighting films.

Although prizefighting was illegal in nearly every state and territory of the union in the late 19th century, it was extremely popular. As a result, in the mid-1890s, moving picture entrepreneurs began exploring the possibility of making

prizefighting films to attract customers. In 1894, the Kinetoscope Exhibiting Company was formed to produce eight prizefight films. After its film of the Leonard-Cushing Fight opened to great success, prizefighting films proliferated—and attracted the attention of community leaders and law enforcement officials. Opponents of prizefighting objected to its brutality. In that day, boxers fought without gloves, and the unregulated matches often resulted in injuries, and sometimes death.

On March 20, 1897, the state of Maine passed a law that prohibited the exhibition of prizefight films in the state:

> Any Person exhibiting publicly any photographic or other reproduction of prize fights shall be punished by a fine not exceeding five hundred dollars.

Maine's anti-prizefighting legislation became a model for the enactment of similar laws in Illinois, Minnesota, Massachusetts, New Jersey, New York, and Pennsylvania. In addition, some municipal leaders began to enact anti-prizefighting regulations. On July 26, 1897, the City of Los Angeles approved an ordinance that prohibited the "exhibition of photographic or kinetoscopic pictures or other representations of any prize fight or any fight of similar nature."

Ten years after Maine enacted its anti-prize fight film law, municipalities and state governments began to enact film censorship laws that provided opponents of fight films with a weapon to prevent them from being shown. Prizefighting law scholar Barak Orbach noted in the *Yale Journal of Law and the Humanities*, though, that by 1940 prizefight film censorship had come to an end. By that time, boxing had attained mainstream popularity in many parts of America.

FORMATION OF THE NATIONAL BOARD OF CENSORSHIP (1909)

In December 1908, New York Mayor George McClellan closed the city's nickelodeons, the first type of indoor exhibition space meant to show motion pictures. This gave moving picture exhibitors a bitter taste of what they could expect if they failed to do something to stave off the development of an even tougher regulatory environment. It prodded the budding industry's leaders into the 1909 establishment of the National Board of Censorship (NBC), a body devoted to industry self-censorship as an alternative to stricter government regulations. The People's Institute, which since 1897 had provided the city's working class adults and immigrants with educational programs, was selected to organize the NBC. Its work involved reviewing films to determine whether they were suitable for public consumption. Participation in the program was strictly optional for film companies, however.

The NBC was comprised of leaders representing citizen organizations such as the Women's Municipal League, the Public Education Association, the Federation of Churches, and the League for Political Education, as well as those from the ranks of motion picture exhibitors and manufacturers. Together they decided how the work of the Board should proceed. Both sides agreed, for example, that moving pictures should never feature obscenities or the glorification of crime.

During its first year of operation, the organization's censorship committee started viewing films and issuing statements about their suitability for exhibition. Among their decisions were the rejection of a film for depicting "the criminal passion and rough handling of a white girl by Negroes," as well as films that included infidelity, suicide, and the ill treatment of the insane. In addition to rejecting films altogether, the board's film review committee sometimes called for the elimination of certain sections.

Criticism of the board came from the moving picture industry, progressives who objected to censorship, the general public, and even from within its own ranks. Film manufacturers and exhibitors clashed with the board over its decisions; board members became embroiled in disputes; community members claimed the board was ineffective; and progressives championed the cause of free speech. In 1915, the NBC changed its name to the National Board of Review. In June 1916, representatives of the moving pictures industry met to discuss a strategy for the avoidance of further censorship legislation. Two months later, they formed a new association, the National Association for the Motion Picture Industry (NAMPI). For the next five years, its leaders continued to seek to thwart the government's growing interest in more regulation. Across the nation, though, citizens and community leaders called for stronger film regulations, and in 1921, the state of New York passed such a bill. A year later, NAMPI supported the establishment of the Motion Picture Producers and Distributors Association—the organization that would become known as the Hays Office.

CHICAGO'S FILM CENSORSHIP SYSTEM (1907)

As the 20th century dawned, the motion picture industry was beginning to take shape as a powerful commercial force. As it grew, so did the voices of critics who considered the new medium an increasingly pervasive threat to public morality. Involved in the movement to control the movie industry and its films were government, religious, and other community leaders. Many called on police to censor the movies, and Chicago's elected officials heeded their warnings.

In 1907, Chicago became the first U.S. city to establish a film review system requiring anyone intending to exhibit a motion picture to obtain a permit from the chief of police. If the city's censor denied a permit because of its "immoral or obscene" content, the exhibitor would have to either cut the offensive material out of the film or remove it from the theater altogether.

Critics of Chicago's film review system challenged the regulations in court, but in 1909, both the Illinois Supreme Court and the United States Supreme Court upheld the city's movie censorship system. It became a model for the enactment and enforcement of similar ordinances in approximately 100 other U.S. cities. In addition, some states, including New York, Pennsylvania, Ohio, and Kansas, enacted laws that provided for the establishment of motion picture review boards.

In the 1920s, Chicago replaced its police censors with a commission of citizens. When the U.S. Supreme Court ruled in 1952 that film was eligible for protection

under the First and Fourteenth Amendments, challenges to the authority of the city's film review commission were raised. In 1961, in the U.S. Supreme Court case *Times Film Corp. v. Chicago*, the court said the city's licensing scheme was not a prior restraint on speech, leaving the courts to rule in individual challenges to the city's censorship of films. During the next few years, appellate courts at the state and federal levels consistently rejected efforts around the country to censor films.

THE WOMAN'S CHRISTIAN TEMPERANCE UNION'S ANTI-MOVIE CAMPAIGN (EARLY 20TH CENTURY)

The Woman's Christian Temperance Union's (WCTU) mission went far beyond attempting to rid society of alcohol. In 1887, the members of this well-known national organization formed a department devoted to the promotion of purity in literature and the arts. As movies quickly grew in popularity in the early decades of the 20th century, the WCTU sought to "purify" movies by joining the growing campaign to regulate them.

In 1906, just a year after nickelodeons started opening, the organization began to publish statements about the dangers of movies. Its purity department had noticed an increase in the number of young girls going to the movies, as well as the growing number of theaters opening in the better neighborhoods of a number of cities. The author of an editorial that appeared in the organization's weekly newspaper, *The Union Signal*, issued a dire warning about the impact of movies on audience members.

> Natural modesty receives its first shock. Crime is made "interesting," "romantic," "exciting,"—everything but criminal. Deformities of the human frame are made laughable. Age is represented as a target for youthful scorn and laughter.

In 1914, the WCTU began to lobby aggressively for government regulation of film by supporting the first proposed federal movie censorship law, the Smith-Hughes Picture Censorship Bill. If it had been enacted, the bill would have created a Federal Motion Picture Commission as part of the Bureau of Education. The WCTU approved the bill's stated intention to "censor all films, endorsing the good and condemning those which come under the specification for what is obscene, indecent, immoral, inhuman, or those that depict a bull-fight, or a prize-fight, or that will corrupt or impair the morals of children or incite to crime."

Although the bill failed to receive enough votes to become law, it set the stage for the WCTU's other anti-movie efforts. Throughout the first three decades of the century, among other things, its members sought to convince local lawmakers to regulate movies; produced and distributed films to educate society about their view of the evil effects of film; and tracked the number of children who went to the movies.

MUTUAL FILM CORP. v. INDUSTRIAL COMMISSION OF OHIO (1915)

Two decades after the first peep shows introduced moving pictures, the stage was set for a legal confrontation between the movie industry and the regulatory bodies that had emerged across the nation to monitor the content of films. The battle involved movie producers, exhibitors, film artists, and free speech advocates on one side, and government officials and conservative activists who supported censorship of film on the other. This all came together in 1915, when the U.S. Supreme Court agreed to review a case titled *Mutual Film Corp. v. Industrial Commission of Ohio.* The question the court's nine justices considered was whether the State of Ohio was violating the First Amendment rights of movie distributors through their enforcement of a law that permitted a board of censors to review and approve all films scheduled for exhibition in the state. In addition, the board had the power to arrest anyone who showed an unapproved movie in the state.

The case originated in 1913 after the owners of Mutual Film Corporation were ordered to submit any films they planned to sell or lease for exhibition in Ohio to state censors. At the time, they were distributing an average of 56 prints of films per week to Ohio theater owners. Mutual was warned that its refusal to submit films for review would result in the arrest of anyone involved in their distribution. Because the company was doing a significant amount of business with Ohio film exhibitors, Mutual's owners argued that complying with the order would lead to serious financial losses.

On February 23, 1915, in a unanimous decision, the court announced that the Ohio film censorship board would continue its work on behalf of the state's citizens. It justified its decision by arguing it was "supporting the common sense of this country, [which] sustains the exercise of the police power of regulation of moving picture exhibitions." It further stated:

> The exhibition of moving pictures is a business, pure and simple, originated and conducted for profit like other spectacles, and not to be regarded as part of the press of the country or as organs of public opinion within the meaning of freedom of speech and publication guaranteed by the Constitution of Ohio.

This decision was a landmark in the history of American film. Not until 1952, in *Joseph Burstyn v. Wilson*, would the U.S. Supreme Court change its position on the worthiness of film for First Amendment protection.

D. W. GRIFFITH'S *THE BIRTH OF A NATION* (1915)

On February 8, 1915, the silent film *The Birth of a Nation* was released for exhibition in America's movie houses. Based on *The Clansman*, a novel and play by Thomas Dixon Jr., the film was coproduced by Harry Aitken and the well-known filmmaker D. W. Griffith. The film's narrative follows the stories of two

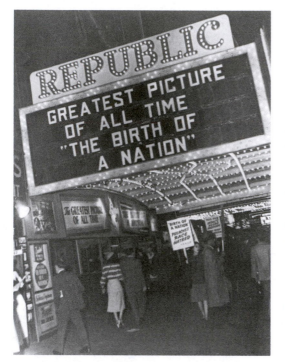

Members of the National Association for the Advancement of Colored People (NAACP) picket outside the Republic Theatre, which was showing the controversial movie *The Birth of a Nation,* New York City, 1947. Shortly after the film's release in 1915, the organization attempted unsuccessfully to have it banned for its controversial portrayals of African American men and the Ku Klux Klan. (Library of Congress)

families: the Stonemans, who were Northern abolitionists, and the Camerons, who were Southern Confederates.

What happened when the film opened was unprecedented. Although a commercial success, its highly controversial portrayals of African American men and the Ku Klux Klan, and its sexually aggressive stance toward women, led to widespread protests, violence, and calls for censorship. The National Association for the Advancement of Colored People (NAACP) unsuccessfully tried to convince officials to ban the film throughout the country, although the boycott campaign it spearheaded was considered successful. Three states banned the film, as did a number of cities.

The nation's newspapers and magazines were filled with stories and editorials about the film. American social reformer Jane Addams voiced her concerns about the way the film portrayed history in an interview published by the *New York Evening Post* on March 13, 1915:

> One of the most unfortunate things about this film is that it appeals to race prejudice upon the basis of conditions of half a century ago, which have nothing to do with the facts we have to consider today. Even then it does not tell the whole truth. It is claimed that the play is historical; but history is easy to misuse.

In a 1991 *Kansas History* article, historian Gerald R. Butters Jr. states that *The Birth of a Nation* was banned more than any other film in American history. What happened in Kansas in the wake of the film's release illustrates the tensions it stirred. Kansas was one of seven states with a film censorship board. In December 1915, its

members reviewed the film and ruled against its exhibition. They asserted that Griffith's film was historically inaccurate, filled with racial hatred, laced with immoral and sexually suggestive content, and likely to increase the tension that existed between the people of the North and South. The board had the support of many Kansans, both African American and white, who organized activities designed to keep the film out of the state. Thus began an eight-year struggle involving numerous hearings, appeals, and protests. After years of political struggle, in 1924, *The Birth of a Nation* finally opened in theaters across Kansas.

More than a century after the film was released, its images and themes still disturb viewers. As *New York Post* writer Lou Lumenick observed in 2015, in an article titled "Why the 'Birth of a Nation' is Still the Most Racist Movie Ever," Griffith's use of white actors in blackface to portray the film's African American characters still has the power to shock viewers.

MOTION PICTURE ASSOCIATION OF AMERICA CREATES THE HAYS CODE (1930)

In 1922, a group of movie studio moguls and film distributors combined to form an association to advance their business interests. Originally called the Motion Picture Producers and Distributors of America (MPPDA), the organization was envisioned by its founders as a vehicle for enlisting the public's support in ridding filmmakers of the scrutiny of local or state censorship boards. On assuming office, the MPPDA's first president, former Postmaster General Will H. Hays, launched a series of strategies designed to convince the public that the industry could be trusted to "purify" itself.

In 1930, after years of trying to get movie studios to work with them, the MPPDA established a new program named the Hollywood Production Code. Also known as the Hays Code, it consisted of a set of general principles and guidelines dealing with crime, sex, vulgarities, obscenities, profanity, costume, dances, religion, national feelings, and certain "repellent subjects" on film. The code also discussed the value of film as art and the moral obligations of filmmakers.

Part of the new program involved the establishment of the Production Code Administration (PCA), which carried out the film review process. If a script passed the PCA's review, it was authorized for distribution. If not, reviewers told filmmakers how to alter them so they could be released. From 1930–1934, many filmmakers pushed the envelope or simply ignored the code. To make it less comfortable for them to do so, the MPPDA announced in 1934 that a "seal of approval" certificate would be awarded to the producers of the movies it approved.

For many years after the establishment of this certificate program, the major studios would not release a film without the code's seal of approval. To do so would have been to risk a torrent of bad publicity. But in the 1950s, filmmakers started balking, and by the 1960s, the association, which in 1945 had been renamed the Motion Picture Association of America (MPAA), had relaxed many of its restrictions. In

1968, the MPAA introduced an entirely voluntary movie rating system, which still exists today, to help parents decide what films their children can see.

THE NATIONAL LEGION OF DECENCY AND OTHER PRO-CENSORSHIP GROUPS (1930s)

By the early 1930s, the moral campaign against Hollywood was in full bloom. Many organizations, such as the Citizens League for Better Pictures, were formed in direct relation to film. Others came from the ranks of women's, religious, and social reform organizations. Their rhetoric was so loud and "in your face," it was heard across the nation.

Cinematic depictions of crime and sex stirred the reformers up more than any other topics. On January 15, 1930, *Christian Century* published a pair of articles called the "Menace of the Movies," by drama professor Fred Eastman, who claimed that most films were "social sewage" full of "blood and thunder, crime, gun-play, lasciviousness, sentimentality, and inanity. . . . [Films are a] menace to the mental and moral life of the coming generation."

In 1932, "A Report of the Chairman of the Committee on Motion Pictures of the General Federation of Women's Clubs, in Seattle" stated that movies were "ugly, unclean, abnormal, sordid, suggestive, or criminal" vehicles that were resulting in "an unbalanced interpretation of life" that was "distasteful, unpleasant, and repellent."

The exhibitors of motion pictures sought to join the fray. In 1929, a new organization known as the Allied States Association of Motion Picture Exhibitors (ASAMPE) argued that the elimination of the studio's block booking and other strategies that hurt its members was needed to protect communities from the industry's "filth" and "indecency." The ASAMPE was just one of several exhibitor trade associations that reached out to the organizations involved in the film purification movement. Its members resented the movie industry, which they claimed did not give them enough say on what films they could exhibit. Among other things, between 1928 and 1930, movie reformers sponsored several congressional proposals that combined federal film censorship with government regulation of industry trade practices.

The Roman Catholic Church was one of Hollywood's most vocal critics, and in 1933, it decided to take a clear stand against the release of films it considered sinful. Its leaders hoped that its new National Legion of Decency would not only send a strong message to movie producers but also provide guidance to the members of its flock regarding which motion pictures to see and shun. The heart of this organization's work involved the review and rating of films as A's (morally unobjectionable), B's (morally unobjectionable in part), or C's (condemned by the Legion of Decency). Every Sunday, parish priests announced the ratings of movies scheduled to open at their community's theaters. In 1934, the legion composed a membership pledge. Mentioned by Paul W. Facey in *The Legion of Decency: A Sociological Analysis*, it read:

I condemn all indecent and immoral motion pictures, and those which glorify crime or criminals. I promise to do all that I can to strengthen public opinion against the production of indecent and immoral films, and to unite with all who protest against them. I acknowledge my obligation to form a right conscience about pictures that are dangerous to my moral life. I pledge myself to remain away from them. I promise further, to stay away from places of amusement which show them as a matter of policy.

During its first year, the legion condemned 22 movies, but in the 1940s, the numbers of films declined. Some of the films blacklisted by the Church were critically acclaimed. Among the films rated C that were awarded Oscar nominations were *Some Like it Hot* (1959), *Spartacus* (1960), *Psycho* (1960), *Rosemary's Baby* (1968), *Carrie* (1976), *Never On Sunday* (1960), *All That Jazz* (1979), *Last Picture Show* (1971), *Clockwork Orange* (1971), and *8½* (1963).

Through the years, the Legion of Decency's programs had a dramatic impact on the industry. In addition to rating films, it staged campaigns in hopes of motivating Catholics to boycott community movie theaters that insisted on showing films deemed objectionable by the Legion's reviewers. It kept up the battle until 1980, when it released its last film reviews.

JOSEPH BURSTYN, INC. v. WILSON (1952)

The question that had bedeviled the movie industry for more than 50 years was resolved in 1952 by the U.S. Supreme Court in *Joseph Burstyn, Inc. v. Wilson*. Called the "Miracle Decision," the court's decision superseded its 1915 *Mutual Film Corp. v. Industrial Commission of Ohio* ruling, which stated that film is not worthy of First Amendment protection. Justice Tom C. Clark's majority decision in the 1952 *Burstyn v. Wilson* case stated that film is an artistic medium entitled to protection under the First Amendment.

At the heart of the dispute was *The Miracle*, a short Italian film directed by Roberto Rossellini. Its story revolves around the pregnancy of Nanni, a mentally disturbed peasant who was sexually seduced by a man who called himself "Saint Joseph." The New York Board of Regents was ordered to examine the film after its initial U.S. opening, which was followed by a loud mixture of derision and acclaim. The three board members who viewed *The Miracle* agreed that it was "sacrilegious," and said it would be banned if its distributor could not convince them to do otherwise. On February 16, 1951, the board decided *The Miracle* was not suitable for public display, and it ordered the Commission of Education to rescind its license.

The film's distributor, Joseph Burstyn, petitioned the New York courts to reverse the board's action on the grounds that the statute it was based on "violates the First Amendment as a prior restraint upon freedom of speech and of the press," that it is invalid under the same Amendment as a violation of the guaranty of separation of church and state and as a prohibition of the free exercise of religion," and "that the term 'sacrilegious' is so vague and indefinite as to offend due process." After

New York's courts upheld the Board's action against the film, Burstyn's lawyers petitioned the Supreme Court to review the case.

Although a victory for Burstyn, the Miracle decision ignored the question of whether local and state film boards' power to review and censor films was a violation of the First Amendment. Not until *Freedman v. Maryland*, in 1965, did the court invalidate that state's film licensing process. In the wake of that decision, local and state licensing boards around the country quickly disappeared.

"THE HOLLYWOOD TEN" (1950s)

In response to the excesses of U.S. Senator Joseph McCarthy's efforts to stamp out communism and anyone associated with it, a group of 10 filmmakers, actors, and writers denounced him in a 16 mm short documentary film released in 1950. The film was named after the group, which had been dubbed the "Hollywood Ten" after refusing to answer questions from McCarthy and other congressional

Nine of ten Hollywood writers, directors and producers, indicted by a Washington, D.C., grand jury on charges of contempt of Congress, surrender in a group at the U.S. Marshal's office in Los Angeles, December 10, 1947. From left: Robert Adrian Scott, Edward Dmytryk, Samuel Ornitz, Lester Cole, Herbert Biberman, Albert Maltz, Alvah Bessie, John Howard Lawson and Ring Lardner Jr. The tenth, Dalton Trumbo, sent word he would surrender the following day. (AP Photo/Harold Filan)

interrogators about communist "infiltration" of the American movie industry. Decrying McCarthy's s questions as a latter-day witch hunt, they cited both the First Amendment (which provides for freedom of speech and association) and the Fifth Amendment (which provides for freedom against self-incrimination) for defying McCarthy and his allies. All members of the Hollywood Ten were subsequently cited for contempt of Congress and sentenced to jail time and/or fines.

Each of the group's members denounced McCarthyism and Hollywood black-listing. John Berry was the film's director. After its release, he was also blacklisted. The group's members included screenwriter and director Herbert J. Biberman; screenwriter Lester Cole; film director Edward Dmytryk; journalist and screenwriter Ring Lardner Jr.; screenwriter and playwright John Howard Lawson; playwright, diction writer, and screenwriter Albert Maltz; screenwriter and novelist Samuel Ornitz; screenwriter and film producer Robert Adrian Scott; screenwriter and novelist James Dalton Trumbo; and novelist, journalist, and screenwriter Alvah Bessie.

In 1960, the blacklist met its demise with the release of two films, *Exodus* and *Spartacus*—the latter of which won four Academy Awards—written by one of The Hollywood Ten, Dalton Trumbo. President-elect John F. Kennedy helped end blacklisting by crossing an American Legion picket line to see *Spartacus*.

THE MPAA'S PRODUCTION CODE COMES TO AN END (1966)

The end of the MPAA's Production Code—also known as the Hays Code—was foreshadowed in a decision it made to approve the release of the 1964 film *The Pawnbroker*, even though it included scenes described as "unacceptably sex suggestive and lustful." The film was initially rejected because of a sex scene and two scenes where actresses exposed their breasts. After the film's producers appealed, the MPAA granted them an exception if they reduced the length of the scenes to which it objected.

The second film that paved the way for the abandonment of the code was the 1966 film version of Edward Albee's *Who's Afraid of Virginia Woolf?* After the producer of the film removed the word "screw," the board allowed the film to be released, even though it still contained language it normally would not have approved.

The code finally met its demise in 1966 after Metro Goldwyn Mayer released the British film *Blowup*, even after it had been rejected for approval. This was the final blow to the code, which was no longer enforceable, as the studios and movie exhibitors essentially ignored it.

THE MPAA ESTABLISHES A FILM RATING SYSTEM (1968)

In 1968, the Motion Picture Association of America announced its new voluntary MPAA film rating system. Two organizations agreed to assist the MPAA by monitoring the sensitive process of rating films: the National Association of Theater

Owners, and the International Film Importers and Distributors of America. Over the years, several rating systems have been devised for films. Since the late 1990s, the MPAA film ratings have included the following:

G—For General Audiences
 All Ages permitted. Nothing that would offend parents for viewing by children.
PG—Parental Guidance Suggested
 Some material may not be suitable for children. Parents urged to give "parental guidance." May contain some material parents might not like for their young children.
PG-13—Parents Strongly Cautioned
 Some material may be inappropriate for children under 13. Parents are urged to be cautious.
R—Restricted
 Under 17 requires accompanying parent or adult guardian. Contains some adult material. Parents are urged to learn more about the film before taking their young children with them.
NC-17—Adults Only
 No one 17 and under admitted. Clearly adult. Children are not admitted.

THE LAST TEMPTATION OF CHRIST (1988)

A dispute over the release of the film *The Last Temptation of Christ* erupted in 1988 over its portrayal of the life of Jesus Christ. In July, a group of Southern California Protestant ministers threatened to organize a boycott against Music Corporation of America (MCA) if Universal Pictures, one of its companies, released the film. The ministers, who had not yet seen the film, based their objections on their reading of its screenplay. They complained that it portrayed Jesus as a "mentally deranged and lust-driven man who convinces Judas Iscariot to betray Him."

Some Eastern Orthodox Church clergy condemned Nikos Kazantzakis, the author of the 1951 novel the movie was based on, because he portrayed Christ as a man rather than a deity. For years, the film's producer and director, Martin Scorsese, was unable to find a studio willing to back the production. In 1983, however, Paramount agreed to do so, although it abruptly cancelled the production four weeks before shooting was set to begin.

When it was announced that MCA's Universal Pictures had picked up the project, religious leaders once again organized protest activities in hopes of discouraging them from completing it. During the month before the film's August 12, 1988, scheduled opening, thousands of protesters picketed and marched to discourage its release. As people waited in line to buy tickets on opening day, verbal skirmishes broke out between them and the film's protesters. A *New York Times* article said that in response to signs with the word "Blasphemy," people in line yelled that they had the right to see the movie. In Paris, a group of Catholic protestors set fire to a

theater while it was showing the film. As a result, 11 people were injured, including four who sustained severe burns.

Not all Christians objected to the film. To the contrary, it was praised by some liberal Catholics and Protest ministers for revealing Christ's humanity. In consideration of the film's sensitive treatment of Christ, it begins with a disclaimer that it is not based on the Gospel, but is a "fictional exploration of the eternal conflict" between the "spirit" and "flesh" that arises from man's "yearning . . . to attain God."

NATURAL BORN KILLERS ATTRACTS BOYCOTTS AND A LAWSUIT (1994)

The main characters in the Oliver Stone film *Natural Born Killers* embark on a bloody killing spree, every step of which is recounted in sensationalist fashion by the press. After the film's August 26, 1994, release, it quickly became notorious for its violent content. In 2006, *Entertainment Weekly* named it the eighth most controversial film of all time.

Before its release, the MPAA threatened to give it an NC-17 rating unless certain scenes were cut. After Stone did so, it was re-rated as an R. In 1996, Vidmark Entertainment and Pioneer Entertainment released *Natural Born Killers: The Director's Cut*. An August 17, 1996, a *Billboard* article reported that although many mass marketers, as well as Blockbuster video, refused to carry it because of its content, it was selling well at Musicland, Best Buy, and other a number of other retailers.

Meanwhile, in Louisiana, the family of a shop assistant killed as a result of a 1995 robbery filed a lawsuit against Stone and the film's distributors, alleging the film inspired the crime. The killers admitted to police that they had watched the film many times before they committed their crimes. In 2001, Judge Robert Morrison ruled against the family, arguing they had failed to prove that either Stone or the film's distributor intended to incite violence. Afterward, *Variety* reported that Stone's attorney said, "Litigation of this type chills creative activity."

THE NATIONAL COALITION AGAINST CENSORSHIP'S LIST OF MOST CENSORED FILMS

The National Coalition Against Censorship (NCAC) periodically issues a list of 40 "top censored flicks" on its website, and a review of the top ten on its list offers insight into the kinds of things that through the history of the medium have hit the panic buttons of censors and the general public.

Number one on NCAC's 2014 list is *Ecstasy*, a 1933 Czech film starring Hedy Lamarr, who plays Eva, its main character. A married woman, Eva has a love affair with a young man, swims in the nude, runs through the countryside naked, and is shown having an orgasm.

Number two is *From Here to Eternity*, a 1953 American film that received support from both the critics and public. Issued during the era of Hollywood's Production

Code, its makers had trouble getting approval for its release because of the negative way it portrayed the military. Before it could be released, it had to pass an inspection by the U.S. Army.

Third on the list is *Some Like It Hot*, a 1959 Hollywood comedy that censors claimed "promoted homosexuality, lesbianism, and transvestitism." The main characters, played by Jack Lemon and Tony Curtis, dress as women to escape from Chicago police chasing them after they witnessed a Mafia murder. After it was released without approval from the MPAA and still proved a box office success, it helped bring about the demise of the Hays Code.

Fourth is the 1966 film *Who's Afraid of Virginia Woolf?* Based on an Edward Albee play of the same name, the critically acclaimed film was accused of being perverse and dirty minded. It subsequently helped inspire the formation of the MPAA's rating system.

Scarface, a 1932 film, which has been said to be one of the most controversial films ever released in the United States, is fifth on NCAC's list. With its depiction of more than 30 deaths, it offers a graphic glimpse into that era's gangster lifestyle. Before it could be released, MPAA censors ordered cuts, rewrites, and an alternative ending.

Monty Python's Life of Brian is number six on the NCAC's list because of its "blasphemous" and "inappropriate" religious content. The 1979 film tells the story of Brian, who was born on the same day as Jesus in the stable next door. Throughout his life, Brian is mistaken for a messiah. The film was banned in many towns in the United Kingdom, as well as in Ireland, Norway, Bhutan, Oman, Singapore, and South Africa.

Number seven is Martin Scorsese's *The Last Temptation of Christ*, a 1988 film that depicts Jesus struggling with fear, temptation, and lust. Long before its release, the film generated fierce protests, and even led to violence. It was banned and censored all over the world.

Number eight, the 1979 German film *The Tin Drum*, outraged many because of a scene where an 11-year-old boy appears to be having oral sex with a 16-year-old girl.

Je Vous Salue, Marie, which in English is *Hail Mary*, is a 1985 Jean-Luc Godard film featuring a modern retelling of the life of Christ's mother Mary. It is number nine on the list because of the furor it precipitated because of its portrayal of the Virgin Mary. She is shown working at a gas station when she meets Joseph, who is a taxi driver.

Number ten on the list is *Farewell My Concubine*, a 1993 Chinese film withheld from release in its home country because of its political content and homosexuality. The complete film has never been shown in China.

SONY'S *THE INTERVIEW* (2014)

In December 2014, a furor erupted over the pending release of a Sony film titled *The Interview*. Billed as a political satire comedy, it tells the story of a pair of journalists who set up an interview with North Korean leader Kim Jong-un and are recruited by the CIA to assassinate him.

Over the previous year, a series of events foreshadowed the danger the film's producers found themselves in. In June, North Korean government leaders threatened Columbia Pictures that it would attack the United States if it released the movie. In response, Columbia said it altered the film to make it more acceptable. In November, a group called the "Guardians of Peace" broke into Sony's computer system. The FBI claimed the group, which threatened to attack movie theaters that exhibited the film, had ties to North Korea.

In the midst of the controversy, on December 24, 2014, Sony released the film to any theaters that dared to run it, and for online rental and purchase. Many major theater chains had refused to open the film.

FURTHER READING

Black, Gregory D. (1994). *Hollywood Censored: Morality Codes, Catholics, and the Movies* (Cambridge Studies in the History of Mass Communication). Cambridge: Cambridge University Press.

Butters, Gerald R. (1991). "The Birth of a Nation and the Kansas Board of Motion Pictures: A Censorship Struggle," *Kansas History*, 14(1): 2–14.

Doherty, Thomas (1999). *Pre-Code Hollywood: Sex, Immorality, and Insurrection in American Cinema 1930–1934*. New York: Columbia University Press.

Eastman, Fred (1930). "Menace of the Movies," *Christian Century*, January 15.

Facey, Paul W. (1974). *The Legion of Decency: A Sociological Analysis of the Emergence and Development of a Social Pressure Group* (New York: Arno), 144–145.

"Five Cent Schools of Crime" (1906). *Union Signal*, October 18.

Horowitz, David A. (1997). "An Alliance of Convenience: Independent Exhibitors and Purity Crusaders Battle Hollywood, 1920–1940, *The Historian*, 59(3), 553–72.

Jowett, Garth (1976). *Film—The Democratic Art: Social History of American Film*. Waltham, MA: Focal Press.

Leff, Leonard J., and Jerold L. Simmons (2013). *The Dame in the Kimono: Hollywood, Censorship and the Production Code*. Lexington: University of Kentucky Press.

Lumenick, Lou (2015). "Why 'Birth of a Nation' Is Still the Most Racist Movie Ever," *New York Post*, February 7.

Musser, Charles (1991). *Before the Nickelodeon: Edward S. Porter and the Edison Manufacturing Company*. Berkeley: University of California Press.

Orbach, Barak (2009). "Prize Fighting and the Birth of Movie Censorship," *Yale Journal of Law and the Humanities*, 21(2): 251.

Parker, Alison M. (2006). "Women Reformers and Popular Culture, Movie Censorship and American Culture," in Francis G. Couvares (ed.). *Movie Censorship and American Culture*. Amherst: University of Massachusetts.

Shprintz, Janet (2001). "'Killers' Case Closed," *Variety*, March 13.

Vita, Tricia (2013). "Saturday Matinee: A Peep Show on the Mutoscope Machine," *Amusing the Zillion*, January 5, https://amusingthezillion.com/2013/01/05/saturday-matinee-a-peep-show-on-the-mutoscope-machine.

SEVEN

Fashion (Clothing, Jewelry, and Body Decoration)

INTRODUCTION

Although some Americans live in such poverty that they struggle just to put food on the table, many others begin their days agonizing over what to wear to work or school. This is because fashion, popular culture, and social identity have become so intertwined that it's hard to tell one from the other. As the legendary fashion maven Coco Chanel put it, "Fashion is not something that exists in dresses only. Fashion is in the sky, in the street, fashion has to do with ideas, the way we live, what is happening."

Many people embrace the important role fashion plays in their lives, including both those who enjoy following current trends and those who like to thumb their nose at them. Others prefer to keep a lower profile. At times, the dress and body decoration expectations or requirements of parents, teachers, employers, or others who wield power, lead to discord. Clothing, hairstyles, jewelry, and body decorations have been banned because of societal and cultural norms and values pertaining to sex, gender, race, religion, and age, among other things. Some of these conflicts are settled amiably on the interpersonal level, but others are more difficult to solve. The field of fashion law has developed to address questions related to fashion and intellectual property, business and finance, dress codes and religious apparel, and a host of other things. Today, Americans typically think of their clothing and body decoration choices as a form of personal expression that is protected by the First Amendment and other laws that outlaw discrimination and guarantee basic human rights. But U.S. history is full of incidents that have sparked fierce debates about whether all fashion "statements" deserve free speech protections."

ONE-PIECE BATHING SUIT LEADS TO ARREST (1907)

In 1907, an Australian female swimmer named Annette Kellerman, who had been dubbed the "Original Mermaid" by newspapers for setting a variety of women's swimming records, was arrested for indecency when she stepped onto a Boston beach wearing a one-piece bathing suit that ended just above her knees. Most swimsuits worn by female swimmers in the early 20th century consisted of black, knee-length wool dresses with bloomers and puffed sleeves, long-black stockings, slippers, and a swimming cap.

Kellerman was at Revere Beach, where she had gone to train for an upcoming 13-mile swim meet. In a 1953 interview with the *Boston Sunday Globe*, Kellerman reminisced about the incident.

> Me, arrested! We were all terribly shocked, especially my father, for I was his innocent protected little girl. But the judge was quite nice and allowed me to wear the suit if I would wear a full-length cape to the water's edge.

As it turned out, the controversy over her swimsuit was short-lived. Within a few years of Kellerman's arrest, one-piece suits had become the norm for women at beaches and public pools in many parts of the United States.

THE ZOOT SUIT RIOTS (1943)

During the 1930s and early 1940s, so-called "zoot suits" became popular among many young men in Los Angeles's Chicano community. The suits had high waists, full-legged tight-cuffed pegged trousers, wide lapels, and padded shoulders. African Americans, Filipino Americans, and Italian Americans also enjoyed wearing them.

In 1943, long-standing racial tensions in the Los Angeles community erupted into what became known as the zoot-suit riots. Deep-seated racial and ethnic prejudice, anxieties about crime, and institutional discrimination all contributed to the explosion of violence against Latinos. Young men wearing zoot suits, which some white people had come to equate with juvenile delinquency, were particular targets of this violence. The sensational 1942 Los Angeles "Sleepy Lagoon Murder" and subsequent trial had further aggravated the situation. The "Sleepy Lagoon Murder" was the term Los Angeles newspaper writers used to refer to the arrest, trial, and conviction of 17 Mexican American teens for murder. On June 3, several days after a series of altercations between military personnel and zoot suiters, 50 sailors left their base and attacked anyone wearing a zoot suit. The mob violence continued for several more days after that, with growing numbers of white sailors and civilians attacking Mexican Americans and African Americans on the city's streets. By that time, people were being targeted whether they were wearing zoot suits or not. Journalist Carey McWilliams, who witnessed the riots, described the scene in his 1949 book *North from Mexico: The Spanish-Speaking People of the United States*:

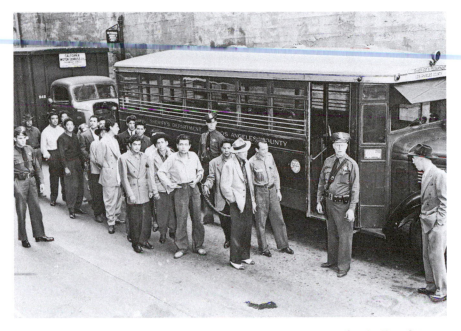

Mexican Americans line up outside a Los Angeles jail en route to court after the Zoot Suit Riots, June 9, 1943. Los Angeles police responded by enacting a resolution making it a crime to wear a zoot suit within city limits. (Library of Congress)

Marching through the streets of downtown Los Angeles, a mob of several thousand soldiers, sailors, and civilians, proceeded to beat up every zoot suiter they could find. Pushing its way into the important motion picture theaters, the mob ordered the management to turn on the house lights and then ran up and down the aisles dragging Mexicans out of their seats. Street-cars were halted while Mexicans, and some Filipinos and Negroes, were jerked from their seats, pushed into the streets and beaten with a sadistic frenzy.

In the midst of the crisis, the Los Angeles City Council criminalized the wearing of "zoot suits with . . . pleats within the city limits of LA." According to LA Councilman Norris Nelson, "The zoot suit has become a badge of hoodlumism." Los Angeles Lieutenant Sheriff Edward D. Ayres wrote in a report that dealt with crime and the city's Hispanic population:

They [Mexican authorities] have stated that which we are now learning the hard way. The Mexican Indian is mostly Indian—and that is the element which migrated to the United States in such large numbers and looks upon leniency by authorities as an evidence of weakness or fear, or else he considers that he was able to outsmart the authorities.

By the middle of June, the Los Angeles riots had dissipated, but racial violence had begun spreading to other urban communities, including Detroit, Chicago, Philadelphia, and Harlem.

CHANGING HAIRSTYLES FOR BOYS AND MEN (1960s–1970s)

The social upheaval of the 1960s affected the fashion world, including the way white, middle-class young men wore their hair. From World War I until the 1960s, most favored short styles. This began to change in the 1960s, in part because of pop stars such as Elvis and The Beatles. The clashes in this era over how boys and young men should wear their hair illustrate generational upheavals over American ideals and norms. Parents, teachers, religious leaders, and others not only lectured young men about the need to cut their hair, but they punished them if they refused to do so.

American schools were one of the primary battlegrounds in the 1960s cultural war over how young men wore their hair. In 1968, the principal of a New Hampshire Catholic school removed 18 boys from their classes and took them to a barbershop to have their hair cut. That same year, Brien McMahon High School in Norwalk, Connecticut, suspended 53 boys whose hair covered their eyes, and/or hung over their ears or shirt collars. One of its officials said, "We aren't anxious to see boys' hair becoming as long as girls." *The Bridgeport Telegram* subsequently reported that 12 of the 53 boys complied with the school's "cut-your-hair" order,

A young man has his hair styled by a woman on Hollywood's Sunset Strip in 1966. As the style of long hair for men and boys became popular, parents, school officials, business owners, and other authority figures sought to stop the trend. (AP Photo/George Brich)

but some refused to do so, picketing outside the school with signs bearing comments such as "It's 1968, not 1984," "Does society hang by a hair?" and "It's not just the hair on top, but the mind beneath."

The American Civil Liberties Union (ACLU) agreed to represent four of the students after their parents decided to sue the school. Arguing that the school had violated the students' human rights, the ACLU's attorney quoted the Magna Carta and U.S. Constitution and asserted that hair length has nothing to do with education. Luther A. Howard, the school's principal, testified that the boys' hair was such a major classroom distraction that the school's order was justified. The judge ruled against the students, contending that it would be unfair to the students who had complied with the school's order to rule in favor of the four students who had refused to do so.

In 1970, a 17-year-old Marlboro, Massachusetts, student won when he sued his school for ordering him to cut his hair. The judge in the U.S. Court of Appeals case, *Richards v. Thurston*, wrote:

> We see no reason why decency, decorum, and conduct require a boy to wear his hair short. Certainly eccentric hair styling is no longer a reliable sign of perverse behavior. We do not believe that mere unattractiveness in the eyes of some parents, teachers, or students, short of uncleanliness, can justify the proscription. Nor, finally, does such compelled conformity to conventional standards of appearance seem a justifiable part of the educational process.

Since the 1970s, male hair length faded as a topic of controversy. But even in the 21st century, disputes about the issue occasionally crop up. In 2010, for example, a young man was cut from the Greensburg, Indiana, high school basketball team after he refused to cut his hair. His parents, Patrick and Melissa Hayden, challenged the coach's grooming policy in December 2010, and by 2014 he had won at both the district and circuit court of appeals levels.

Schools aren't the only places where disputes over how boys and men wear their hair have arisen. Up until the late 1960s, Disneyland refused to sell tickets to any male customer whose hair was considered too long. By the summer of 1970, Disney had lifted the ban, but that didn't stop a group of long-haired Yippies from invading the theme park. The Yippies, who were members of a political protest group named the Youth International Party, were fond of staging outlandishly theatrical political protest events. Disney reacted by closing the park.

Disney has continued to make known its preference for short-haired and well-groomed men in its company policies. As of 2016, in fact, the company continued to impose fairly strict hair and beard restrictions on its male employees.

EMPLOYEE-IMPOSED HAIR GROOMING POLICIES (1981)

"Dress for Success" is an American mantra that guides many of us as we decide what to wear for work and play, but if warned by your employer not to come to

work wearing certain clothing, jewelry, or hairstyles, many will think their rights are being violated. In reality, however, federal, state, and local laws offer little protection from the requirements of employer's dress or grooming codes. Although civil rights laws restrict employer-enforced clothing and grooming policies that discriminate based on race, color, national origin, sex, religion, disability, genetic information, or age, Congress has created a "bona fide occupational qualification" exception that applies to employers who find an otherwise discriminatory policy "reasonably necessary to the normal operation of that particular business or enterprise."

The outcomes of civil rights lawsuits filed against employers in this area are difficult to predict, because courts have generally been deferential to employers' wishes to control what their employees wear in the workplace. A significant example is *Rogers v. American Airlines*, a 1981 case wherein the court supported a private employer's ban on a hairstyle frequently referred to as "corn rows." The plaintiff, Renee Rogers, had worked for American Airlines for more than 10 years in various positions that involved public contact. After arriving at work, on September 15, 1980, with all of her hair braided, Rogers was told she could not wear her hair in such a style. In response, Rogers filed a discrimination charge against the company, arguing the policy violated Title VII of the 1964 Civil Rights Act and the Thirteenth Amendment of the United States Constitution, which outlaws slavery and involuntary service in the United States and its territories, including all practices that constitute a "badge of slavery." The court immediately dismissed Rogers's Thirteenth Amendment claim and proceeded to consider her civil rights claim.

Rogers argued that the grooming policy discriminated against her as an African American, explaining that the "corn row" style was part of the historical essence of the African American woman. She claimed that the style had recently become popular once again because actress Cicely Tyson, an African American, had attended the Academy Awards with her hair braided.

The court ruled against Rogers, asserting that the airlines' policy applied equally to members of all races, and that people of all colors wear all-braided hairstyles. The court also determined that the policy wasn't a violation of Title VII, but was a reasonable management policy enforced by a private company seeking to run its business as they saw fit. The court agreed that the airlines had a right to manage their employees in a way that projects "a conservative and business-like image."

The *Rogers* decision has never been overturned, although it has not been universally accepted. For example, Paulette M. Caldwell, a professor at New York University Law School, lamented in a 1991 *Duke Law Journal* article that "something as simple as a black woman's hair continues to threaten the social, political fabric of American life."

HARRAH'S "PERSONAL BEST" FEMALE MAKEUP POLICY (2006)

One of the cases looked to by other courts seeking precedents to guide them in their decisions ensued when a female bartender at one of Harrah's casinos

objected to the requirement that she abide by its new appearance code. The 2006 U.S. Ninth Circuit Court of Appeals decision, which ruled against the plaintiff in *Jespersen v. Harrah's Operation Co.*, is considered a landmark because so many other courts rely on it to support decisions allowing grooming policies that apply to the members of only one of the sexes.

After serving as a Harrah's bartender for many years, Darlene Jespersen learned that management would be adopting an appearance code the company called its "personal best" program. It required bartenders to be "well groomed, appealing to the eye, firm and body-toned, and be comfortable with maintaining this look while wearing the specified uniform." Females, unlike males, were required to have their hair "teased, curled or styled," and to wear stockings, nail polish, and makeup that included lip color. Jespersen, who never wore makeup, resigned from her position and filed a sex discrimination claim against the casino. The court ruled against her, arguing that the sex-differentiated policy did not unfairly burden the casino's female employees.

FEMALE IN TROUSERS AT WORK (2009)

In addition to court decisions over how employees groom their hair and apply makeup for work, others have considered cases that address disagreements over what clothing people can wear while on the job. *Seabrook v. City of New York*, decided in 2009 by the U.S. Federal District Court in the Southern District of New York, focused on the extent of an employer's right to implement a dress code. Seabrook, a female Department of Corrections officer, filed a class action lawsuit against her employer for requiring that both men and women officers wear trousers. She claimed that the First and Fourteenth Amendments, as well as the New York State Constitution, protected her from having to wear pants because it was against her religious beliefs to do so. The court disagreed, reasoning that the safety gear used by corrections officers in emergencies can't be used properly be someone wearing a skirt.

SAGGY PANTS AND THE FIRST AMENDMENT

Can the government tell you how to wear your pants? The answer is, it depends on whom you talk to. Those who have taken steps to criminalize the wearing of "saggy pants," that is, wearing trousers or jeans so low that several inches of underwear are visible, don't appear to have any doubt that they are doing the right thing. However, many of the city ordinances that have banned saggy pants have been struck down as unconstitutional violations of the First and Fourteenth Amendments.

Saggy pants are typically accompanied by brightly colored boxer shorts. The style's origins lie somewhere in the late 1980s and have been given a boost in popularity over the years by celebrities such as 50 Cent, Nelly, and Justin Bieber. Although some claim saggy pants first appeared in the U.S. prison system, fashion historian Tanisha C. Ford of the University of Massachusetts-Amherst told National Public

Radio in a 2014 interview, "I don't think we can definitively say that sagging began in prisons."

What *is* easy to document about saggy pants is that many people loathe them so much that they are willing to go to great lengths to outlaw them. In 2008–2009, for example, a "saggy pants ordinance" enacted by the City Council of Riviera Beach, Florida, attracted national attention. In September 2008, the ordinance's legality was challenged in a lawsuit filed after 17-year-old Julius Hart was arrested as he rode a bike with four or five inches of his blue and black boxer shorts sticking out of his black trousers. According to the *Palm Beach Post*, circuit Judge Paul Moyle declared the city's saggy-pants law unconstitutional "based on the facts of [the] case":

> We're not talking about exposure of buttocks. No! We're talking about some-one who has on pants whose underwear are apparently visible to a police officer who then makes an arrest and the basis is he's then held overnight, no bond. No bond! . . . You can have Speedo underwear, which is way less than boxer shorts, and that is perfectly legal, but boxer shorts, with pants over them, is not?

Another Florida anti-saggy pants ordinance that generated considerable interest was enacted by the Ocala (Florida) City Council in 2014. The ordinance banned the wearing of saggy pants on public-owned property. Violators faced a $500 fine or up to six months in jail. A July 17, 2014, *Ocala Star-Banner* story reported on the motivations of Mary Sue Rich, the city council member behind the ordinance. Rich said, "I think it's disrespectful and dirty. You don't want to see people's underwear when you are in a restaurant." Rich also said the city council hoped the ordinance would "enhance the lives of people in this city." A month after the council voted to enact the ordinance, however, it was repealed to avoid a threatened lawsuit from by the National Association for the Advancement of Colored People (NAACP).

Not all saggy pants ordinances have been struck down as unconstitutional. In 2007, the City Commission of Opa-Locha, Florida, enacted an ordinance titled "Ban on Wearing Saggy Apparel in Public Facilities," which remains in effect.

Plaintiffs in saggy pants First Amendment cases are aided by an influential precedent established by the members of the U.S. Supreme Court's 1971 decision in *Cohen v. California*. The case started after Paul Cohen was arrested and convicted for wearing a jacket displaying the words "Fuck the Draft" in the corridor of the Los Angeles Courthouse. Cohen's conviction was overturned by a group of justices who agreed that wearing certain kinds of clothing is expressive conduct worthy of First Amendment protection.

RACIALLY INSENSITIVE FACE PAINT, COSTUMES AND T-SHIRTS ON CAMPUS

Examples abound of incidents on university and college campuses involving the wearing of costumes, face paint, and T-shirts that have led to complaints about some students' seeming lack of sensitivity concerning white America's history of racial intolerance. In November 2014, the athletic department at Arizona State University banned students from wearing face paint at university football games. The policy was implemented to deflect criticism of ASU students, who at a previous game had worn black face paint in hopes of blacking out the stadium. Some found the students' gesture of school spirit to be highly offensive. Blackface is a form of makeup that non-black theatrical performers started using in the 19th century. Seen as a reference to the "happy-go-lucky darky on the plantation," it was viewed by many as a symbol of racist whites' insensitivity. In an interview with journalist Jasmine Watkins for *Sporting News*, African American student Chinenye Okudoh explained:

> I was so appalled and disgusted. I just felt completely hurt. A lot of comments are, "What's the big deal? It's just a black face." What they don't understand is that there is a major history behind blackface.

The article included the athletic department's explanation for its decision to ban face paint. It announced:

> As an inclusive and forward-thinking university, it is important for us to foster an environment in which everyone feels safe and accepted. Therefore, we discourage the use of face paint at an event, whether the theme is black, maroon, gold or white, and ask our fans to show their Sun Devil Pride in other ways.

Ibram H. Rogers, an assistant professor of Africana Studies at the University of Albany–SUNY, reported in a 2013 article in *Diverse Issues in Higher Education* that incidents in which white students put on blackface had occurred at many colleges over the past few years, including North Dakota State, East Tennessee State, Northwest Missouri State, Clemson University, and Tarleton State University, among others.

Such incidents are similar to other racially insensitive events that have taken place on college campuses. In 2015, at the University of California–Los Angeles, the organizers of a fraternity-sorority party gave it a "Kanye Western" theme. Partiers were invited to wear blackface makeup and costumes related to Kanye West and his wife, Kim Kardashian. In response, hundreds of students holding signs that read "Our culture is not a costume," marched on campus. And in 2016, at Sanford University in Birmingham, Alabama, a sorority designed a T-shirt to promote its spring dance that included a map of the State of Alabama with a black man eating

watermelon and slaves picking cotton. The university announced it had rejected the design, but the sorority went ahead with the production of the T-shirts. After the incident was brought to light, the president of the sorority apologized, maintaining that they had "failed to focus" on the images within the map.

ANTI-TATTOO LAWS

The old proverb "beauty is in the eye of the beholder" certainly applies to tattoos, as people tend to either love or hate them. But despite the lingering aura of unacceptability that surrounds tattoos, more Americans than ever before have them. A 1936 *Life* magazine article reported that 6 percent of all Americans had at least one or more tattoos. In contrast, a website titled The Vanishing Tattoo, which compiles statistics about tattoos, reports on Harris Polls research indicating that in 2003, 16 percent of all Americans had one or more tattoos, whereas in 2012, 21 percent had one or more. In 2016, Statistic Brain Research Institute's website reported that 40 percent of Americans between the ages of 28 and 40 have one or more tattoos.

In light of the increasing popularity of tattoos, many states and municipalities have re-examined their anti-tattooing legislation and laws, some of which have been on the books for years. In South Carolina, tattooing advocate Ron White fought for years to convince the legislature to lift the state's ban on the practice. In 1999, in *State v. Ron P. White*, after being arrested and convicted for violating the law, he sued South Carolina, arguing that the action violated his First Amendment rights.

The last state to legalize tattooing was Oklahoma, in 2006, although all states and many municipalities have enacted statutes that regulate the practice in one way or another. Some community's restrictions have precipitated legal disputes concerning freedom of expression. A Pennsylvania man who was denied employment with the state police after he refused to remove one of his tattoos lost his 2012 First Amendment lawsuit, *Scavone v. Pennsylvania State Police*. Scavone argued that the agency violated his free-speech rights by selectively enforcing the tattoo policy against him after he spoke out against the policy and hired a lawyer.

Also in 2012, a California court ruling ordered the state to change its probation rules so that a probationer could no longer be punished for acquiring a new tattoo he or she didn't realize involved a symbol adopted by a gang. In *People v. Huerta*, Adelso Perez Huerta won the case by arguing that the restriction violated his First Amendment rights to expression and association because it was too broad.

A third legal dispute, decided in 2012, concluded with an Arizona Supreme Court ruling that tattoos are a form expression protected by the First Amendment. The decision is notable because other court decisions have not found tattooing expressive enough to warrant free-speech review. The case began in 2008, after the city of Mesa refused to award Ryan and Laetitia Coleman a permit to operate a tattoo business. The high court's opinion, in *Coleman v. Mesa*, noted that tattoos contain words, messages, images and artwork that "express a broad range of

messages, and they may be purely decorative or serve religious, political, or social purposes."

"I ♥ BOOBIES!" AND OTHER SCHOOL DRESS CODE SEX DISCRIMINATION CASES

Many of today's young people are so caught up in being seen in the latest popular fashions that they'll go to great lengths to acquire their favorite shoes, jewelry, and jeans. Aside from parents, school officials are more aware of this than anyone, for if left unchecked, today's youth-oriented fashion wars can cause tensions at school. Indeed, two of the strongest justifications for dress codes and uniforms requirements are that such policies help school officials keep order, and establish a more level playing field by removing evidence of socioeconomic disparities.

But if school officials aren't careful, they might enforce rules that unwittingly impose a gender-related double standard. A film that explores this topic, *Shame: A Documentary on School Dress Code*, has attracted more than 360,000 YouTube views, as of September 19, 2016. Its writer and producer, 16-year-old Maggie Sunseri, first noticed this phenomenon as a middle school student in Versailles, Kentucky. She said that the girls at her school were disciplined for dress code violations more frequently than the boys and that administrators blamed girls for dressing in ways that led boys to misbehave—rather than the boys themselves for engaging in unacceptable behavior. Sunseri claimed that girls in the middle of these situations often feel a confusing mixture of shame and righteous indignation, and that boys needed to be held responsible for their own actions.

There is plenty of evidence to suggest that Sunseri is right. A 2016 *University of Richmond Law Review* article, "Sexualization, Sex Discrimination, and Public School Dress Codes," offers a litany of examples.

- At the Maggie Walker Governor's School in Virginia, administrators used the PA system to notify female students they would be conducting a shorts-length spot check. Any offenders would be forced to change clothes; if 10 or more were found to be in violation of the rule, all girls would be banned from wearing shorts for a day.
- In Evanston, Illinois, girls were forbidden to wear leggings because administrators believed them "too distracting" for boy students.
- In Florida, a new student who violated her school's skirt rules was forced to wear a "shame suit": red sweatpants and a huge neon yellow shirt emblazoned with the words "Dress Code Violation."

Depending on a potential lawsuit's particular facts, at least three legal approaches are available to those who petition the courts for redress of their grievances: claims can be made under the First Amendment, the Fourteenth Amendment's Equal Protection clause, and/or Title IX of the Civil Rights Act. A widely publicized case

involving all of these approaches case arose in Pennsylvania in 2010, after Easton Area School District (EASD) punished two female students for refusing to stop wearing pink rubber cancer awareness bracelets that include the phrase "I ♥ Boobies! (Keep A Breast)."

The Keep A Breast Foundation, a nonprofit organization devoted to eradicating breast cancer by educating young people, distributes the bracelets. The school district announced the ban after a number of students had been wearing their bracelets for more than a month without creating any disruption to the school's operations. Administrators justified the ban by claiming the bracelets would make some students uncomfortable, that the bracelets prompted some male students to make inappropriate comments about breasts, and that the bracelets were offensive to some staff members.

The two girls disciplined for refusing to stop wearing the bracelets were banned from participating in extracurricular activities. Supported by their parents, the American Civil Liberties Union of Pennsylvania agreed to litigate their case. Based on the theory that the school had violated their First and Fourteenth Amendment rights, the plaintiffs' complaint asked the court to order EASD to revoke their punishment. The Court agreed to do so, and the case went to trial. After losing at the federal district U.S. circuit court levels, EASD asked the U.S. Supreme Court to review the case, but its members refused to do so, thereby allowing the lower court's ruling to stand.

One of the First Amendment decisions that served as a crucial precedent in the "I ♥ Boobies!" case was *Tinker v. Des Moines Independent School District*, a 1969 U.S. Supreme Court decision. The *Tinker* case, which involved a group of Des Moines students expelled for wearing black armbands as a silent protest against the Vietnam War, argued that their expulsions violated their speech rights. The author of the decision's majority opinion asserted that students don't "shed their constitutional rights to freedom of speech or expression at the schoolhouse gate," and that schools must be careful not to punish students unless their speech disrupts the educational process.

The publicity that these and other school dress code disputes have attracted has precipitated even more concern among students and their parents. For example, Change.org, a website that presents itself as "The World's Platform for Change," has served as a launching pad for scores of petition drives designed to prod school administrators into altering various aspects of their dress and grooming codes.

FURTHER READING

"ACLU Vows Pupil Hair Case Fight" (1968). *The Bridgeport Telegram*, January 31.

Ayres, Edward (1943). "Statistics," Foreign Relations Bureau of the Los Angeles Sheriff's Office.

"Ban on Freak Suits Studied by Councilmen" (1943). *Los Angeles Times*, June 9, p. A3.

Caldwell, Paulette M. (1991). "A Hair Piece: Perspectives on the Intersection of Race and Gender," *Duke Law Journal*, 365.

Carr, Susan Latham (2014). "Local Reaction to Droopy Drawers Ordinance," *Ocala Star-Banner*, July 17, http://www.ocala.com/news/20140717/local-reaction-to-droopy-drawers-ordinance.

Demby, Gene (2014). "Sagging Pants and the Long History of 'Dangerous' Street Fashion," National Public Radio, September 11, http://www.npr.org/sections/codeswitch/2014/09/11/347143588/sagging-pants-and-the-long-history-of-dangerous-street-fashion.

Harbach, Meredith J. (2016). "Sexualization, Sex Discrimination, and Public School Dress Codes," *University of Richmond Law Review*, 50: 1039.

Hillstrom, Kevin (2012). *The Zoot Suit Riots*. Aston, PA: Omnigraphics, Inc.

Hilman, Betty Luther (2015). *Dressing for the Culture Wars: Style and the Politics of Self-Presentation in the 1960s and 1970s*. Lincoln: University of Nebraska Press.

Johns, Ishbel (1953). "Boston Arrest a Mistake, Says Annette," *Boston Sunday Globe*, October 11.

Kleinberg, Elliott (2008). "Judge: 'Saggy Pants' Ban Unconstitutional" *Palm Beach Post*, September 16.

Madsen, Axel (1991). *Chanel: A Woman of Her Own*. New York: Holt, Henry and Company.

McWilliams, Carey (1949). *North from Mexico: The Spanish-Speaking People of the United States*. Philadelphia: J. B. Lipponcott Co.

"Shaggy-Haired Students Get Lawyer's Help" (1968). *Standard-Speaker*, Hazleton, Pennsylvania, January 31.

Watkins, Jasmine (2014). "Arizona State Warns Students Not to Wear Facepaint," *Sporting News*, October 16, http://www.sportingnews.com/ncaa-football/news/arizona-state-bans-face-paint-blackface-blackout-sun-devils/1m3b4oazmywxa1wx07fx8pvo06.

EIGHT

Television and Radio Broadcasting

INTRODUCTION

The histories of American radio and television broadcasting and popular culture are so interwoven that it is difficult to tell one from the other. Arguably, the success of the country's broadcasting industries has depended on the creation of radio and TV pop icons such as *Amos and Andy* and *I Love Lucy*. But as early as the 1920s, it became clear that broadcasters and, by extension, the creators of the programs that they aired, would not be granted the same First Amendment rights as the operators of newspaper and magazines. The origins of this two-tier system are hidden in the details of the industry's historical transformation from a relatively simple mass communication system into a sophisticated vehicle for the delivery of entertainment and public service programming. Because the inventors of American broadcasting had nothing on which to base radio's development, they were forced to create an entirely new medium. Not only did they need to figure out what kind of content should be aired but also how to make broadcasting economically viable. This led to the eventual development of advertising commercials, the first of which aired in 1922.

Early radio listeners' problems with station interference had to be worked out before the medium would thrive. Radio's spectrum was limited, meaning stations began to crowd each other out. This played a significant role in the government's establishment of a broadcasting regulatory agency.

As the fledgling radio industry grew, concerns about the growing ubiquity of its programming further fostered an environment conducive to the acceptance of government regulation. America's first commercial radio station was established in Pittsburgh, Pennsylvania, in 1920, and the first television broadcast was aired in 1936. By the end of the 1950s, nearly every American home had a radio and television, as did many bars and restaurants. Because commercial broadcasters depend

on advertising for operating funds, the industry is a rating game. This has led some broadcasters to air material that some find objectionable but others find entertaining or titillating. Commercial sponsors uncomfortable with such programs have at times pressured broadcasters to remove or change them. And the public has not only complained about programming but has formed organizations whose mission it is to publicize its concerns more widely.

For insight into popular culture and freedom of expression, this section explores the complicated web of relationships that exists between the broadcast industry, the creators of broadcast programming, the federal government, the U.S. Congress, listeners and viewers, and the organizations that have been formed to serve as the public's broadcasting watchdogs.

FORMATION OF THE FEDERAL RADIO COMMISSION (1927) AND FEDERAL COMMUNICATION COMMISSION (1934)

One of the greatest ironies in the history of broadcasting is that the leaders of the fledgling medium of commercial radio welcomed the federal government's earliest regulatory requirements. On February 23, 1927, President Calvin Coolidge signed the Radio Act, the nation's first major piece of broadcasting legislation. For radio to be a commercial success, it was imperative that the Federal Radio Commission (FRC), the agency the act created to oversee the airwaves, fix their congestion problems. It was created to regulate radio use "as the public interest, convenience, or necessity" requires.

Just after the FRC's establishment, a torrent of new stations sought access to the airwaves, thus worsening the fledgling medium's problems with bandwidth interference. It would take months for the new FRC to work out its operating plans, but by the end of the year it announced that all stations must formally apply for licenses no later than January 15, 1928.

The legislation that established the FRC gave it the power to grant and deny licenses, and assign frequencies and power levels for licensees. It did not, however, bestow it with official censorship power, although radio programming was forbidden to include "obscene, indecent, or profane language." Nevertheless, the commission wielded some power over content in the licensing process, which involved its review of programming.

Before licensing, radio was used by many as a place to share their views, whether they were popular or not. With the creation of the FRC, members of the public offended by what they heard had a place to complain. One of the broadcasters it received numerous complaints about was "Fighting Bob" Shuler, a controversial evangelist and political figure on station KGEF in Los Angeles. Shuler attacked Catholics, African Americans, Jews, and the president of the University of Southern California, whom he condemned for permitting the teaching of evolution. He attacked the morals of gamblers, bootleggers, grafters, and corrupt politicians and police officials. On July 21, 1930, the FRC announced it would conduct an investigation into Shuler's broadcasts. In 1931, it revoked his station's license.

By 1934, the federal government considered the FRC too limited to carry out the regulation of the nation's quickly developing telecommunication infrastructure. Congress subsequently enacted legislation that created the Federal Communication Commission (FCC), which replaced the FRC, and took over the regulation of wire communication from the Interstate Commerce Commission. Its purpose is to create and enforce rules that lead to the fulfillment of its responsibilities. A governing board consisting of a chair and four commissioners operates as part of the government's executive branch. According to the Communications Act of 1934, its overall mission is to

> make available as far as possible, to all the people of the United States, without discrimination on the basis of race, color, religion, national origin, or sex, rapid, efficient, nationwide, and world-wide wire and radio communication services with adequate facilities at reasonable charges.

The agency prohibits any speech the U.S. Supreme Court has ruled is not eligible for First Amendment protection, including obscene and indecent speech, libel, threats that pose a clear and present danger, and fraudulent communication. In addition, the agency has some authority over stations' use of their time to air political messages during campaigns. Beyond this, the FCC has not been endowed with censorship powers, and it is forbidden in carrying out any of its licensing activities to punish a station merely for airing points of view it finds disagreeable.

Despite such limitations, federal courts have granted the FCC power to affect broadcast station programming in several areas. Its "safe harbor" rule restricts the use of indecent and profane speech in broadcast programming aired from 6 a.m. to 10 p.m. The equal-time rule requires that if a broadcaster offers airtime to a political candidate running for office, the station must provide equivalent opportunities to opposing political candidates who request it.

For the most part, radio and television licensees are responsible for selecting the material that they think will best serve their communities. They are also in charge of deciding what programming their schedules will consist of. An exception involves the FCC's requirement, as codified by the Children's Television Act of 1990, that stations offer at least three hours of "core programming" to the children in their viewing areas. Although the FCC doesn't regularly monitor programming, it urges viewers and listeners to inform them about practices and programming they believe to be problematic.

Questions about the FCC's proposed net neutrality rules have led to a debate over its overall mission and roles. Net neutrality is the principle that Internet service providers should provide access to all content and applications regardless of the source and without favoring or blocking particular products or websites. Net neutrality is relevant to broadcasters because of the rapid growth of interest among consumers in the Internet-enabled television streaming business.

Questions about the role of the FCC in enforcing this principle have become the heart of legal disputes between the agency and Internet service providers. On

June 14, 2016, the U.S. Court of Appeals for the District of Columbia upheld the agency's net neutrality rules in full, declaring the Internet to be a public utility. The court's decision, however, doesn't rule out similar future legal challenges to the FCC's authority.

TELEVISION SELF-CENSORSHIP (1950s–1960s)

Although the 1950s through the early 1960s is often characterized as an era of conformity, the burgeoning medium of television was marked by clashes over the contents of its programming. The medium was growing by leaps and bounds, and programming executives were challenged to produce shows that would capitalize on its growing appeal. But with so much advertising revenue at stake, network executives needed to avoid taking programming risks they feared would offend sponsors.

A famous example involved Elvis Presley's gyrating pelvis. When Presley was booked for three live appearances on *The Ed Sullivan Show*, concerns arose about his act's suitability for primetime audiences. On January 6, 1956, during Elvis's third appearance on the show, network censors ordered the camera's operator to shoot him from the waist up. After the performance, Mr. Sullivan addressed the audience:

> I wanted to say to Elvis Presley and the country that this is a real decent, fine boy, and wherever you go, Elvis, we want to say we've never had a pleasanter experience on our show with a big name than we've had with you. So now let's have a tremendous hand for a very nice person!

Situation comedies were one of the period's most popular forms of television programming, and the *I Love Lucy* comedy series is a prime example. Considered to be one of the best TV shows of all time, it ran on CBS from 1951 to 1957. Lucille Ball and Desi Arnaz, who were married in real life, played the show's main characters, Lucy and Ricky Ricardo. When Ball became pregnant, she and Arnaz decided to write it into the show. To avoid offense, CBS told cast members to use the word "expecting" rather than "pregnant" or "pregnancy."

Another popular situation comedy depicting an American family was *The Dick Van Dyke Show*, which aired on CBS from 1961–1966. Two of its main characters were Rob Petrie (Dick Van Dyke) and Laura Petrie (Mary Tyler Moore). In an interview published in the April 21, 2014, issue of *Entertainment Weekly*, Carl Reiner, the show's producer, recalled his conversation with the network about what beds Rob and Laura would sleep in.

> I said, "My wife and I sleep in the same double bed, I'd like to use a double bed." But the network said oh no you're not allowed to do it. So we had them sleeping in twin beds! I mean I objected to that but I didn't win.

About kissing, he said, "No tongue! We knew not to do that!"

I Dream of Jeannie (1965–1970) was another situation comedy marked by network interference. Its main characters were Jeannie, a 2000-year-old magic genie, and Captain Tony Nelson, an astronaut. Nelson was Jeannie's master, because he had accidentally let her out of her bottle. Played by Barbara Eden and Larry Hagman, Jeannie and Tony's obvious on-screen chemistry may have had something to do with her costume, which consisted of a two-piece outfit that revealed her midriff. NBC executives, however, would not permit Jeannie's navel to show.

American television's popular late-night talk shows originated in 1950, but the first to have any real audience impact was the earliest version of *The Tonight Show*, which debuted in 1954. In 1961, Jack Paar, the second *Tonight Show* host, got into trouble with network censors when he told a joke about an English lady's search for a water closet. The night after it aired, Paar learned they had the cut the joke. He was livid, and the next night, he abruptly left the show, although he returned a month later. He issued the following statement in front of his audience before walking off the stage:

> I've been up thirty hours without an ounce of sleep wrestling with my conscience all day. I've made a decision about what I'm going to do. I'm leaving *The Tonight Show*. There must be a better way to make a living than this, a way of entertaining people without being constantly involved in some form of controversy. I love NBC, and they've been wonderful to me. But they let me down.

Another casualty of late-night comedy censors was the 1981 firing of *Saturday Night Live*'s "Weekend Update" anchor Charles Rocket, who had let a profanity slip. In 1997, after Norm MacDonald let the F-word slip during "Weekend Update," he was not fired.

Television historians call the 1950s its Golden Age, and one of the era's highpoints was *Playhouse 90*, which featured high-quality live drama. The contents of certain plays, however, were bothersome to sponsors disturbed by their portrayals of subjects in ways they feared would reflect poorly on their products. On February 13, 1960, in a *Saturday Evening Post* article, Stanley Frank wrote, "No group has fought harder—or more successfully—than *Playhouse 90* to present intelligent and controversial themes, regardless of sponsor and network pressures."

One of the most infamous examples of sponsor-network interference concerns *Judgment at Nuremburg*, a play based on the post–World War II trials of a group of high-level Nazi perpetrators of the Holocaust's annihilation of millions of Jews and other people. One of the show's sponsors, the American Gas Association, was so troubled by the script's inclusion of the term "gas ovens" that network executives ordered it replaced. In defiance of the order, one of the actors, Claude Rains, decided to use the term anyway. Just beforehand, an engineer pulled a switch and the term was not audible.

THE SMOTHERS BROTHERS PUSH THE ENVELOPE (1967–1970)

The *Smothers Brothers Comedy Hour* further demonstrated that the so-called "era of conformity" in television broadcasting was slowly coming apart. The show's debut signaled it would offer audiences an altogether different kind of comedy-variety program. Dick and Tom Smothers' unprecedented mix of hilarious, politically scathing, and socially relevant satire attracted immediate attention.

The brothers clashed with CBS censors from the beginning as well, and before the opening of its 1968–1969 season, network executives demanded that the show's writers submit their scripts 10 days before their air dates to give management time to edit anything they found problematic. In the midst of the mayhem that arose during the 1968 Democratic National Convention, for example, an entire segment featuring Harry Belafonte singing "Lord, Don't Stop the Carnival" was deleted. In another of the show's segments, singer Joan Baez paid tribute to her then-husband, David Harris, who was in jail for refusing military service during the Vietnam War. It aired without Baez's explanation of why he had been jailed.

On April 4, 1969, in the midst of tremendous pressure from angry viewers and nervous sponsors, the show was abruptly cancelled. In 1973, the brothers won a breach of contract suit against the network and were awarded $766,000 in compensation.

Tommy Smothers, center, rehearses a dance number with the Blackstone Rangers during a taping of *The Smothers Brothers Comedy Hour* in Hollywood, January 17, 1968. The brothers' politically irreverent brand of humor led to battles with network censors. (AP Photo/David F. Smith)

FCC'S REVOCATION OF BROADCASTING LICENSES

From its creation in 1934, the FCC had the power to fine or revoke the licenses of broadcast stations for airing indecent language. Its power came from 18 U.S. Criminal Code §, which reads:

> Whoever utters obscene, indecent, or profane language by means of radio communication shall be fined not more than $10,000 or imprisoned not more than two years, or both.

Not until the 1960s did the agency pursue many indecency-related cases against the country's broadcasters. One of the first casualties of the FCC's heightened interest in the words that were being shared on the airwaves was a radio station in Kingstree, South Carolina. In 1961, the Palmetto Broadcasting Co. lost its license to operate station WDKD because of Charlie Walker. An announcer and disc jockey, Walker's material, according to the FCC's legal files, "was allegedly coarse, vulgar, suggestive, and susceptible of indecent double meaning." He told raunchy stories, made up names for area towns, such as "Greasy Thrill" for Greeleyville, and "Monkey's Corner's" for Monk's Corners, and on multiple occasions said, "Let it all hang out." The FCC found this material to be "obscene and indecent on its face" and in violation of the law.

Another station that ran afoul of the nation's airwave indecency laws was WUHY-FM of Philadelphia. On January 4, 1970, the station broadcast an interview on its Cycle II program with Jerry Garcia of the musical group The Grateful Dead. The show's purpose was to discuss avant-garde artistic expression. The FCC had been keeping the show on its radar due to earlier complaints, and when it heard about Garcia's language, it pulled the plug on the station. Garcia had used the words "fuck" and "shit" a number of times during his interview. The FCC's rationale was that the language standards of other stations would decline if they failed to make an example of WUHY. These words uttered by Garcia on Cycle II, the agency argued, had "no redeeming social value." Another of the FCC's arguments was that radio was a unique medium because of its nearly universal availability to people of all ages.

After an Oak Park, Illinois, station, WGLD-FM, owned by the Sonderling Broadcasting Corporation, broadcast two call-in show discussions of oral sex, it lost its license in 1973. The FCC didn't argue that discussions of sex were totally off limits, but maintained that the station could have instructed the show's host to handle the subject matter in a way that wouldn't lead to the violation of the law.

These disputes foreshadowed the U.S. Supreme Court's landmark 1978 "Dirty Words" decision that pitted comedian George Carlin against the FCC.

COMEDIAN GEORGE CARLIN'S SEVEN DIRTY WORDS

In 1972, comedian George Carlin first gave his now famous "Seven Words You Can Never Say on Television" monologue, in which he pointedly used "fuck" and

six other "swear words." After performing the routine at a show at the Milwaukee Summerfest, he was arrested for disturbing the peace. A few years later, a Pacifica radio station listener called the FCC to complain that he and his son accidentally heard the words while listening to the radio in the car. After asking Pacifica for a response, the FCC upheld the man's complaint. After years of court actions, in 1978, the U.S. Supreme Court, in a 5–4 vote, supported the FCC's power to ban the routine's seven "Dirty Words" on the airwaves. The decision established a formal indecency regulation in American broadcasting.

The question of what can be said over the airwaves has come up time and again in the history of broadcasting. What makes Carlin's arrest and confrontation with the FCC so compelling is that the purpose of his "Dirty Words" monologue was to encourage people to differentiate between the use of words alone and their use in context. In a 2004 interview on the *Fresh Air* National Public Radio program with Terry Gross, Carlin said he was surprised that so many people don't appear to differentiate between words alone and words in context.

> These words have no power. We give them this power by refusing to be free and easy with them. We give them great power over us. They really, in themselves, have no power. It's the thrust of the sentence that makes them either good or bad.

In 1988, another chapter in the debate about the role of the FCC in the regulation of indecent speech opened. During that year's Congressional session, U.S. Senator Jesse Helms, a Republican from North Carolina, introduced a bill that proposed the elimination of television's 10 p.m. to 6 a.m. safe harbor rule in favor of the 24-hour-a-day monitoring of the airways for indecent and profane speech by the FCC. He said, "Garbage is garbage, no matter what the time of day may be." Immediately after Congress enacted the bill, the Commission modified its rules to reflect its new 24-hour responsibility. Eventually, the D.C. Circuit Court of Appeals ruled that the 24-hour statutory ban on broadcast indecency was unconstitutional, thus reinstating the rule that indecent speech was only punishable if uttered from 6 a.m. to 10 p.m.

Although their voices are drowned out by those who have fought so hard against the airing of indecent speech on the airwaves, not everyone agrees that words typically considered indecent are dangerous. In a 2004 *This American Life* interview with Ira Glass, Timothy Jay, a professor of psychology and author of *Cursing in America* and *Why We Curse*, said:

> Our whole obscenity law is predicated on this idea that exposure to indecent material will deprave or corrupt children . . . But there's no evidence that a word, in and of itself, harms someone. . . . By and large, every normal kid knows how to swear. As soon as kids learn how to talk. . . . they are repeating what their parents and siblings say.

FCC VERSUS RADIO'S SHOCK JOCKS

By the early 1990s, the FCC had demonstrated its power over speech it deemed to be indecent or profane. But over the course of the ensuing decade, the agency increased both the number and size of fines it levied against stations it claimed had violated its indecency rules. This increase was precipitated by the expansion of its power over the airing of offensive material. In 1987, the agency had announced it would not only be concerned with words and pictures alone, but henceforth would scrutinize the broader topics and tone of the programs they were uttered within. In addition, the agency warned that it would not limit its review of programs to the period 6 a.m. to 10 p.m. This enabled the agency to go after so-called "shock jocks," the tawdriest of radio's personalities. The number of FCC indecency actions increased dramatically: From 1970–1986, four stations were fined, compared to five fines for indecent material aired in 1987 alone.

One of the agency's most vigorous anti-smut campaigns was against Infinity Broadcasting's Howard Stern, a radio personality who excelled at pushing societal boundaries of decency. Stern discussed his subjects in a deliberately offensive way. His show ran from 1986 to 2005 at WXRK in New York City (though it was syndicated around the country) before it moved to satellite radio's Sirius XM Radio. During Stern's 20 years at WXRK, he garnered millions of listeners and numerous awards. Widely known as the king of America's "shock jocks," from 1991 to 2003, the FCC levied 13 fines, ranging from $2000 to $600,000, against radio stations that carried episodes of his show.

Other shock jocks and shows with material so offensive that listeners complained about them to the FCC have included, among others, Steve Dahl, Garry Meier, Tom Leykis, Perry Stone, Bubba the Love Sponge, Bob and Tom, Lamont and Tonelli, Kramer and Twitch, Mancow Muller, Opie and Anthony, Deminski and Doyle, Elliot Segal, and the Dare and Murphy Show.

THE "FAMILY VIEWING HOUR" (1975)

In January 1975, the FCC announced that the first hour of primetime television would be reserved for "family-friendly" shows. The policy was implemented in response to the 1974 made-for-TV television movie *Born Innocent*, which featured a lesbian rape scene. In response to the many complaints it received after the show, the FCC pressured the industry to refrain from airing content clearly intended for adults when children were still watching. As a result, the National Association of Broadcasters (NAB) and the three major networks, ABC, CBS, and NBC, agreed to an initiative called the Family Viewing Hour, which mandated that local stations air family-friendly programs from 8–9 p.m. Eastern standard time (EST).

Among the popular shows affected by the new rule was *All in the Family, The Rookies*, and *Kojak*, and few movies were given a family hour slot. In their places, a flurry of uncontroversial new programming was introduced at the major

networks, including new sitcoms like *Happy Days* and *Welcome Back, Kotter*; family dramas like *The Waltons* and *Little House on the Prairie*; superhero shows such as *The Six-Million Dollar Man*; and variety shows including *Cher* and *Tony Orlando and Dawn*.

Television producers claimed their First Amendment rights were violated by the "family viewing hour." It was especially unpopular among the creators and producers of the most popular television shows aired from 8–9 p.m. EST, such as Norman Lear's *All in the Family*. Lear objected to the First Amendment implications of this change, but also worried the show would lose some of its viewers when it was moved to a later time. The Writers Guild of America took up Lear's cause and filed a lawsuit against the FCC, the networks, and the NAB. After the court ruled against the family viewing hour, the FCC appealed, and in 1979, the 9th U.S. Circuit Court of Appeals vacated the district court's 1976 decision, but the family viewing hour was never reinstated.

Since then, there have been periodic calls for the return of the family viewing hour from groups like the Parental Television Council (PTC), an advocacy group founded in 1995 by conservative Roman Catholic L. Brent Bozell III to fight for more family-oriented entertainment programming and less violence and indecency on television. In 2007, PTC published a report full of evidence it claimed warranted the return of the family hour. Titled "The Alarming Family Hour . . . No Place for Children," the PTC report contended, "Only 10.6% of the episodes [studied] were free of any violent and sexual content and foul language."

TELEVISION'S PARENTAL RATING SYSTEM AND THE V-CHIP

Since the 1960s, television has pushed the limits of what society and the FCC will accept by increasing the amount of sexually provocative and violent content in their programs. The federal government responded in 2000 by requiring that American televisions be sold pre-installed with V-chips—devices that make it possible for parents and others who object to violent and sexually provocative programming to block or scramble shows they don't want their kids or other family members to watch. V-chips respond to a rating system established by the FCC-mandated TV Parental Guidelines Monitoring Board. This pair of initiatives puts the onus of deciding what shows children can watch on parents, rather than depending on the government and industry.

The monitoring board's rating system differentiates between programming in the following ways:

- TV-Y—The programs are appropriate for all ages.
- TV-Y7—Designed for children age 7 and up. The FCC states that it "may be more appropriate for children who have acquired the developmental skills needed tell the difference between make-believe an reality.
- TV-G—Most parents would find this programming suitable for all ages.

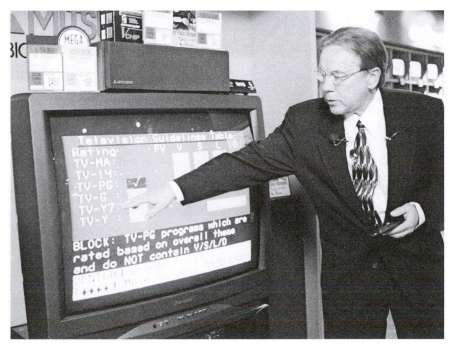

Lawrence Lien, CEO of Parental Guide Inc., shows how the new V-chip is used for blocking television programs containing violence, sex, and inappropriate language at Nebraska Furniture Mart in Omaha, Nebraska, on July 13, 1998. (AP Photo/Cynthia J. Kohll)

- TV-PG—This rating warns parents about material parents may find inappropriate for younger children. Such shows may contain moderate profanity, some sexual content, and/or violence.
- TV-14—Programming with this rating contains material many parents consider problematic for under 14 years of age.
- TV-MA—An MA-rated show should only be viewed by adults and is not suitable for children under 17.

The FCC has also established the following sub-ratings system:

- D—Suggestive dialogue (not typically used with TV-MA)
- L—Coarse language
- S—Sexual content
- V—Violent content, including FV for fantasy violence (exclusive to V-Y7) and E/I, which includes educational and informative (usually used for children's program; exclusive to TV-Y and TV-Y7)

The PTC has periodically urged the FCC to toughen up the Monitoring Board's rating categories. In April 2016, after looking at the current state of the TV ratings in a particular period of time, its researchers were unable to find any TV-G rated shows on the Big Four (ABC, NBC, CBS, and Fox) broadcast networks it studied; they found that graphic violence and sexually explicit content was increasing in frequency and level; and they reported that all content on broadcast television is rated as appropriate for a 14-year-old. In light of these findings, it recommended that the old system be thrown out and redesigned with a return of "family" programming, among other things.

Because judging whether television content should be rated as inappropriate for children of various ages is so subjective, disagreements over certain shows are commonplace. The Parents Television Council (PTC) was established to observe and report on the suitability of television programming for children and society in general. Among the many popular shows it has issued complaints about are *Dexter, Without a Trace, MTV's Skins, Glee,* and *The Walking Dead.* From time-to-time, they "have been successful in helping implement change. In March 2016, after PTC alerted the nation's top 200 advertisers about the violent content in a new miniseries *Of Kings and Prophets*, its parent company, ABC, cancelled it after its first two episodes.

SATURDAY NIGHT LIVE'S "CONSPIRACY THEORY ROCK!" (1998)

The leaders of the corporations that own radio and television never appreciate it when their values and practices become fodder for criticism, especially when it comes from within. This was amply demonstrated when *Saturday Night Live* aired a cartoon called "Conspiracy Theory Rock!" in its March 1998 show. Thereafter, NBC banned it from the episode's reruns. One of the show's popular "TV Funhouse" cartoon segments took aim at NBC, its owner, by depicting it as part of a "media-opoly." When the segment was aired, General Electric (GE) owned NBC, meaning network officials could not air programming that reflected negatively on any of the power company's products, services, or policies.

"FLEETING EXPLETIVES" AND "WARDROBE MALFUNCTIONS"

From time to time, radio and television hosts and guests utter nonscripted profanities. The legal term for such words is "fleeting expletives," and since 2003, when Cher, Nicole Ritchie, and Bono used them on national television during live broadcasts, they have attracted considerable attention.

In 2004, the FCC began censoring "single uses of prohibited words." Previously, the agency had only sent notices to stations, warning them that someone had complained about them. After Fox Television, which was cited for the Cher and Ritchie expletives, filed a lawsuit against the FCC, the U.S. Supreme Court agreed to review the question of whether the agency's order imposing liability on Fox Television was

"arbitrary and capricious" considering its previous acceptance of similar expletives. In 2009, in a contentious 5–4 decision in *FCC v. Fox Television Stations*, the court ruled that the FCC's order was neither "arbitrary" nor "capricious" and remanded it back down to a lower court.

In 2012, however, *FCC v. Fox Television Stations* wound its way back to the Supreme Court again. This time the Court invalidated the fines imposed against Fox for the 2002 and 2003 expletives, claiming the FCC's policy was so vague, it would be difficult to figure out how to avoid violating it.

Additional notable examples of fleeting expletives include the following:

- *Saturday Night Live*—2009—Newcomer Jenny Slate used the "F-word" in a parody of a talk show by biker women.
- *Big Brother*—2010—An argument with lots of muted expletives included one that didn't get bleeped.
- Presidential press conference—2010—Vice President Joe Biden let the "F-word" slip when praising the enactment of Obama's Affordable Care Act.
- Dolphin-Colt football game—2012—A referee said "God damn it!' so loud that it was heard by TV audiences.

In addition to indecent speech, television's "wardrobe malfunctions" have come under the FCC's scrutiny since the nipple of one of singer Janet Jackson's breasts was exposed for a half second during the 2004 Super Bowl halftime show. The incident precipitated a tremendous controversy. The PTC issued a condemnation of the show; the FCC received more than 500,000 complaints; the FCC's Chairman Michael Powell launched an investigation; and the whole thing became a popular topic among disc jockeys and late-night TV hosts.

After concluding its investigation, the FCC imposed a $550,000 fine against CBS. In response, CBS filed a lawsuit to contest the fine, which eventually was invalidated by the Third U.S. Circuit Court of Appeals. In 2012, the U.S. Supreme Court refused to reinstate the fine. The National Football League has announced that MTV, the halftime show's producer, will never again be part of one of their Super Bowl halftime shows.

SPIDER-MAN'S PUNCHINESS (1994–1998)

The over-the-top physical antics of television superheroes like Iron Man, the Incredible Hulk, and Spider Man add to their entertainment value. Some who have written about the shows claim that the networks have ordered their writers to dampen the vigor with which their characters pursue and conquer their enemies. It is widely thought, for example, that there was little punching in FOX's 1994–1998 *Spider-Man* series because its executives forbade all but the mildest physical violence. John Semper Jr., the show's lead writer, disputes this idea. In a

2016 interview with Craig McKenzie, which was published in a blog titled *Kneel Before Blog*, Semper discussed the show:

> My series has been the subject of an urban myth that we had lots of censorship. This drives me crazy . . . [In] comment threads, someone will say, "I really liked that Spider-Man series." And then someone will respond, "I don't like the show because of all the censorship." . . . We did not have lots of censorship. That is a rumor and a myth. . . .
>
> I don't believe that if you're doing a show for kids as young as six years old that your lead character should be socking people in the jaw, especially when he has webbing, which is much more colorful and much more interesting. . . . I wouldn't have him do that because that's just not the way I work. I have to live with myself at the end of the day.

SOUTH PARK AND THE PROPHET MUHAMMAD (2010)

Comedy Central's award-winning animated sitcom *South Park* has often found itself in the midst of controversy because of its taboo-busting humor. Its creators, Trey Parker and Matt Stone, rarely mince words in their irreverent treatment of contemporary politics, social demographics, religion, and pop culture. In the United States, the show is rated TV-MA, which is considered unsuitable for children under the age of 17, and its viewers are also warned that episodes will possibly include indecent language, strong sexual content, and graphic violence.

In one of its many complaints about *South Park*, the PTC called it a "curdled, malodorous, black hole of Comedy Central vomit" that "shouldn't have been made." Arguably, the show's great popularity among young people has added to their concerns. It drew huge audiences from the start, and in season two, the episode "Cartman's Mom Is Still a Dirty Slut" broke basic cable's rating record for a non-sports program.

But Comedy Central drew the line when Parker and Stone included depictions of the Prophet Muhammad in two 2010 *South Park* episodes. The Muslim faith forbids portrayals of the Prophet Muhammad, and some of its members reacted with hostility and even threats. A New York group warned that Stone and Parker "will probably wind up like Theo van Gogh." Van Gogh was a Danish filmmaker murdered in 2004 after the release of his documentary on the abuse of women in Muslim countries. Although Comedy Central ran the episodes, their portrayals of Muhammad were covered by a message that read: "Comedy Central has refused to broadcast an image of Muhammad on their network."

DUKES OF HAZZARD CONFEDERATE FLAG CONTROVERSY (2015)

The television series *Dukes of Hazzard* aired on CBS from 1979 to 1985. The program followed the adventures of cousins Bo and Luke Duke, who live on a farm in

fictional Hazzard County, Georgia, with their cousin and uncle. The pair manage to get into a lot of trouble as they drive around chasing crooks in their customized 1969 Dodge Charger stock car named "The General Lee." The car's roof is emblazoned with a Confederate flag, and the words "General Lee" are painted over each of its doors.

When the original series ended in 1985, it was picked up for syndication by a number of stations and cable channels, including TV Land. In 2015, however, TV Land announced it was cancelling the show's reruns because of its tacit approval of racism through its association with the Confederacy. This action followed a shooting at a historically African American church in Charleston, South Carolina, by a white supremacist who frequently featured the flag as a symbol of his racist beliefs on social media.

Actor Ben Jones, who played Cooter Davenport on the show, defended its use of the flag. The Confederate flag, he wrote on his Facebook page, is "a symbol that represents the indomitable spirit of independence." But critics of the flag's prominence on the program expressed disapproval.

In the meantime, the Confederate flag itself came under greater scrutiny than ever before in the wake of the racially motivated South Carolina mass shooting. The state's governor, Nikki Haley, and President Barack Obama called for its removal from South Carolina's capitol grounds. In his eulogy for the church's slain pastor, President Obama proclaimed that taking down the flag was the right thing to do but that "God doesn't want us to stop there."

FURTHER READING

Bozell III, L. Brent (2004). "Winners and Losers, 2004," Media Research Center. http://www.mrc.org/bozells-column/winners-and-losers-2004.

Bozell III, L. Brent (2007). "The Alarming Family Hour: No Place for Children, A Content Analysis of Sex, Foul Language and Violence During Network Television's Family Hour," Los Angeles, CA: Parents Television Council, September 5.

Brainard, Lori A. (2004). *Television: The Limits of Deregulation*. Boulder: Lynne Rienner.

Glass, Ira (2004). "Propriety," *This American Life*, National Public Radio, June 11, http://www.thisamericanlife.org/radio-archives/episode/267/transcript.

Griffin, Drew, and Tim Lister (2010). "Islamic Group: 'South Park' Post a Call to Protest, Not Violence," CNN, April 21, http://www.cnn.com/2010/SHOWBIZ/TV/04/21/south.park.islamic.reaction.

Gross, Terry (2004). Interview with George Carlin, *Fresh Air*, National Public Radio, November 1, http://www.npr.org/templates/story/story.php?storyId=4136881.

Hilmes, Michele, and Jason Loviglio (2002). *Radio Reader: Essays in the Cultural History of Radio*. New York: Routledge.

Huber, Peter (1997). *Law and Disorder in Cyberspace: Abolish the FCC and Let Common Law Rule the Television*. New York: Oxford University Press.

Jay, Timothy (1999). *Why We Curse: A Neuro-Psycho-Social Theory of Speech*. Amsterdam, The Netherlands: John Benjamins Publishing Company.

Levi, Lili (2008). "The FCC's Regulation of Indecency." *First Reports*, 7(1). The First Amendment Center.

McCrummen, Stephanie, and Elahe Izadi (2015). "Confederate Flag Comes Down on South Carolina's Statehouse Grounds," *Washington Post*, July 10.

McKenzie, Craig (2016). "Interview with John Semper, Jr.," June 8, http://kneelbeforeblog.co.uk/interviews/john-semper-jr.

Pondillo, Robert (2010). *America's First Network TV Censor: The Work of NBC's Stockton Helffrich*. Carbondale, IL: SIU Press.

Rice, Lynette (2014). "Carl Reiner Looks Back on *Dick Van Dyke Show* Finale," *Entertainment Weekly*, April 21, http://www.ew.com/article/2014/04/21/carl-reiner-looks-back-on-dick-van-dyke-show-finale.

"Transcript: Obama Delivers Eulogy for Charleston Pastor, the Rev. Clementa Pinckney" (2015). *Washington Post*, June 26.

NINE

The Internet

INTRODUCTION

The Internet as we know it today is a complex set of electronic, digital, and communication technologies that together make it possible to connect computers and send and receive text, graphics, voice, video, and computer programs. Its development began in the late 1950s, but not until the World Wide Web was established in 1989 did the Internet become known to many people outside the engineers, computer scientists, physicists, and government leaders across the globe who contributed to its spectacular growth.

From a practical standpoint, the Internet has led to the rapid reconfiguration of many of society's institutions and industries, and inspired innovation. But because historical change is always a two-way street, the Internet has also been shaped by society's needs and demands. Such dynamics extend to the relationship between the Internet and popular culture. Although they don't completely overlap, each of them affects the other.

The dialectical relationships among the Internet, society, and popular culture are visible in the disputes that arise over online freedom of speech. Conflicts arise almost daily concerning where freedom should begin and end on the Internet. The debates they trigger are visible in the news, public debate, the education system, and the courts. Society is currently undecided about who should control the Internet, where we can or can't use it, and what kind of content should or shouldn't be allowed on it.

When radio was first introduced to the public, multiple questions arose about who should be responsible for regulating and monitoring the content carried over this new technology. Broadcasting was an entirely new medium with technical aspects that made it much different from newspapers. To deal with the difficulties of spectrum interference, for example, radio station operators needed the

government to step in to manage who would be allotted places on the dial. In a similar vein, during the past decade, questions about who should control the Internet have arisen, sparking a fierce debate over the concept of net neutrality.

Net neutrality is the principle that Internet service providers should not be permitted to favor or block users' access to content, applications, products, or websites. Internet service providers (ISPs) and other tech industry people tend to see net neutrality as a form of government regulation that makes the Internet less free. In contrast, advocates of a totally open and free Internet argue that if industry leaders are allowed to favor or block content or applications at will, the medium will not be free. They assert that without net neutrality rules, powerful corporations and groups would dominate the Internet—and marginalize less powerful voices in the process.

After several years of intense debate, lobbying, journalistic reporting, commentary, and public hearings, the Federal Communication Commission (FCC) adopted a set of rules to support what they refer to as an "Open Internet." The program went into effect on June 12, 2015. The FCC's website includes the following statement about the mission of an Open Internet:

> Open Internet rules are designed to protect free expression and innovation on the Internet and promote investment in the nation's broadband networks. The Open Internet rules are grounded in the strongest possible legal foundation by relying on multiple sources of authority, including: Title II of the Communications Act and Section 706 of the Telecommunications Act of 1996. As part of this decision, the Commission also refrains (or "forbears") from enforcing provisions of Title II that are not relevant to modern broadband service. Together Title II and Section 706 support clear rules of the road, providing the certainty needed for innovators and investors, and the competitive choices and freedom demanded by consumers.

ISPs are opposed to the FCC's new rules. Their representatives argue such governmental oversight will hurt consumers because they won't be free to make management decisions that serve the "best interests" of Internet users. Thus, they claim, the Internet will become less, rather than more, open.

THE CHILD PORNOGRAPHY PREVENTION ACT (1996)

By the mid-1990s, many Americans were upset about the kind of graphic sexual content that was proliferating on the Internet. In response, the U.S. Congress enacted a series of federal laws designed to restrict indecent, profane, and obscene Internet content. Most of these laws were never put into effect because the courts found them to be violations of the First Amendment to the U.S. Constitution.

The Child Pornography Prevention Act (CPPA) was enacted in 1996. The law included a provision that expanded the definition of child pornography to criminalize "virtual child pornography," also known as "morphed" child pornography.

More specifically, the law outlawed the dissemination of images that appear to portray children, but which actually display images of adults made to look like children.

In 2002, in *Ashcroft v. Free Speech Coalition*, the U.S. Supreme Court struck down the CPPA, for the following reasons:

> First, the law, as written, is overbroad, prohibiting otherwise legal, non-obscene images depicting teenagers engaging in sexual activity, such as filmed depictions of Romeo and Juliet or Lolita.

> Second, the prohibition of child pornography is based on the link between the creation of the image and the sexual abuse of the children shown in the image. If an image is created by use of computer technology or by photographing adults pretending to be children, there is no basis in the law to ban the image.

THE COMMUNICATIONS DECENCY ACT (1996)

Also in 1996, Congress passed the Communications Decency Act (CDA). The CDA consisted of two parts: one that banned obscene and indecent material on the Internet, and a second, Section 230, that exempts operators of Internet services from legal liability for words used by people who post on their sites. Section 230 has been a boon to ISPs, but the section of the law that pertained to indecent speech did not survive a challenge from the American Civil Liberties Union, which argued that it was an unconstitutional abridgement of the First Amendment. The decision, titled *Reno v. American Civil Liberties Union*, was announced in 1997. The Court stated that the indecency clause of the act violated the First Amendment largely because it failed to define "indecent" clearly enough. As a result, it would kill speech that is not legally indecent.

CHILD ONLINE PROTECTION ACT (1998)

Not long after the court's decision, in 1998, the U.S. Congress enacted the Children's Online Privacy Protection Act (COPPA), which was narrower in its definition of the kinds of indecent material it mandated should be off limits to minors. In 2004, the U.S. Supreme Court invalidated the law in *Ashcroft v. American Civil Liberties Union*. It reasoned that if the law's provision requiring online publishers to prevent children from accessing "material that is harmful to minors" were enacted, it would violate the First Amendment because of the overbreadth and vagueness doctrines. The overbreadth doctrine is a principle used in some First Amendment cases to scrutinize laws that punish constitutionally protected speech or conduct along with speech or conduct that is not protected to fulfill a compelling government interest. The vagueness doctrine is closely related and means that a law cannot be enforced if it is so vague or confusing that it is difficult to discern what it prohibits.

THE OFF-CAMPUS ONLINE RIGHTS OF HIGH SCHOOL STUDENTS (1990s–PRESENT)

Public school teachers and administrators can limit the online speech of students at school, but what about off campus? As the Internet has grown in popularity, numerous courts have addressed this question. The first case to do so was decided in 1998 by a U.S. Federal District Court in the State of Missouri.

The dispute, titled *Beussink v. Woodland R-IV School District*, began when Brandon Beussink used profanity in a statement he published on his personal website, using his own computer, that criticized his high school. School officials at Woodland R-IV High School in Marble Hill, Missouri, subsequently suspended Beussink for 10 days and ordered him to remove the offending material from his site. Beussink flunked the semester because of the days he was forced to miss school, meaning he would not be able to graduate with his class.

In response, Beussink and his father asked a federal district court to order the school to rescind its punishment orders. The court sided with them, asserting that administrators had failed to provide convincing evidence that Beussink's webpage would lead to substantial disruption within the school. The court's opinion stated:

> Provocative and challenging speech, like Beussink's . . . is most in need of the protections of the First Amendment. Popular speech is not likely to provoke censure. It is unpopular speech that invites censure. It is unpopular speech that needs the protection of the First Amendment. The First Amendment was created for this very purpose.

Since the Beussink decision, many courts have addressed this and similar questions pertaining to students' use of off-campus computers, websites, and social media to criticize schools, administrators, and teachers. The results have been mixed, and in 2016, Judge John E. Jones III commented on the need for more clarity in an opinion he wrote in *R.I. v. Central York School District*. This case concerned Central York School District's 23-day suspension of a student for posting a bomb threat on Facebook. Jones ruled that the suspension did not violate the student's First Amendment rights, but suggested the Supreme Court ought to step in to help the lower courts make their decisions. He wrote:

> Schools need clear guidance from . . . Circuit [Courts] or the Supreme Court as to whether and when they can regulate off-campus speech. Once a clearer rule is pronounced, schools would be well advised to revise their disciplinary policies to clearly outline when off-campus student speech or conduct can be regulated by the school.

Jones's comments may have been in reaction to the fact that in 2016 the Supreme Court declined to review *Bell v. Itawamba County School Board*, a case in which the lower courts were not able to agree on where to draw the line between free and censorable off-campus student speech.

REGULATING ONLINE CONTACT BETWEEN STUDENTS AND TEACHERS

In 2007, the Associated Press published research that indicated that between 2001 and 2005, the credentials of 2570 teachers had been revoked because of sexual misconduct. Some claim the Internet and social media are aggravating the problem, and high-profile child abuse scandals in the news seem to validate their concerns. A well-known case involves the state of Missouri, where, during the summer of 2011, the legislature approved a bill (SB 54) that allowed its schools to discipline teachers and other school personnel for communicating with students online if they failed to notify school officials and parents that they were doing so.

The bill's author, Senator Jane Cunningham (R-Chesterfield), named the law after Amy Hestir, who years earlier had testified that a junior high school teacher had used the Internet to talk her into having a sexual relationship. Eventually, the teacher left Hester's school, but because he was allowed to transfer to other Missouri schools, he was able to repeat his offenses. Cunningham wanted to make sure that teachers fired for sexually abusing students at one school could not be hired elsewhere in the state's educational system. Brian Heaton reported in *Government Technology* on August 3, 2011, that Cunningham said:

> One school district would let somebody go for sexual misconduct, they would sign a confidentiality agreement and even sometimes pay severance to keep everybody shut up—and that educator would go on to the next district and [the misconduct] would continue jumping from one district to another, passing the trash.

The response to the passage of the bill was mixed. Some argued it was a step in the right direction, but others claimed it wasn't the right solution to the problem. Just before the bill was set to go into effect, the Missouri State Teachers Association (MSTA) filed a lawsuit against the state, seeking to stop the state from enacting the section of the law (Sec. 162.069) that would prevent teachers from interacting with students on non-work-related websites without school or parental knowledge. MSTA leaders claimed the law, if allowed to go into effect, would impair the constitutional rights of school district employees. In addition, they said it would make it harder for teachers and coaches to do their jobs. For example, the law would stop the use of online chat functions, a strategy used by some teachers to make it easier to answer students' questions. And text messaging, which is used by some teachers and coaches as a primary means of communication with students, would also be banned.

After a Missouri trial court issued an injunction that prevented the law from going into effect because "the statute would have a chilling effect on speech," Democratic Governor Jeremiah W. (Jay) Nixon called a special session of the legislature to work on the bill's wording. After his request was ignored, Cunningham and members of MSTA worked together to revise the bill. In October of 2011, Nixon signed the new bill, one that eliminated SB 54's Section 162.069.

Missouri is not the only place where public officials and educators have addressed the thorny problem of regulating social media interactions between teachers and students. In 2009, the Louisiana Legislature enacted a law that has not yet been subjected to a legal challenge, categorically banning teacher–student communication on social-networking sites. In Ohio, the Dayton Public School District has implemented a similar policy. And a New Jersey law requires school districts to adopt policies on social media contacts between teachers and students. Challenges to such laws and policies may be coming, because some legal experts argue that such bans and policies stifle speech between teachers and students that in most cases is totally appropriate—and often beneficial to students.

SOCIAL MEDIA, ONLINE BULLYING, AND SUICIDE

Tina Meier of St. Charles, Missouri, holds pictures of her daughter, Megan, who committed suicide in October 2006, after receiving cruel messages on her MySpace account, November 19, 2007. On May 15, 2008, a federal grand jury indicted Lori Drew of suburban St. Louis, for her alleged role in perpetrating the hoax against Megan. (AP Photo/ Tom Gannam)

The Internet and social media allow people to communicate, congregate, and share information in new and exciting ways. Sadly, there are people who use this new technology to cruelly deceive and attack or openly bully those they consider easy targets. In light of a number of highly publicized suicides linked to bullying on social media, family and friends of victims of such bullying, together with social and mental health workers, student advocates, and lawmakers are searching for ways to stop what appears to be a growing problem.

One of the best-known cases connecting social media to suicide happened in 2006, when a 13-year-old Missouri girl hung herself after receiving a MySpace message from a boy she had developed a crush on. The post read, "The world would be a better place without you." In fact, the boy didn't really exist; the mother of the bullied girl's former friend

created his identity and sent the series of posts, with help from her daughter and an 18-year-old family friend, that helped precipitate the tragedy. In November of 2008, a Los Angeles federal jury convicted Lori Drew on three misdemeanor charges of computer fraud for her involvement in creating the account and its phony message. Shortly after her conviction, Drew filed a motion for acquittal, and on August 28, 2009, U.S. District Judge George H. Wu granted Drew's motion and overturned the jury's guilty verdict. Wu explained that if Drew's convictions were allowed to stand, a "multitude of otherwise innocent Internet users [would be turned] into misdemeanant criminals."

By 2016, 15 state legislatures had enacted laws that make the use of the Internet to bully someone a crime. No anti-cyberbullying law has been enacted on the federal level, although federally funded universities that do not come to the aid of students who are being severely harassed on the Internet are in violation of civil rights laws.

ONLINE MUSIC AND DIGITAL RIGHTS MANAGEMENT

You can't always do what you want with the digitally formatted songs, albums, or music videos you purchase on the Internet. This is because Internet-based businesses and organizations that feature music, such as iTunes and YouTube, are involved in digital rights management (DRM). DRM policies are designed to prevent the unauthorized distribution of copyright-protected media such as music, video, books, and film by Internet users. For example, iTunes limits the number of copies their customers can make of songs or albums they purchase, and YouTube requires anyone who wishes to upload videos to their site to promise they will comply with its "terms of service," which forbids the uploading of copyrighted material without an owner's permission.

The U.S. Digital Millennium Copyright Act (DMCA) of 1998 provides the foundation of digital rights policies. The section of the act that deals with the uploading of copyrighted material online is titled the Online Copyright Infringement Liability Limitation Act (OCILLA). Section 512(c) of OCILLA offers safe harbor protection to online service providers for the online aggregation and storage of copyrighted material uploaded by site users, as long as service providers abide by its requirements. Under their required "notice and takedown" policies, if service providers fail to remove uploaded material they are convinced violates copyright law, they lose their safe harbor status. In addition, the operators of Internet sites are prohibited from editing, cropping, or changing the intellectual property uploaded by their users in any way.

Critics of content aggregators' "notice and takedown" policies contend that they are having a chilling effect on content creators whose fear of reprisals discourages them from sharing their content. Patrick McKay, who writes for a website titled FairUseTube.org, informed the site's readers in an April 4, 2013, article about what happened to a YouTube user named John who mainly uploads his reviews of old vinyl records. After John posted a seven-minute video of himself in his kitchen

talking about an old record by Eric B. & Rakim, Universal Music Group (UMG) told YouTube to take it down.

After his video was taken down, John sent a counter-notice to YouTube, arguing that its inclusion of a couple of short clips (less than a minute) of himself playing low-quality snippets from the record for critical commentary and review was protected by the fair use doctrine. In response to John's counter-notice, YouTube sent him an email informing him that the takedown order would stand. They informed John, "YouTube has a contractual obligation to this specific copyright owner that prevents us from reinstating videos in such circumstances."

McKay criticized YouTube's rationale for refusing to honor John's counter-notice with the following statement:

> This message is extremely disturbing for multiple reasons. It appears that YouTube is saying it essentially has a contract with UMG to ignore DMCA counter-notices sent against its copyright claims, so that even if the copyright takedown has no legal basis, YouTube must nevertheless refuse to restore the video if UMG "reaffirms" the information in its DMCA notice. . . . So the user is stuck. Their video could be fair use, in the public domain, or contain no UMG content whatsoever, but as long as UMG "reaffirms" their takedown notice. . . . YouTube will refuse to restore the video. YouTube and UMG (and possibly other copyright holders) have made a contractual end-run around the DMCA notice and counter-notice process, giving certain preferred copyright holders a free pass to take down any video on YouTube they wish with impunity, having been guaranteed that their takedowns will be immune from counter-notices.

Relief from the kind of abuses illustrated by this example may be in sight for content creators. In September 2015, the U.S. Court of Appeals for the Ninth Circuit ruled that copyright holders must consider fair use prior to issuing takedown notices for potentially infringing content. The author of the opinion in *Lenz v. Universal Music Corp* stated:

> Copyright holders cannot shirk their duty to consider—in good faith and prior to sending a takedown notification—whether allegedly infringing material constitutes fair use, a use which the DMCA plainly contemplates as authorized by the law.

Another episode in DMCA's takedown notice campaign started late in 2015, when the U.S. Copyright Office announced it would accept public comments on the effectiveness of the law's safe harbor provisions. The office told the public they would have from approximately February 1 until March 21 to send them their comments. By early March, the office had heard from only a few people. In response, digital rights organizations launched a campaign to make people aware of the impending deadline. As a result, the Copyright Office received more than 100,000

comments by March 21, many of which urged them to change the act's fair use and free speech protections.

One of the fiercest critics of web aggregators' "notice and takedown" policies, Evan Greer, campaign director of Fight for the Future, wrote:

> Copyright laws are among the biggest threat to freedom of expression in the digital age. Taking down content from the Internet en masse doesn't benefit artists and individual creators, it benefits large corporations. I supported my family as a musician for years before coming to Fight for the Future, and I believe creators should be compensated for their work. But the Internet is the best thing to ever happen to creative people and independent artists. We need to fight to defend it from those pushing censorship in our names.

Digital rights activists have long been incensed by such "abuses," which they argue are the result of the unfair and inefficient system imposed by the DMCA. Examples abound of "notice and takedown" orders that aggravate those seeking to protect the fair use rights of those subjected to punishment for crimes they don't believe they've committed.

LIMITATIONS ON EMPLOYER INTERNET AND SOCIAL MEDIA USE

The popularity of the Internet, smartphones, and social media has blurred the line that separates peoples' work and personal lives. Today, employees frequently use their smartphones and work computers to access Facebook and other social media platforms at work, even when doing so isn't part of their job description. A 2016 research study published by the Pew Research Center for the Internet reports that 34 percent of American workers use social media platforms to take mental breaks, and 27 percent use them to connect with friends and family. To control such behavior, employers often enforce rules that limit their employees' use of the Internet at work. In addition, some employers establish rules regarding their employees' use of Internet and social media outside of work.

Employers are generally on safe legal ground when they limit their employees' use of company-owned technology to activities related to their jobs, and use technology to monitor employees' compliance with such rules. Whether the employees work for private businesses or public agencies doesn't matter. In contrast, because of laws and ordinances that limit how employers limit their off-duty use of their own communication devices to access the Internet, employers must be careful only to limit such activity if they can establish that doing so would undermine their legitimate business interests.

Another thing employers, public or private, must avoid is the unlawful limitation of their employees' First Amendment rights. For example, in *Bland v. Roberts* (2012), a U.S. Circuit of Appeals ruled that it is a violation of employees' First Amendment rights to order them to click, or not click, Facebook's "Like" button. Another protection afforded workers is assured by the National Labor Relations

Board (NLRB), which protects the rights of employees to use communication technologies to discuss their employer's policies or treatment of their staff.

FLASH-MOBS AND CELL PHONES (2010–2011)

Flash mobs are public gatherings quickly organized and dispersed by smart phones, that is, cell phones equipped with email, text messaging software, and social media. They are held for various reasons, including for political or commercial purposes, or for satirical or artistic expressions. The use of the term for this phenomenon started in 2003, after Bill Wasik, a senior editor at *Harper's Magazine*, organized the convergence of 130 people at the rug department of New York City's Macy's department store. The participants sought the attention of sales consultants about purchasing a "love rug" for their "suburban commune." Within a few years, flash mobs grew in popularity, especially in large urban areas. Pillow fights were held in New York, group disco routines in London, and huge snowball fights in Washington. In a March 24, 2010, *New York Times* interview with Ian Urbina, Wasik said he started the 2003 event as a "kind of playful social experiment meant to encourage spontaneity." Unfortunately, some flash mobs by that time were more like brawls that included assaults and vandalism. Local authorities began to crack down on them.

In 2010, in Philadelphia, police stepped up enforcement of the city's local curfew and announced they would hold parents legally responsible for any damage their children were responsible for during flash mob events. During that year, four flash mobs had broken out in the city, resulting in injuries and arrests.

Up to that point, public officials hadn't banned the use of cell phones in public places to make it harder to organize flash mobs. But this is what happened in 2011, in California's San Francisco Bay area. On July 11, protesters met at Bay Area Transit Authority (BART) railway station where, a week before, its security officers had fatally shot a man. The protesters' actions, according to BART, led to serious disruptions throughout the system. Service disruptions occurred as a result of the protest meetings. Anticipating further trouble, on August 11, BART announced it was shutting down Internet and cell phone service from 4 p.m. to 7 p.m. at certain railway terminals, an act its officials claimed was necessary to preserve public order.

The shutdown made it impossible for protesters to organize the August 11 gatherings they'd been planning. Simultaneously, the ban led to outrage among commuters, civil libertarians, and an activist international hacker network known as Anonymous, whose members proceeded to shut down BART's official website for six hours. In addition, the hacker group released the names, home addresses, and e-mail addresses and passwords of more than 100 BART security officers.

Across the nation, defenders of free speech issued statements criticizing BART's actions. The Electronic Frontier Foundation (EFF), a nonprofit organization formed to defend civil liberties in the digital world, for example, issued this statement:

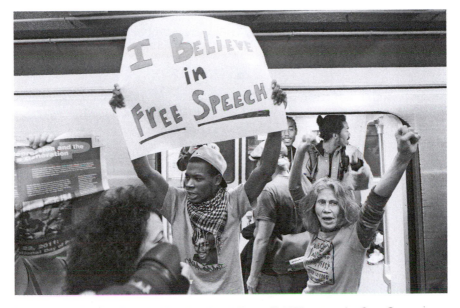

Protesters stand in the door of a Bay Area Rapid Transit (BART) train at the Civic Center station in San Francisco, August 15, 2011. Demonstrators and computer hackers targeted BART for shutting down wireless service at Civic Center on August 11, to quell a brewing protest over a shooting by transit police. (AP Photo/Jeff Chiu)

One thing is clear, whether it's BART or the cell phone carriers that were responsible for the shut-off, cutting off cell phone service in response to a planned protest is a shameful attack on free speech. BART officials are showing themselves to be of a mind with the former president of Egypt, Hosni Mubarak, who ordered the shutdown of cell phone service in Tahir Square in response to peaceful, democratic protests earlier this year. . . . Freedom of expression is a fundamental right. Censorship is not okay in Tahir Square or Trafalgar Square, and it's still not okay . . . [at San Francisco's] Powell Street Station.

Along with others, the EFF filed complaints against BART at the Federal Communication Commission (FCC), recommending that it forbid cell phone shutdowns during future protests. BART defended its shutdown of cell phones and the Internet at its platforms as a means to protecting its employees and the public at large. Its officials said that legally sanctioned protests could be held at BART sites, but not on its railway platforms. In December 2011, to accommodate the First Amendment, BART created a new policy that allows for the shutting down of services only under extraordinary circumstances. Its policy reads that shutdowns can only be imposed when there is

Strong evidence of imminent unlawful activity that threatens safety ... [and] the interruption will substantially reduce the likelihood of such unlawful activity ... [and] such interruption is narrowly tailored ... [as] necessary to protect against unlawful activity.

The policy includes examples of situations where the shutting down cell phone and Internet communication would be warranted, such as when BART had strong evidence that cell phones would be used to detonate explosives, or to facilitate someone's plans to destroy public property or disrupt train service.

SMARTPHONES AT SCHOOL

There's no doubt that kids love smartphones, and want to use them wherever they go, even at school. According to a 2013 research report by Grunwald Associates and the Learning First Alliance, *Living and Learning with Mobile Devices*, 51 percent of high school students and 28 percent of middle school students carry smartphones with them to school everyday. What they can do with them once they get there, however, depends on the perspectives and policies of those in charge.

School administrators must take two pieces of federal legislation into consideration when planning their mobile communication device policies: the Children's Online Privacy Protection Act (COPPA) and the Children's Internet Protection Act (CIPA). COPPA was enacted to protect children under 13 from having their personal information collected by website operators without parental consent. CIPA, on the other hand, requires schools and libraries that receive federal funds to install Internet filtering systems on their computer networks so offensive content can't be accessed on them.

Beyond these federal requirements, state and local school officials can make up their own minds about the use of mobile communication devices in classrooms, halls, lunchrooms, and other school facilities. Not surprisingly, their rules and guidelines vary widely. Whereas some school districts allow students to use their phones in the halls and in classrooms, others ban them entirely. Among them is the Prince George County School District in Maryland, which not only forbids students from using their phones at school but has also banned the posting on social media sites of photos taken on school property, including those taken at sporting events, dances, and other extracurricular activities.

Not everyone is supportive of such strict policies. In "Can Social Media and School Policies be 'Friends'?" published in the winter 2011 issue of ASCD's "Policy Priorities" column, S. Craig Watkins, an author and University of Texas educator, discussed his views on the value of allowing students to use communication technologies at school. He argued that allowing students in all socioeconomic groups to engage through use of social media will help close the digital divide by teaching them to become responsible contributors to the online world.

[OVER]REACTIONS TO THE PUBLIC'S USE OF SOCIAL MEDIA

Elected and appointed public officials periodically demonstrate how careful they ought to be when they are tempted to censor or otherwise chastise members of the public for tweets or other social media messages they don't especially like. On November 21, 2011, on a field trip at the Kansas State Capitol, Shawnee Mission East High School senior Emma Sullivan jokingly tweeted in reference to a speech made by Gov. Sam Brownback, "Just made mean comments about gov brownback [*sic*] and told him he sucked, in person #heblowsalot." After Brownback's office put pressure on Shawnee Mission school officials to punish Sullivan, she was called into the principal's office and told to write a letter of apology to the governor. With the support of her parents, she refused to do so. After the incident drew national attention, Brownback issued the following statement: "My staff over-reacted to this tweet, and for that I apologize. Freedom of speech is among our most treasured freedoms." Sullivan's Twitter followers grew from 60 to more than 10,000 followers in the wake of the incident.

In June 2013, another state governor aroused considerable controversy with his response to uncomplimentary Facebook posts. The incident started when Indiana Gov. Mike Pence commented on the recent U.S. Supreme Court's decision on the Defense of Marriage Act (DOMA) on his Facebook page. Pence's comment lamented the fact that the court had struck down the controversial act. It read:

> I believe marriage is the union between a man and a woman and is a unique institution worth defending in our state and nation. For thousands of years, marriage has served as the glue that holds families and societies together and so should it ever be.

Within 24 hours, Pence's remark attracted approximately a thousand comments, and it wasn't long before his staff began deleting those posted by people who disagreed with the governor's position on DOMA. When criticized for allowing his staff to act as censors, he defended the removal of the posts on the basis of the office's policy forbidding obscene and indecent posts and personal attacks. After further consideration, however, Pence used Facebook again, this time to apologize for his staff's removal of the comments that criticized the governor. He wrote that "on careful review, it appear [*sic*] that . . . some comments were being deleted simply because they expressed disagreement with my position. I regret that this occurred and sincerely apologize to all those who were affected."

A few months later, in Washington, D.C., Washington Metropolitan Area Transit Authority (WMATA) officials were so irritated with one of the agency's most persistent critics that they decided to block him from following WMATA's Twitter feed. Transit authority watchdog Chris Barnes had been using Twitter to critique WMATA, and by May 2013, the agency's staff decided to pull the plug on him. The publicity that the blocked account attracted made matters worse for WMATA. Barnes became even more notorious for his criticism of the transit authority after he established a rider advocacy group, called MetroTAG.

These incidents and the others like them that are leading to the public embarrassment of elected and appointed officials demonstrate the restraint they should exercise when using social media. Social media experts recommend that the best way for them to react is to simply turn the other cheek.

THE *FREE THE NIPPLE* DEBATE ON SOCIAL MEDIA (2015)

In 2015, a debate erupted over Facebook and Instagram's alleged "double standard" policy regarding the display of naked upper torsos. Both social media titans had policies that allowed male users—but not female members—to post photos that showed their nipples. Facebook and Instagram allow female breasts to show as long as no areola is visible. The issue has long been prominent among feminists but grew in stature with the 2014 release of a film titled *Free the Nipple*, which tells the story of a group of New York City women who go topless to fight the censorship of women's bodies.

Photographer Lina Esco directed *Free the Nipple*, which centers on the argument that it is hypocritical for social media sites and others to censor women's bodies in a media-dominated entertainment environment where killings are glorified. Esco questioned why Facebook and other social media sites blocked her after she posted her film's teaser on her accounts. Stressing her belief that the issue isn't merely a lifestyle question, but one about women's well-being, Esco highlighted the injustice inherent in the fact that women are still being arrested for going topless in places where it's legal for them to do so. She learned that Facebook and Instagram allow users to post images of mutilated dead bodies but censor any images that include female nipples as violations of their terms of service.

The film ignited further criticism of society's double standard regarding topless females across the globe, and celebrities such as Miley Cyrus, Amber Rose, Scout Willis, Naomi Campbell, Norman Reedus, and Matt McGorry, among others, joined the campaign. The *New York Times* reported early in 2016 that Google trends research indicated that the search term "free the nipple" had surpassed phrases like "equal pay" and "gender equality."

Despite the uproar, Facebook and Instagram have refused to alter their anti-nipple restrictions. Under the heading "Encouraging respectful behavior," Facebook's nudity policy states the following:

> We restrict the display of nudity because some audiences within our global community may be sensitive to this type of content—particularly because of their cultural background or age. . . . We remove photographs of people displaying genitals or focusing in on fully exposed buttocks. We also restrict some images of female breasts if they include the nipple, but we always allow photos of women actively engaged in breastfeeding or showing breasts with post-mastectomy scarring. We also allow photographs of paintings, sculptures, and other art that depicts nude figures.

"TRUE THREATS" AND FACEBOOK (2015)

In 2015 the U.S. Supreme Court ruled on its first Facebook case. *Elonis v. United States* arose after Anthony Elonis challenged his criminal conviction under a federal anti-threat statute (18 U.S.C. § 875c) for issuing threats against his ex-wife, coworkers, a kindergarten class, and local police, on Facebook. Distinct from threats made for humorous purposes in everyday life, a "true threat" is a communication that is so serious that those who issue them can be prosecuted under criminal law. The U.S. Supreme Court created the concept in the 1969 decision *Watts v. United States*. The case arose after a man who threatened to shoot President Lyndon B. Johnson was convicted under a law that makes it a crime to threaten the president. The Court agreed that "true threats" are not protected speech, but argued that not all "vehement, caustic, and sometimes unpleasantly sharp" speech aimed at others should be restricted. Before deciding whether statements are true threats, courts must consider them within their contexts, and must distinguish them from mere hyperbole. The court overturned Watts' conviction because it did not believe that his statement was a true threat.

At trial, Elonis asked the court to dismiss the charges against him, arguing that his Facebook comments were not meant as real threats. He said that he was an aspiring rap artist and that his words were merely a form of artistic expression and a way for him to deal with the events in his life. He compared his words to those in a song he said he had parodied. In addition, he reminded the court that on several of his Facebook comments, he posted a disclaimer that read, "This is not a threat."

The trial court convicted Elonis and sentenced him to 44 months imprisonment and three years of supervised release. Elonis appealed his conviction to the U.S. Court of Appeals for the Third Circuit, which affirmed the lower court's decision. The U.S. Supreme Court agreed to review the case, and on June 1, 2015, its majority issued a judgment reversing the previous courts' rulings. The author of the majority opinion, John G. Roberts Jr., wrote that prosecutors must do more than prove that reasonable people would view the statements in question as true threats. A defendant's state of mind, for example, should be considered, as well as contextual matters. Legal experts believe that this ruling will make it more difficult for prosecutors to obtain convictions in cases involving threats issued on Facebook or other social media.

FURTHER READING

Belli, Luca, and Primavera De Filippi, eds. (2015). *Net Neutrality Compendium: Human Rights, Free Competition, and the Future of the Internet*. New York City: Springer Publishing.

Citron, Danielle Keats (2014). *Hate Crimes in Cyberspace*. Cambridge, MA: Harvard University Press.

Fight for the Future (2016). "Nearly 100,000 Internet Users Call for Copyright Office to Improve Fair Use and Free Speech Protections in DMCA," *Fight for*

the Future, April 4, https://www.fightforthefuture.org/news/2016-04-04-nearly-100000-internet-users-call-for-copyright.

Galperin, Eva (2011). "Bart Pulls a Mubarak in San Francisco," Electronic Frontier Foundation, August 12, https://www.eff.org/deeplinks/2011/08/bart-pulls-mubarak-san-francisco.

Goldsmith, Jack, and Tim Wu (2008). *Who Controls the Internet: Illusions of a Borderless World*. New York: Oxford University Press.

Heaton, Brian (2011). "Social Media Between Students and Teachers Restricted in Missouri," *Government Technology*, August 3, http://www.govtech.com/policy-management/Social-Media-Between-Students-Teachers-Restricted-Missouri.html.

Jeong, Sarah (2015). *The Internet of Garbage*. Jersey City, NJ: Forbes Media.

McKay, Patrick (2013). "YouTube Refuses to Honor DMCA Counter-Notices," *FairUseTube*, April 4, http://fairusetube.org/articles/27-youtube-refuses-counter-notices).

Nunziato, Dawn (2009). *Virtual Freedom: Net Neutrality and Free Speech in the Internet Age*. Palo Alto: Stanford Law Books.

Rothchild, Scott (2011). "Brownback Apologizes for Overreacting to Student's Tweet," *Lawrence Journal World*, November 28, http://www2.ljworld.com/news/2011/nov/28/brownback-apologies-over-reacting-students-tweet.

Schnell, Bernadette (2014). *Internet Censorship: A Reference Handbook*. Santa Barbara, California: ABC-CLIO.

Urbina, Ian (2010). "Mobs Are Born as Word Grows by Text Message," *New York Times*, March 24, http://www.nytimes.com/2010/03/25/us/25mobs.html.

Zetter, Kim (2009). "Prosecutors Drop Plans to Appeal Lori Drew Case, *Wired*, November 20, https://www.wired.com/2009/11/lori-drew-appeal.

Zuchora-Walske, Christine (2010). *Internet Censorship: Protecting Citizens or Trampling Citizens?* Minneapolis: Twenty-First Century Books.

Index

About the Author

Patricia L. Dooley is the Elliott Distinguished Professor of Communication at Wichita State University's Elliott School of Communication. Her research and teaching explore journalism history, freedom of speech, popular culture, gender, and communication theory.